A Fine Line

A Fine Line

**SCRATCHBOARD
ILLUSTRATIONS BY
SCOTT MCKOWEN**

FIREFLY BOOKS

A FIREFLY BOOK

Published by Firefly Books Ltd. 2009

First printing

Publisher Cataloging-in-Publication Data (U.S.)
McKowen, Scott.
 A fine line: scratchboard illustrations by Scott McKowen/ Scott McKowen.
[208] p. : col. photos. ; cm.
Includes index.
Summary: A thorough review of the scratchboard art of Scott McKowen,
from theatre posters to magazine and book covers. Detailed analysis
of the underlying meaning and inspiration for each piece of artwork,
as well as a brief overview of the actual process of scratchboard is covered.
ISBN-13: 978-1-55407-451-8
ISBN-10: 1-55407-451-7
1. McKowen, Scott. 2. Scratchboard drawing. 3. Graphic artists—Canadian.
4. Illustrators—Canadian. I. Title.
741.29/092 B dc22 NC915.S4M356 2009

Library and Archives Canada Cataloguing in Publication
McKowen, Scott
A fine line : scratchboard illustrations by Scott McKowen / Scott McKowen.
Includes index.
ISBN-13: 978-1-55407-451-8
ISBN-10: 1-55407-451-7
1. McKowen, Scott. 2. Scratchboard drawing. I. Title.
NC143.M35A4 2009 741.971 C2008-908159-5

Published in the United States by
Firefly Books (U.S.) Inc.
P.O. Box 1338, Ellicott Station
Buffalo, New York 14205

Published in Canada by
Firefly Books Ltd.
66 Leek Crescent
Richmond Hill, Ontario L4B 1H1

Cover and interior design by Scott McKowen

Printed in China

The publisher gratefully acknowledges the financial support for our
publishing program by the Government of Canada through the Book
Publishing Industry Development Program.

"HER MAJESTY'S SERVANTS"
FROM *THE JUNGLE BOOK*.

CONTENTS

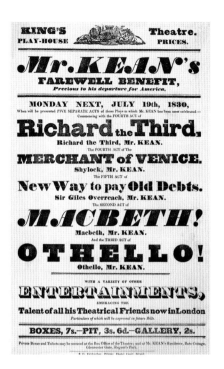

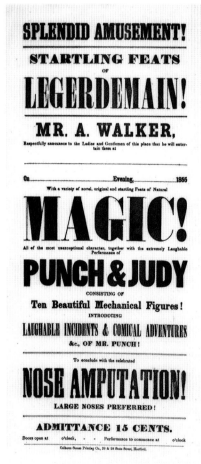

HANDBILL FOR A PERFORMANCE BY EDMUND KEAN IN LONDON, 1830; HANDBILL FOR A VARIETY SHOW IN HARTFORD, CONNECTICUT, 1855.

INTRODUCTION

IN 1881, THE THEATRICAL POSTER CAME OF AGE. Of course there had been posters before this date, but often they were simply complex typographical extravaganzas. They were called letterpress posters and they combined crude woodcuts with various typefaces. The cheap ones were in black ink, the more expensive in red. In the second half of the 19th century, photomechanical printing techniques were perfected and the world of the ubiquitous full-colour image was upon us.

But why do I choose 1881? It's a useful date because in 1881 *The Magazine of Art* published an article called "The Street as Art Galleries." The well-known British artist, Hubert von Herkomer — a fellow of the Royal Academy — had designed a poster. The article discussed the implications quite sympathetically of this step into the gutter of commerce. In the same year, an article in *Punch* (April 30, 1881) derided the idea of established artists like Leighton or Burne Jones ever condescending to provide poster images.

This tension was never really resolved until the late 20th century. There was always a slight stigma attached to the artist who went into "commercial art," as it was known in my childhood. And yet, artists needed to make a living and commercial work was a relatively sympathetic environment in which to labour. Indeed, several members of the Group of Seven worked for advertising agencies without compromising their principles. Many other artists made excursions into the advertising world: Toulouse-Lautrec designed posters for various notorious bars; Millais sold one painting — *Bubbles* — to the Sunlight Soap Company. No artist wanted to live and die in poverty in a tiny garret in order to create great art. It's a pretty conceit for a novel, but no template for a life.

And what are theatre posters? What are they supposed to do? Today they are nowhere near as important as they were a hundred years ago, when images on the street — on hoardings, on omnibuses and trams, outside the numerous theatres — could seduce passersby into spending money on entertainment. Nowadays images seducing us into visiting a theatre show can appear in a dozen different media. A hundred years ago they were chiefly limited to the

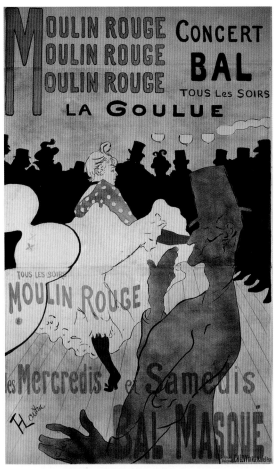

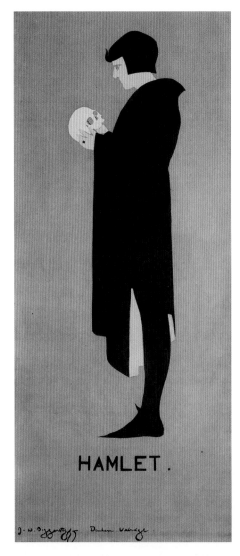

HAMLET.

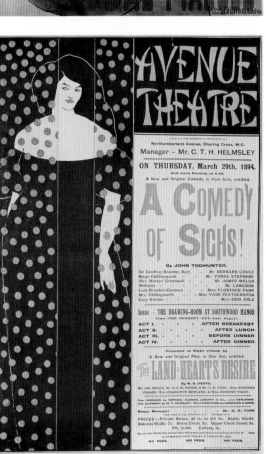

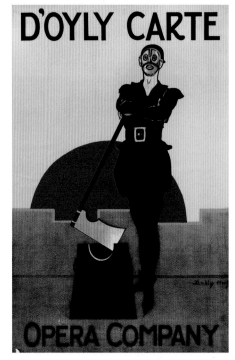

CLOCKWISE FROM TOP LEFT: 1891 POSTER BY HENRI DE TOULOUSE-LAUTREC; 1894 POSTER FOR EDWARD GORDON CRAIG AS HAMLET, BY J. & W. BEGGARSTAFF — THE PSEUDONYM OF WILLIAM NICHOLSON AND JAMES PRYDE; 1907 POSTER FOR GILBERT AND SULLIVAN'S *THE YEOMAN OF THE GUARD,* BY DUDLEY HARDY; 1894 POSTER FOR A DOUBLE BILL AT THE AVENUE THEATRE BY AUBREY BEARDSLEY.

street. Still the aim is the same today as yesterday, no matter what the means of distribution. It is to create a striking image that will be noticed by as many people as possible and encourage them to see the show. And, of course, this still happens.

It's a curious thing that there are still images from a hundred years ago — and more — which easily resonate with us today. Frederick Walker's wood-cut advertising the dramatization at the Olympic Theatre of Wilkie Collins' novel *The Woman in White* is still powerful enough to be used today. Some of the Gilbert and Sullivan operettas spawned famous posters and the cabarets and dance palaces of Montmartre stimulated Lautrec and Jules Chéret to create works which are perhaps more famous today than they were at the end of the 19th century. Then they served a strictly commercial purpose; now they are considered works of art.

Book illustration is something else. Illustration is not about finding a startling image which will attract attention. Illustrations for a story are explorations. As we read a novel or short story we follow the action in the same way that we inhabit a dream. We cannot change the action in a novel, although we can stop and think about what is happening. I do this a lot, particularly when something unpleasant is about to happen to a sympathetic character. I want to delay the inevitable until I can deal with it. Action is clear. The setting, though, is not. The backgrounds of the story exist in a kind of fog. There are, naturally, detailed descriptions when the author needs to be extremely specific. However, the reader usually will construct in his or her own head the landscape, the street, or the room in which the action takes place from what is known or has been experienced. This is why so many films made from novels prove unsatisfying. The images on the screen seldom approach our own inventions.

Illustrations, too, can disappoint and disconcert us when we turn a page and find a picture instead of text. Two things need to happen to prevent a disruption of the narrative. We need to be prepared for the style of the illustration and we need the illustration to expand our understanding. Preparation can be as simple as a frontispiece. "Ah," we say, "this is how the illustrator conceives of the book." And we

can accept or reject this concept. If, and this does happen, we don't like the initial image, then it is possible to ignore what comes after it, leaving us to live in our own invented landscapes with no help from the illustrator. If we accept the style, then the illustrations will provide detail in the more vague dream-like world that we create in our heads.

It is this provision of detail that interests me as a theatre director, because this is what I do when I direct a play. This detail should connect with what the reader or the audience member already knows, and it has to be theoretically possible, however strange the circumstances. This is where an illustration can illuminate a particular moment and thus enrich the story. The landscape outside the bus window, a landscape only glancingly touched upon by the writer, can come to life and enlarge our understanding of an internal narrative or a state of mind. A room can take on a different relevance because the size is revealed. A gesture can gain in significance when we see how a character observing the gesture reacts. A great illustrator intensifies our experience by demonstrating layer upon layer of detail, even if the details are themselves only suggestions.

Would *Alice Through the Looking-Glass* be quite so extraordinary without Tenniel's illustrations? I doubt it. The Jabberwock would not possess its most specific characteristics in its readers' memories without that terrifying image, which, once seen, can never be expunged from the mind.

I have always treasured my first encounter with certain illustrations — Tenniel's of course, then Arthur Ransome's sparse and amateurish illustrations of his own children's books, Kipling's drawings for his *Just So Stories* and Sidney Paget's illustrations in *The Strand* magazine for Conan Doyle's Sherlock Holmes stories. I've just looked at *The Speckled Band* and the last picture of Dr. Grimesby Roylott and I experienced the same kind of shock I had when I was 8 years old, as I devoured the stories late at night, reading with the help of a flashlight under the bed clothes. Holmes has never really changed from these first images. Had Sidney Paget any idea that his portrait of Holmes would outlast all the others?

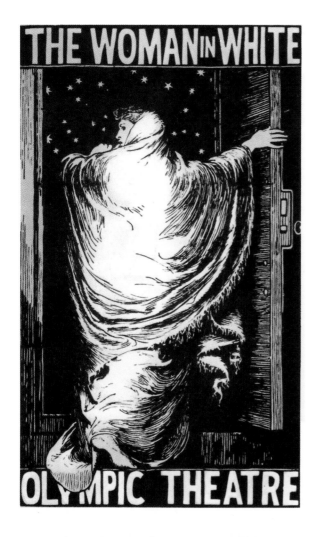

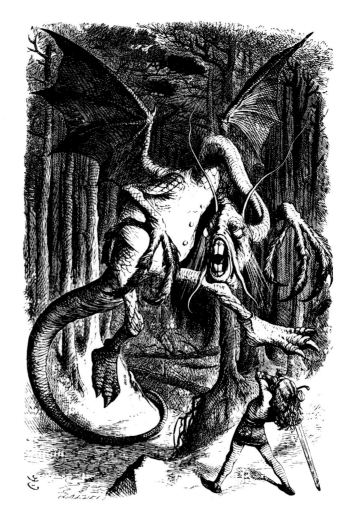

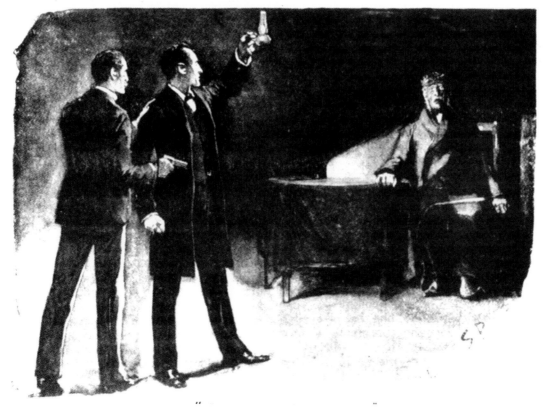

CLOCKWISE FROM TOP LEFT:
WOODCUT BY FREDERICK WALKER
FOR *THE WOMAN IN WHITE*, 1871;
"THE JABBERWOCK" BY JOHN
TENNIEL, FROM *THROUGH THE
LOOKING-GLASS AND WHAT ALICE
FOUND THERE*, 1872; HOLMES AND
WATSON DISCOVER THE BODY OF
DR. GRIMESBY ROYLOTT IN *THE
SPECKLED BAND*, ILLUSTRATION
BY SIDNEY PAGET, 1892.

I SPREAD SOME OF SCOTT MCKOWEN'S POSTERS on the carpet. The majority are for the Roundabout Theatre Company in New York. But there are also posters for The Grand Theatre in London, Ontario, for the Denver Center Theatre Company, for The Acting Company and many others. I wonder if there are themes here?

I know that I would recognize any of these posters as the work of Scott McKowen, in part by recognizing his mastery of the specific technique he uses. His scratchboard technique allows him to work with great delicacy without sacrificing a vigorous intensity in the larger statement. This versatility is not really possible in engraving or woodcuts. In Scott's posters, the black and white constructs are linked with a highly subtle use of often quite bold colour; the result is a series of readily identifiable personal statements. But, aside from the accomplished and elegant technique, it took me some time before I could define what it is that makes me so certain an image is a Scott McKowen work. There is an elusive, yet readily apparent, tone to his work. Ultimately I think it is a sense of whimsy.

There is a sense, not of the fantastical, though that is certainly often there, but more often of an intricate complexity. There is, too, a lightness of heart which is not afraid to acknowledge the proximity of darkness. There is a kind of awareness that asks the viewer to go with the artist on a journey that obviously has a structure, but which may take the viewer into strange and remarkable places. There is a sense that something else may well be happening. For a poster artist, especially one whose abiding interest has always been the theatre, this is a particularly attractive trait. In theatre, a gesture or a particular sound can sometimes be so arresting that we suddenly see a scene or a character from an entirely new perspective.

This whimsical view of the world allows both menace and humour to co-exist. I am thinking of the poster for the Roundabout Company's production of *Heartbreak House* where a great mansion floats in a strangely dark sea, the chimneys of the house belch smoke, and the house begins to take on the appearance of a bizarre, doomed liner. Others have explored these land and seascapes — Terry Gilliam easily springs to mind — but Scott seems able to suggest danger and to reassure us at the same time. Again, this is an enormous advantage in the theatre where we know that, unlike ordinary life, the play will have a shape, that it will be finite, and that, whatever the trials and dangers of the unknown world, the visit will come to an end. Unlike real life, a resolution will be found.

I like, too, Scott's outrageous sense of delight. He can show us Neil Simon removing a piece of roof from the Plaza Hotel and thus suggesting that his play — *Hotel Suite* — has some of the attributes of a children's romp, that the shenanigans in the hotel are as lighthearted and as unimportant as an afternoon spent playing in a nursery. The same mad verve is elaborately explored in the poster for *The Man Who Came to Dinner*. Scott has taken a minor incident involving penguins in a play full of surprises and turned it into a metaphor for the play as a whole.

This combination of fantasy and reality is probably seen at its most refined in the series of images that Scott created for the 1990 season at the Shaw Festival. For several years, The Shaw had stressed the beauty of its gardens. The idea was if you found fault with a production you could be soothed by and find solace in the gardens. In this series, Scott began with the idea of a topiary garden — there really are such places — and he developed the concept in such a way that he could create images for plays as disparate as Shaw's *Misalliance* (a propeller takes off the tail feathers of a topiary peacock), and Cole Porter's *Nymph Errant* (underwear is scattered around a box parterre dominated by a stone statue of Cupid). This sense of delight came to dominate Scott's work at The Shaw, thus reflecting the happy eclecticism of the company.

Scott McKowen takes great pleasure in the human figure. And it is perhaps ironic that one of his most powerful posters (*Tartuffe* at the Roundabout) suggests the human figure without actually showing it. All we have is an empty 17th-century corset. The top of the corset is undone and the laces entwine to form the title of the play. The implications are myriad. Is it Tartuffe himself who has undone the corset? And who was in it to begin with? It could be anyone — maid or mistress. The image is seductive, entic-

Trelawny of the 'Wells'

Dusting off a classic like *Trelawny* is like discovering rose petals pressed between the pages of a favourite old book.

Victorian values and young dreams reconciled. Who else but Arthur Wing Pinero – where else but the Shaw Festival!

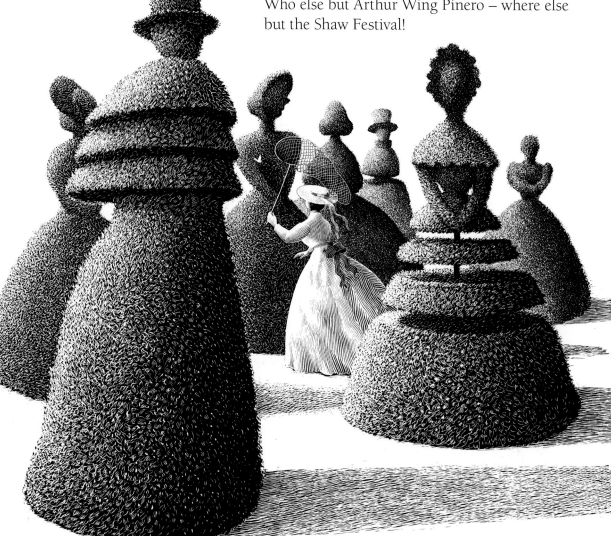

Festival Shaw 1990
AMAZING THEATRE

12

Misalliance

This is the one with the airplane, the Polish acrobat and the steam bath.

Ideas and laughter collide. Who else but Shaw – where else but the Shaw Festival!

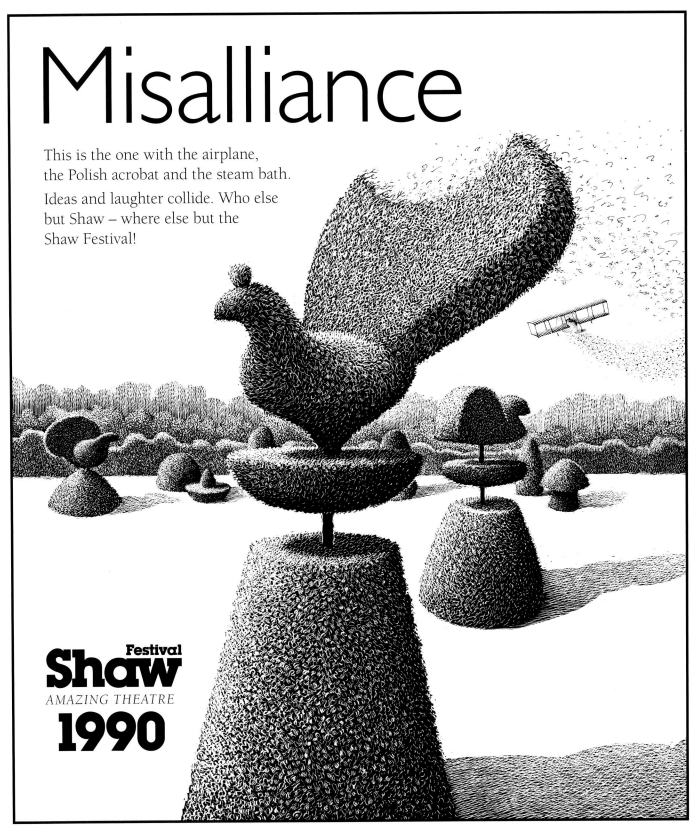

Shaw **Festival**
AMAZING THEATRE
1990

TWO OF SCOTT MCKOWEN'S 1990 "TOPIARY" ILLUSTRATIONS FOR THE SHAW FESTIVAL.

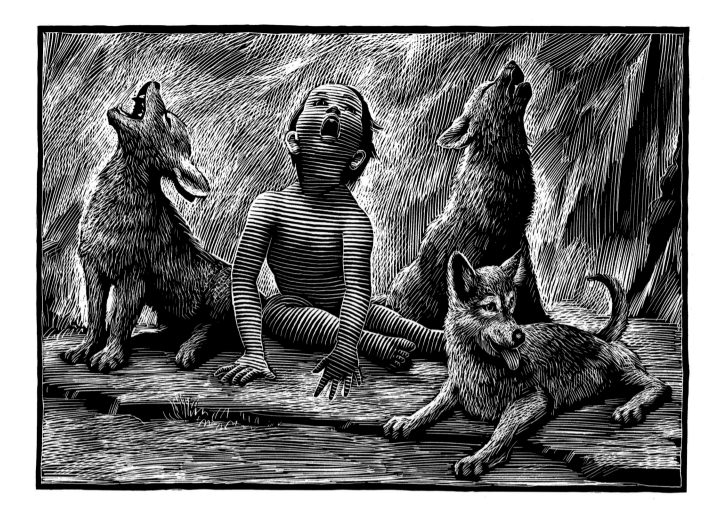

ing and mystifying like the underlying themes of the play. And the result, hopefully, is that the observer is seduced into buying a ticket. The mystery can then be resolved.

In a neat abstraction, Scott has reduced the human figure to a Barbie doll (*The Mineola Twins*) again suggesting that something more is actually occurring than we can fathom just from the single image. He is more forthright in a lovely poster for *Mrs. Warren's Profession*, where the central image, a silhouette of a standing, naked woman, is both sexy and somehow confined and static. Although it is the first image that we notice, it exists as a background for a page from an account ledger. And we realize that the naked woman has become a commodity.

On the other hand, the boys throwing paper airplanes (*All My Sons*) and the dark figure plunging into the ocean (*Gem of the Ocean*) are anything but static. These boys are bursting with energy. The interesting thing here is that we want to be with

them. We want to participate in the thrill of their movement, their rush towards us, and we can only do that if we purchase a ticket.

These people in the posters, who sometimes look an awful lot like actors that Scott and I have known over the years, lead me to his book illustrations. The same whimsical half-smile seems to suffuse these extensions of the writers' worlds and what intrigues me is that Scott has dared to challenge the best of the older illustrators. He has no fear. Territory firmly staked out by Tenniel or E.H. Shepard is undermined, and I realize what it is that so truly impresses me. Somehow we are able to connect the past with the present. Scott affirms that the reader is alive now.

These book illustrations are definitely from the 20th or 21st centuries. Certainly the drawing technique is old-fashioned. The scratchboard skill exploited with great dexterity is timeless, but the images inspired by the texts are brought forward to the present day. I'm not sure how Scott has done this because, often,

the characters are very much of their own time. (I am thinking particularly of the animals in *The Wind in the Willows*.) And yet, I know these creatures. They are very much like people I shop with on Saturdays or pass as they get out of a bus outside the Royal George Theatre. Is it simply that, when an artist fully inhabits his or her own world, this identification helps us appreciate other times and other worlds? We understand Alice's fall down the rabbit hole quite differently after seeing pictures of men floating in space.

It is, perhaps, what any fine artist does. He or she opens doors and makes connections that others only half recognize. A moment of contradiction or the representation of a surprising truth can create laughter, and laughter — as Bernard Shaw knew so well — opens us to other ideas.

But it is not only laughter that is generated by juxtapositions. It can also be understanding and recognition. I keep turning to the illustration of Mowgli and the young wolves in *The Jungle Book*, which shows a real baby surrounded by real wolf cubs. Two of the cubs join the howling baby, another cub is distracted. The distracted cub makes me believe that the whole idea is reasonable, that a child could be raised by wolves. These reasonable details — Mole's fingernails are another example — fuse illustration and narrative. I participate more fully because I recognize.

I CAN'T REMEMBER EXACTLY WHEN I FIRST SAW Scott's work. But when I did, and it must have been over twenty years ago, my first reaction was to compare him with the American painter and book illustrator Rockwell Kent. Scott's works have, I think a comparable broad vigour. It was only later that I began to appreciate the delicacy and wit of Scott's images and the generous discrimination of his whole approach to graphic design.

I was always delighted to see his tall, lanky figure from my office window at the Shaw Festival. In the fall, he would arrive at the stage door almost always burdened by a small suitcase of books and sketches to work on the annual brochure.

The brochure was always an adventure. Scott and David Cooper, the theatre photographer, would develop a basic idea into a set of variations. And these variations would always fly off in all directions. In a brochure emphasizing the countryside around Niagara-on-the-Lake, red apples in our orchards are turned into red books to be harvested by the actors while another actor chases butterflies from the sidecar of an old motorbike. In the most beautiful of all the brochures, an old set — for Coward's *Easy Virtue* — was painted a pale gray, and every play was somehow enticingly suggested by an incident re-created in this evocative room.

In the spring, Scott would arrive with more books and a file of ideas for the programmes. These would be meticulously researched. He must have spent days in the Bridgeman Art Library or the Hulton Archives going through drawer after drawer, envelope after envelope, of forgotten photographs. The great Mander and Mitchenson Theatre Collection would disgorge strange memories. Scott actually found a photograph of Forbes Robertson's set for *Caesar and Cleopatra* being burned on the beach in San Francisco in 1914.

With his wife, Christina Poddubiuk, he seems to live in a glorious whirl of images drawn from everywhere under the sun. This generous eclecticism rules everything he does. For the observer — and even more so for a collaborator like myself — being with Scott is like entering a fairy story. On holiday, he sketches. An adventure travels from eye to brain to hand to paper. Nothing mechanical gets in the way, and I wonder if this is not the key to the vitality of his imagination. Scott is here in our world now, but his connection with the world is respectfully old-fashioned in the way it is experienced and gathered. It is only modern in the distribution. Perhaps this is the whimsical balance that makes his work unique.

CHRISTOPHER NEWTON
ARTISTIC DIRECTOR EMERITUS, SHAW FESTIVAL

OPPOSITE: SCOTT MCKOWEN'S ILLUSTRATION
"MOWGLI'S BROTHERS" FROM *THE JUNGLE BOOK*.

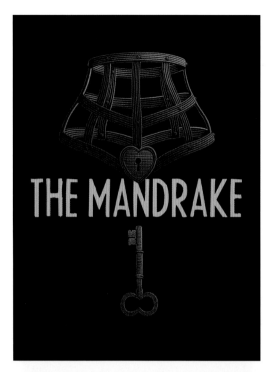

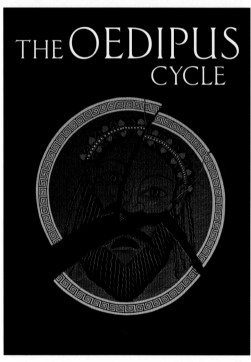

2008-09 POSTERS FOR THE PEARL THEATRE COMPANY, NEW YORK.

THEATRE POSTERS

In 2007, I was invited to create a new graphic identity for The Pearl Theatre Company. This resident acting company — one of very few in the United States and the only one in New York — focuses exclusively on the classical repertory.

I visualized a series of clean, iconic images that would communicate ideas without relying on large scenes with a lot of figures. The Pearl performs in an intimate theatre space on St. Marks Place in the East Village, and I wanted the images to be appropriate in scale. It was also important that the illustrations reproduce well in small ads in newspapers and magazines.

My first assignment for The Pearl was Niccolo Machiavelli's *The Mandrake*. Machiavelli's name is identified with cunning politics, not bawdy comedy — but if you lived in Florence during the Renaissance you could be a musician, poet and playwright and, at the same time, a diplomat and political philosopher. The satirical plot traces Callimaco's scheme to sleep with Lucrezia, the young and beautiful wife of an elderly fool. The Pearl was not afraid of a racy image, and we proposed a chastity belt — with a phallic "key" pointing at the lock. Real ones from the period look more like implements of torture — I tried to make this one more like a 1950s foundation garment with a sly sense of humour.

The Oedipus Cycle was a world premiere adaptation, combining *Oedipus the King*, *Oedipus at Colonus* and *Antigone* into a single evening of theatre. I love the graphics on ancient Greek pottery. I used three broken shards of a plate to represent Sophocles' epic trilogy. My portrait of the mythical king was adapted from a book of Athenian black-figure vases.

The magical, glowing oyster started out as a poster concept for *Twelfth Night* (with twin pearls) — but evolved into a season image for the theatre's 25th anniversary in 2008-09, a symbol of something rare and precious.

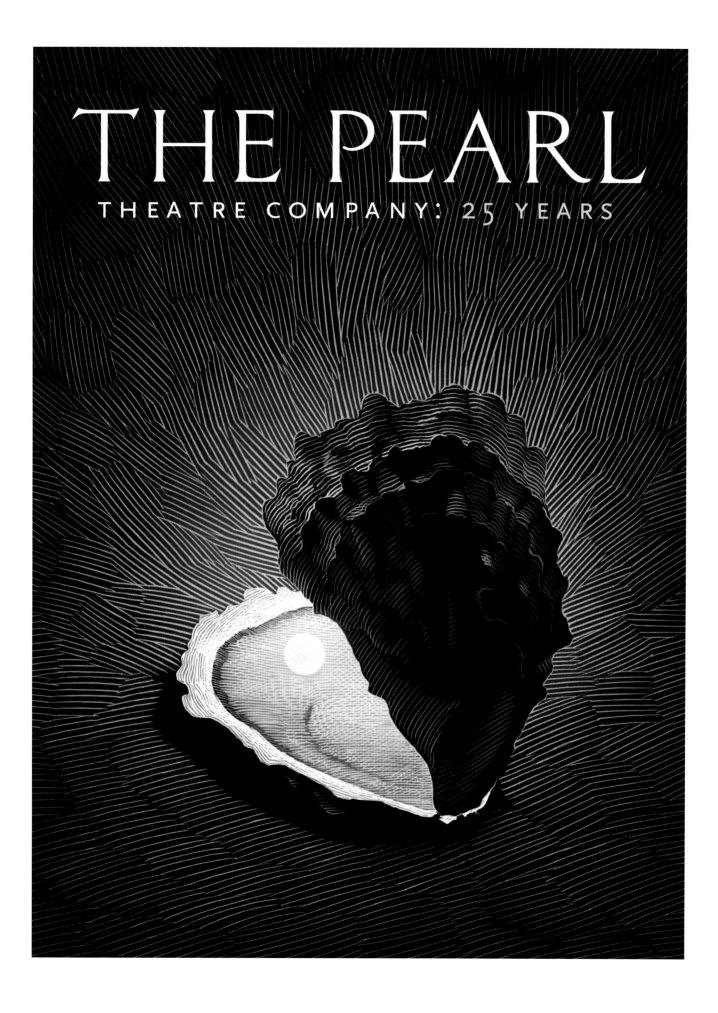

THEATRE POSTERS

The Acting Company has been touring classical theatre productions across America since 1972. This company was my very first professional theatre client in the late 1970s; we have worked together on many projects over the years.

Shakespeare's *Twelfth Night* is often played as youthful comedy, but the best productions I have seen allow the bittersweet side of the story to emerge. For The Acting Company's 1993-94 production, director Bartlett Sher asked for an image that would be playful and inviting — but at the same time mysterious and a little scary. He talked about the play as a "festival of renewal" in which characters exchange their illusions for new realities. He observed that Malvolio is cast out at the end of the play because he's the one character who is not open to change.

As the play begins, Viola is shipwrecked on the coast of Illyria, and believes her twin brother, Sebastian, has drowned. Mr. Sher had decided on a 17th-century setting for his production, so I started by looking at art from the period.

The engravings of Jacques Callot (1592-1635) quickly became my inspiration for this project — in particular several of his fabulously dramatic seascapes.

The organic shapes of Callot's islands somehow led to the idea of the sea monster. They made me think of those blurry photographs purporting to show the Loch Ness Monster, its body snaking in and out of the water. The idea of stepping onto what you think is dry land — but proves to be something else when seen from a different perspective — seemed to fit Mr. Sher's vision. (Jules Verne inverted this idea when his trio of explorers in *Journey to the Center of the Earth* spot what they think is a whale on their subterranean sea voyage — but which turns out to be an island with a geyser.)

In Act III, Sebastian suggests to Antonio "Let us satisfy our eyes with the memorials and the things of fame that do renown this city." Illyria must have had a thriving tourism industry. Orsino's palace would surely be the tallest and grandest building in the centre of town. The architecture in my drawing came from Callot's fortresses and castles perched dangerously on steep cliffs — as well as specific details such as the crane, the ship and the billowing smoke mingling with the wind-swept clouds.

This poster won a silver medal in the Society of Illustrators 1995 annual exhibition in New York.

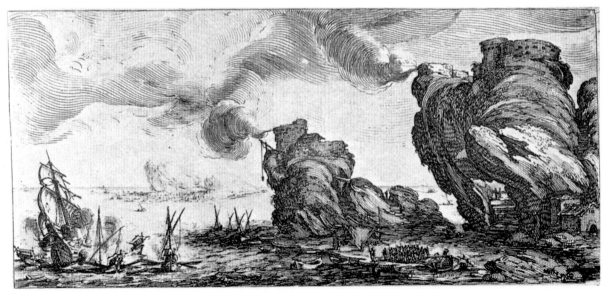

DIE SEECHALACHT BY JACQUES CALLOT, C.1617.

Twelfth Night

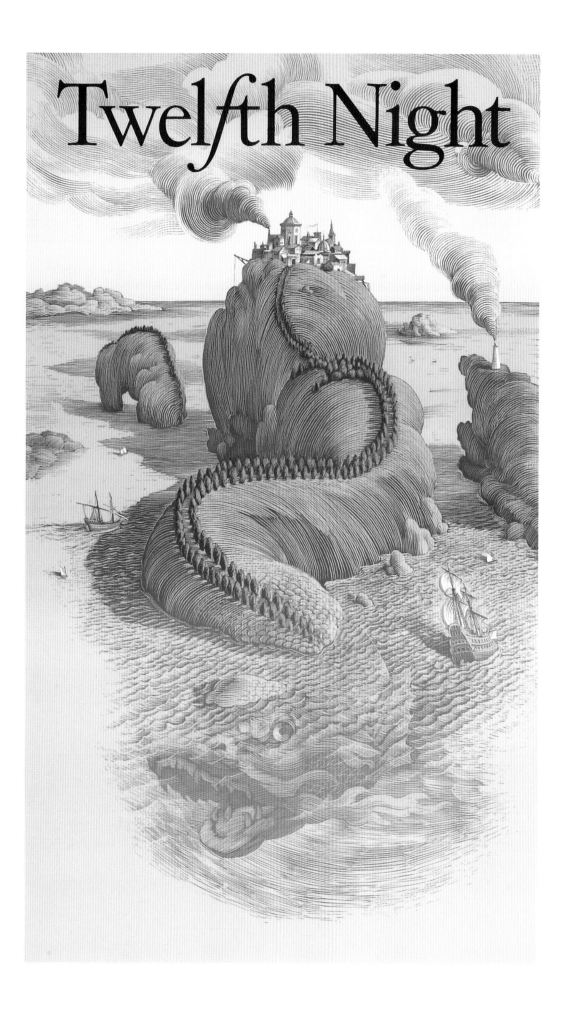

TWELFTH NIGHT

1998 OIL PASTEL ILLUSTRATION FOR THE ACTING COMPANY,
NEW YORK.

THEATRE POSTERS

It's a joy to return to a play like *Twelfth Night* again and again, creating images that reflect different aspects of the play. The Pearl Theatre Company wanted an image that would suggest "passion run amok" through the play's lovelorn characters. The brochure copy observed, "they love the people they can't have and ignore the people they can." Who says Shakespeare isn't modern?

Setting up a scene with costumed figures and models didn't fit the iconic style we had established for The Pearl. Besides, I had done that on a 1998 poster for The Acting Company. (The identical twins Viola and Sebastian each think the other drowned — and spend the entire play missing each other by moments as one exits and the other enters. I put them together on an Illyrian beach, looking for each other in opposite directions.)

I needed a fresh approach for The Pearl, and Christina's perspective as a costume designer came to my rescue. Two identical Elizabethan doublets on wardrobe stands represent the twins — one male, the other a bit smaller to fit a woman. And these inanimate objects have an irresistible attraction to each other — they lean towards each other and their sleeves intertwine, as if there were arms inside. The costume details are borrowed from a famous portrait miniature in the Victoria and Albert Museum — Richard Sackville, 3rd Earl of Dorset, painted by Isaac Oliver in 1616.

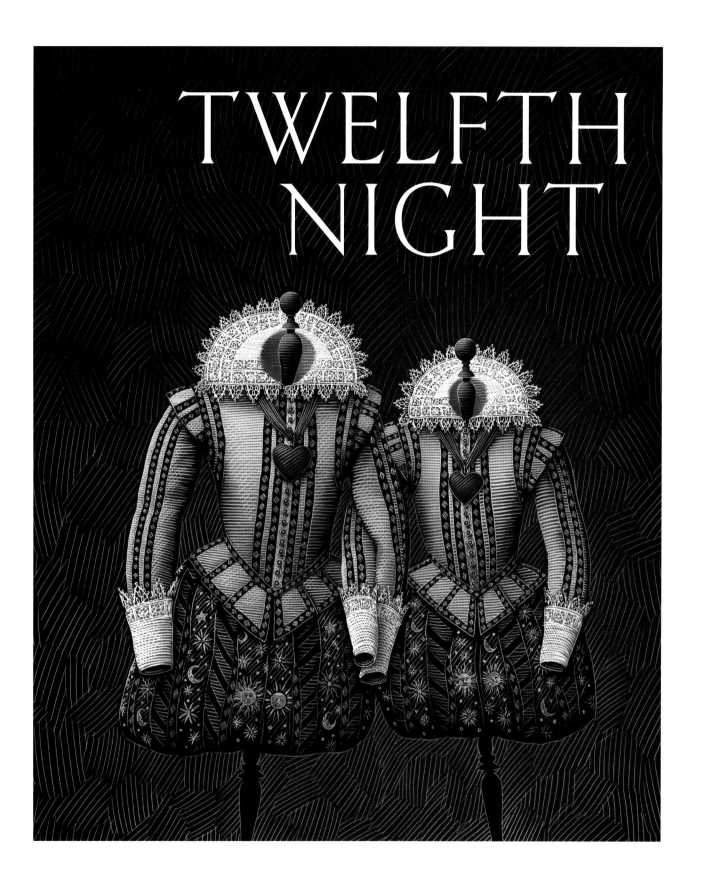

TWELFTH NIGHT

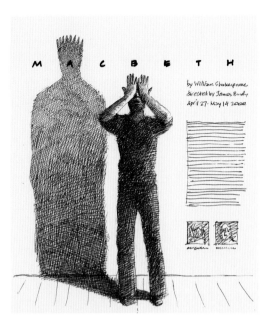

PRELIMINARY PENCIL SKETCH FOR *MACBETH*.

THEATRE POSTERS

"The Scottish Play" was written by Shakespeare to please the Scottish King James, who succeeded to the English throne when Elizabeth I died in 1603. James considered himself an expert on the occult, and had even written a book called *Demonology*.

Isaac Asimov points out in his very useful *Guide to Shakespeare* that the witches in the play are not Shakespeare's invention — they were already associated with the early Scottish king Macbeth in the source material for the story. Asimov contends that their name, "the weird sisters," shows that they are more than mere witches. The word "weird" comes from the Anglo-Saxon word "wyrd," meaning "fate." So the weird sisters are actually the Norns — in Nordic mythology the three sisters representing past, present and future, who were the goddesses of destiny.

In their first encounter in Act I, the First Witch hails Macbeth as Thane of Glamis (which represents the past). The Second hails him as Thane of Cawdor (the present — Macbeth has just been given this second title by King Duncan in the previous scene — although he does not yet know it). The Third witch speaks of what is to come: "All hail, Macbeth, that shalt be King hereafter!"

And this is a self-fulfilling prophecy. Once the idea of kingship is planted, dark thoughts start reverberating inside Macbeth's head. His frightening line in Act III "O, full of scorpions is my mind, dear wife!" inspired this poster image.

Macbeth's gesture of horror — hands covering his eyes — conveys the nightmares unfolding in his mind. The light source from below makes the scene appropriately eerie (a more familiar meaning of weird) and creates the crown-like shadow of his fingers on the wall above his head. This suggests that the apparitions conjured by the witches are a figment of Macbeth's imagination.

The title role in this production at Great Lakes Theater Festival in 2000 was played by Derrick Lee Weeden, and director James Bundy requested an African-American face on the poster. My brother-in-law in Lansing, Michigan, modeled for the illustration.

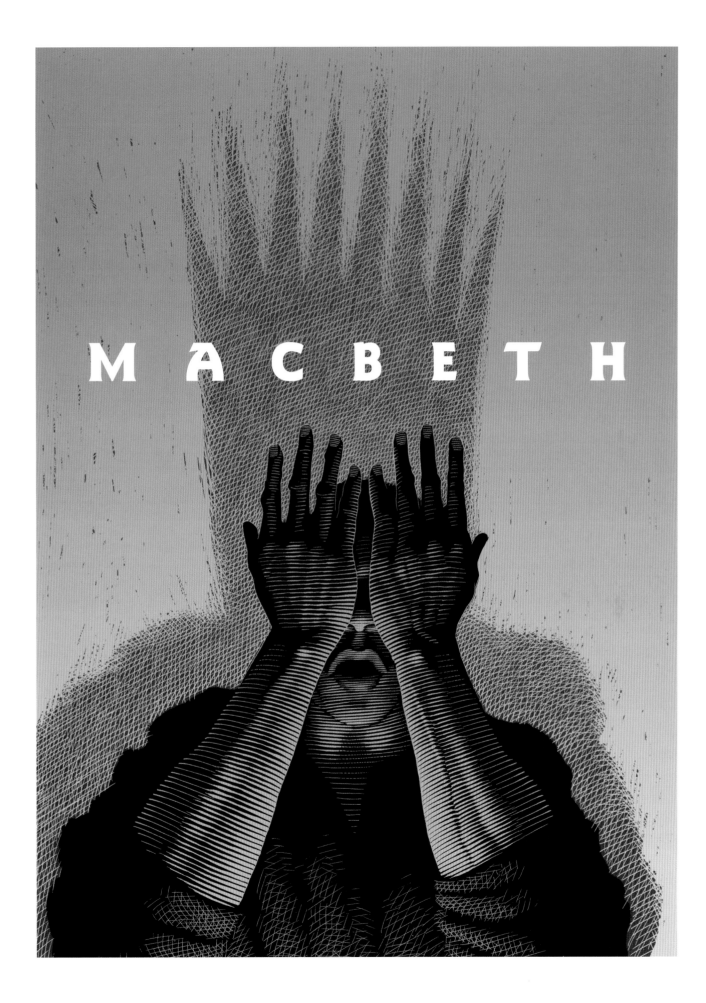

MACBETH

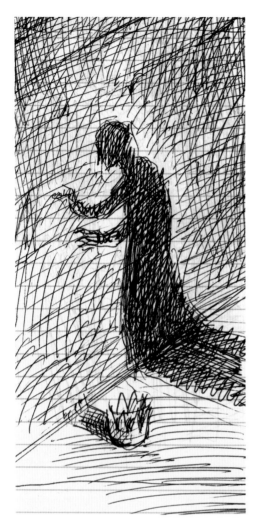

PRELIMINARY PENCIL SKETCH FOR *KING LEAR*.

THEATRE POSTERS

Scratchboard seems the perfect medium for Shakespeare's immense, astonishing masterpiece *King Lear*. I think the medium itself inspired this concept. The sheer blackness of the surface makes me think of all the references in the play to darkness and blindness — literal and psychological. Lear's judgment is clouded because he cannot see clearly — Kent says "See better, Lear, and let me still remain the true blank of thine eye." Gloucester's eyes are put out. The text is full of lines like "Meantime we shall express our darker purpose," or "'Tis the time's plague when madmen lead the blind," or "The prince of darkness is a gentleman." Even "These late eclipses in the sun and moon portend no good to us" refer to the absence of light.

This poster was part of a silhouette series for the Denver Center Theatre Company, and my first thought was that a figure silhouetted against a violent sky would evoke the famous scene on the heath. Kent describes the storm: "Since I was a man, such sheets of fire, such bursts of horrid thunder, such groans of roaring wind and rain, I never remember to have heard. Man's nature cannot carry th' affliction nor the fear."

But Kent Thompson, the director for this production, talked more about Lear's mind and madness: "the storm within." Christina Poddubiuk came up with this stunning concept that combines exterior and interior storms simultaneously. *King Lear* is universal in its questions and implications, and still a remarkably intimate personal drama. This poster addresses both aspects of the play.

The electricity adds sharp dramatic contrast to the darkness, and a high-voltage sense of danger. The lightning had to look convincing against the black background, so I used a Photoshop filter to add an atmospheric "glow" around the lightning bolt as a finishing touch.

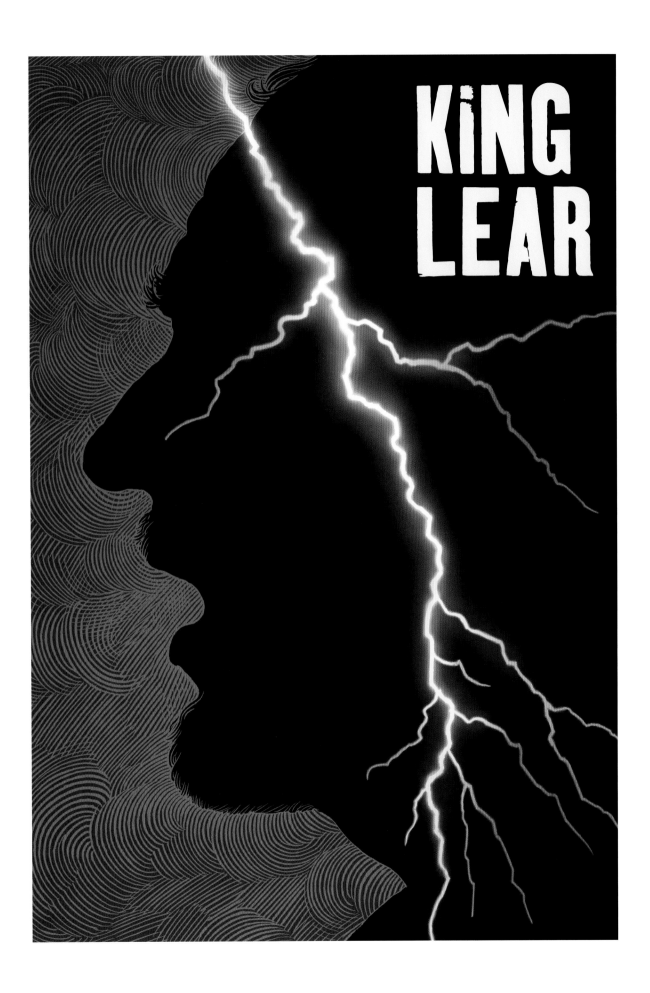

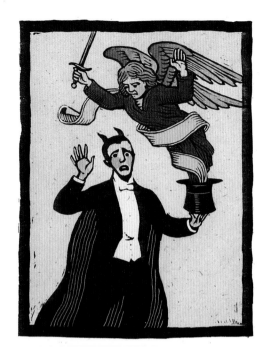

WORLD OF WONDERS

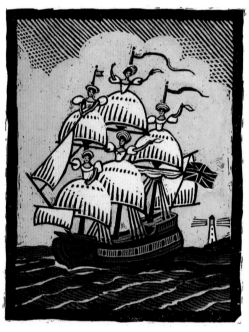

H.M.S. PINAFORE

THEATRE POSTERS

For a 1992 Stratford Festival season brochure, I experimented with the look of bold, primitive woodcuts used in early 19th-century chapbooks and "penny dreadfuls." Once the scratchboard drawings were finished, I photocopied the black and white line work onto textured paper and added watercolour. On the facing page are four Shakespeare images, clockwise from top left:

For *Romeo and Juliet,* a pair of medieval towers symbolizes the "two households, both alike in dignity," that separate the young lovers. I wanted to suggest the couple's plans and dreams — which almost work out — but remain, tragically, just out of reach. (I recycled this idea a couple of years later for The Acting Company, in a more detailed oil pastel illustration).

In an early scene in *The Tempest,* Prospero describes for Miranda how they first came to the island 12 years before — in "a rotten carcass of a boat," after he had been deposed as Duke of Milan by his brother Antonio. This backstory provides a glimpse of the powerful magician in a moment of vulnerability.

In *Love's Labour's Lost,* the youthful King of Navarre and his three scholarly companions have vowed to forsake the company of women. The visual pun on Cupid was suggested by the hunting scene in which the Princess of France and her three ladies-in-waiting shoot a deer with bows and arrows.

In *Measure for Measure,* Isabella faces a horrible dilemma when Angelo, the Head of State, proposes that she sleep with him to save her brother from execution. Lipstick, smeared on a face associated with chastity, seemed a powerful metaphor for the play's themes of sexual immorality.

On this page are two other illustrations from the series — an adaptation of Robertson Davies' novel *World of Wonders,* which tells the story of Magnus Eisengrim, the world's greatest magician; and the Gilbert and Sullivan operetta *H.M.S. Pinafore.*

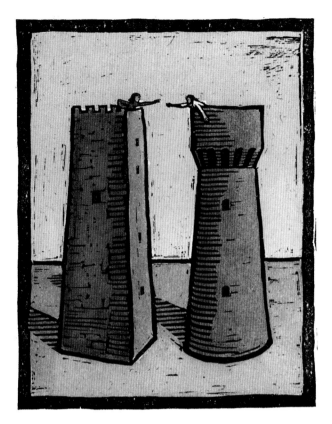

ROMEO AND JULIET

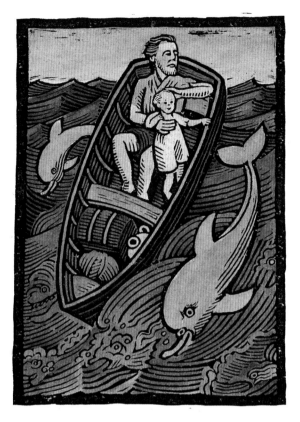

THE TEMPEST

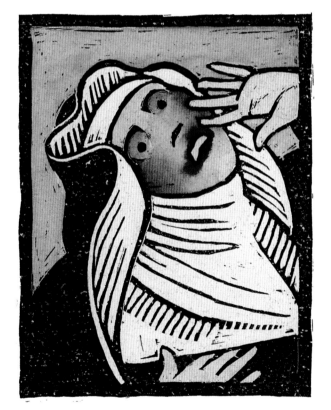

MEASURE FOR MEASURE

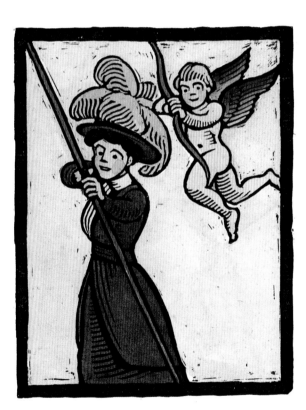

LOVE'S LABOUR'S LOST

An image for Molière's famous play, it seems to me, requires a balance between comedy and the darker complexities of the play. Joe Dowling, director of The Roundabout's 2002 production, felt that the poster image should lean toward the darker side of the story. This production would be set "in period" — more or less the date Molière wrote the play (1664) — but Dowling specifically asked that the poster retain a modern sensibility.

Mr. Dowling wanted to explore Orgon's obsessive devotion to Tartuffe, and had cast Brian Bedford and Henry Goodman in these two roles. (Bedford had played the title role, unforgettably, in a production at the Stratford Festival in 1983, directed by John Hirsch; it was a treat to see him tackle Orgon now). I began with a number of sketches showing Orgon being duped by Tartuffe in various ways; then, attempting to work in the religious plot, I gave Tartuffe little devil horns. No go.

The solution came in Mr. Dowling's response to my sketches of the two male main characters (none of which were working). He wondered if it would help to add Elmire, Orgon's wife, who is the target of Tartuffe's lust. In order to prove to her husband that Tartuffe is an imposter and a villain, she pretends to submit to Tartuffe's sexual advances (on the dining room table with Orgon concealed, hilariously, underneath). Dowling suggested that we go for something more sensual.

And that led to the corset. The period shape of the garment, and the calligraphic corset laces, convey the 17th-century setting; its graphic treatment (almost like a pop art icon) and the hot pink give the poster a contemporary feel.

At one point, the plot hinges on crucial legal documents. Since we already had a calligraphic playtitle, I added a layer of Latin text very quietly in the background, distressed with stray pen strokes and blobs of ink.

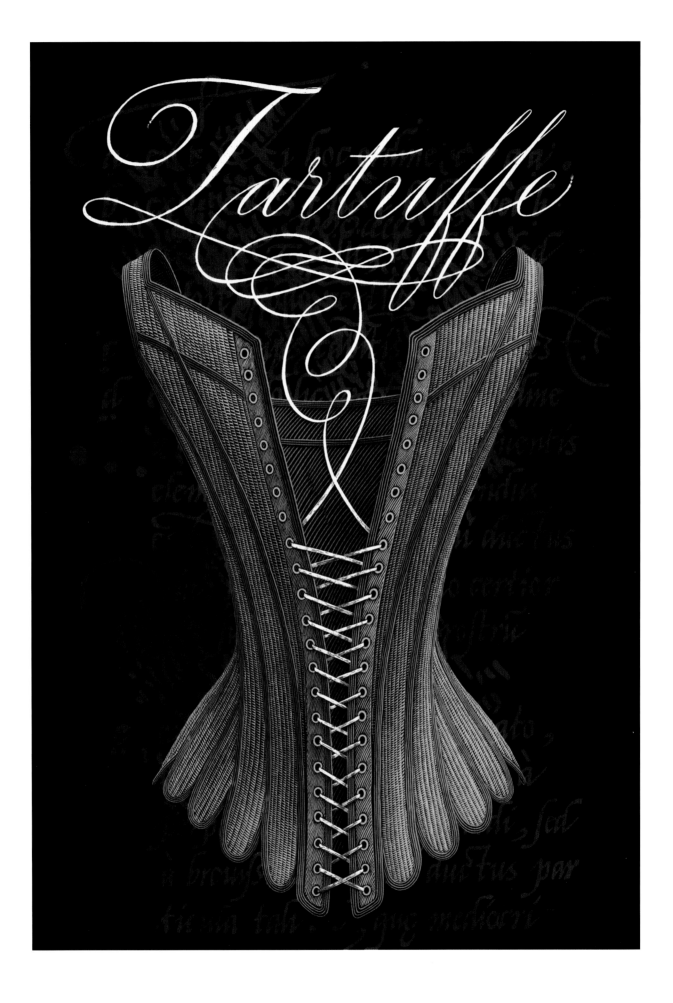

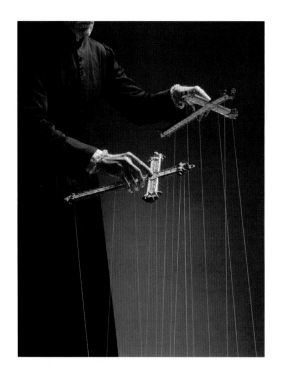

POSTER FOR YALE REPERTORY THEATRE'S 2007 *TARTUFFE*,
WITH A PHOTO BY DAVID COOPER.

THEATRE POSTERS

I revisited *Tartuffe* for Yale Repertory Theatre in 2007, and again for The Pearl Theatre Company in New York in 2008. For both these posters, the central theme of religious hypocrisy became the main focus of the image.

Daniel Fish directed the play for Yale Rep (co-produced with the McCarter Theatre in Princeton). The set consisted of a lavishly detailed period room placed off-centre on the stage — a rich, glowing jewel box juxtaposed against a dark expanse of empty space. The scenes were staged inside the period room — parts of which were tantalizingly out of the audience's sight lines. Other characters, in full view of the audience, watched and eavesdropped from the neutral space outside the room. The audience became voyeurs as well — an onstage videographer filmed the hidden moments, which were played back in real time on large monitors in the dark void.

Our Yale Rep images use photography, not scratchboard — but the problem-solving process is no different. Daniel Fish suggested a pair of lips kissing a crucifix. We had caused a stir at Yale Rep the previous season with an image for Mark Lamos's production of *Lulu* (*The New York Times* refused to run our ads), so we were not afraid of controversy. But the kiss idea seemed to verge too far into fetish. We tried several ideas involving a crucifix, and hit upon a priest/puppeteer. Tartuffe exerts control over Orgon by feigning piety — a marionette control bar is cross-shaped to begin with.

The Pearl's brochure emphasized the potency of Molière's satire. (The play was well received by the public, and even by King Louis XIV, when it first appeared — but the Archbishop of Paris threatened to excommunicate anyone who watched, performed in, or even read the play.) I wanted the image to have some teeth. In Christian symbolism, the snake refers to Satan, the Tempter, enemy of God and the agent of the Fall.

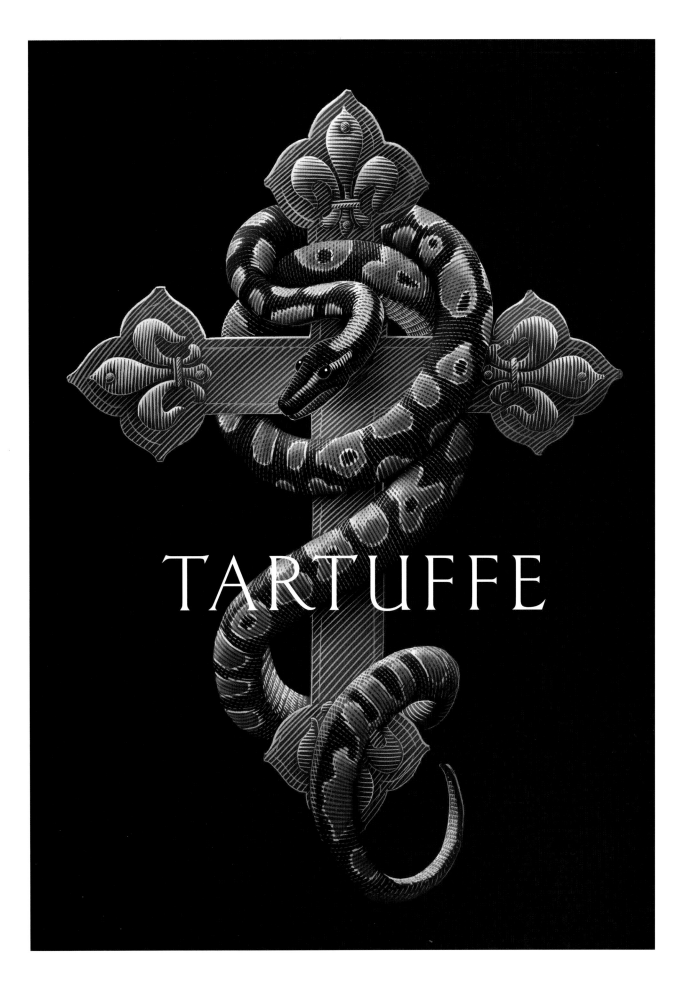

TARTUFFE

THEATRE POSTERS

Given the number of theatres across North America that rely on Charles Dickens to bring home the prize turkey (at the Box Office) every holiday season, I'm surprised that I have not had to tackle this old chestnut more frequently.

This poster was part of James Bundy's first season at Great Lakes Theater Festival in Cleveland, in 1999. The assignment was to freshen up the image of their annual holiday production. I think the marketing department was hoping for Tiny Tim sitting on Bob Cratchett's shoulders — but I said "Humbug!"

I understand the marketing strategy behind a feel-good image — it's a family show. Notwithstanding the happy ending and the universal message, *A Christmas Carol* is a ghost story — and a darned good one to have retained its potency since 1843, when it was written. I wanted something spooky.

I knew better than to try to depict the three spirits (four, if you count Jacob Marley). To reflect the design and staging choices specific to this production (to "show the product," in marketing terms), I would have been reduced to drawing from production photos. Besides, ghosts are always scarier left to the imagination.

Instead we see Ebenezer's reaction to the spirits. I needed a model who could convey fright — but with a sense of fun, like the amusement park ride you're too terrified to get on — and then can't wait to go on again. Bernard Behrens, a wonderful senior actor at the Shaw Festival, gave me exactly what I was hoping for — his fabulously expressive face makes the perfect Scrooge. Not surprisingly, he had played the role years ago at The Guthrie Theater in Minneapolis.

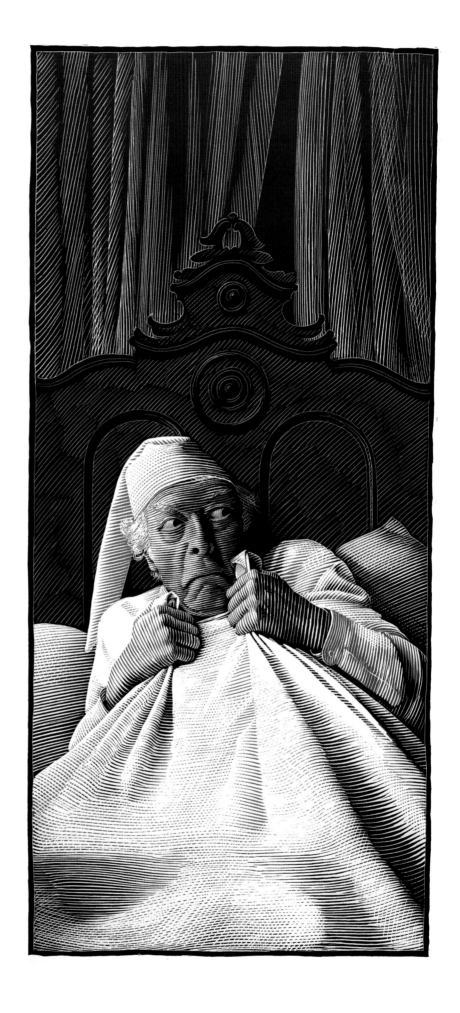

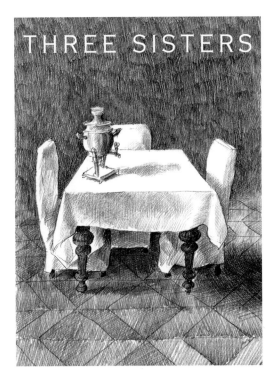

PRELIMINARY PENCIL SKETCH FOR *THREE SISTERS*.

THEATRE POSTERS

Director Scott Elliott told me that his 1997 pro-
duction of Chekhov's *Three Sisters* would be "set
in 1900 in an extravagant black box." He would
be emphasizing darkness and claustrophobia,
and he wanted the poster to reflect this minimal-
ist approach. "The more stark the better."

Elliott had also mentioned that, for him, three
women's faces were not a prerequisite for the
poster. My first pencil sketch suggested the
presence of the title siblings by their absence.
I thought that three slipcovered chairs around
a samovar might evoke the right sense of dis-
possession, loss, and longing for better days.

The sketch that everyone responded to was the
simplest — a woman in the dark, holding up a
candle. It was not meant to illustrate a specific
scene (although it feels a bit like Act III, after the
fire at 3 am) — or even a particular character, but
to conjure up a sense of these girls stuck in this
provincial backwater, trying to figure out where
they belong, where they want to be. Scratch-
board is wonderful for rendering lighting effects
— I was after the mystery and stillness of a
Georges de la Tour painting, adapted into 19th-
century engraving lines.

I did not make it to New York to see the produc-
tion, and I'm still sorry I missed it. The starry
cast included Billy Crudup, Calista Flockhart,
Paul Giamatti, Amy Irving, Eric Stoltz, David
Strathairn, Lili Taylor, and Jeanne Tripplehorn.

THREE SISTERS

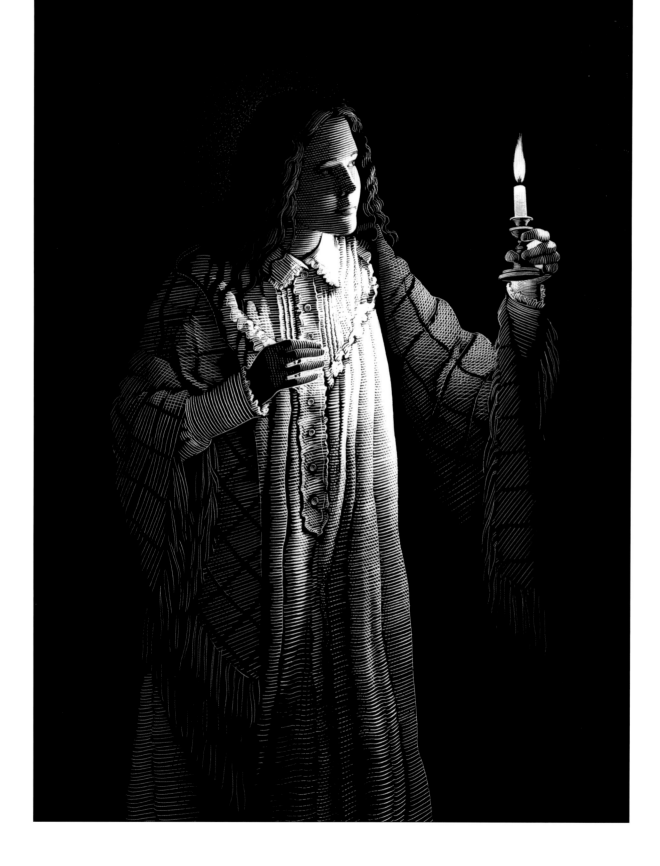

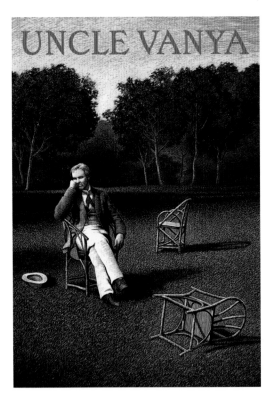

UNCLE VANYA POSTER FOR THE ROUNDABOUT THEATRE COMPANY, NEW YORK.

THEATRE POSTERS

My favourite scene in *Uncle Vanya* comes in Act III: Vanya is hopelessly in love with Yelena, and has cut a bouquet of roses for her in the garden. Holding the flowers, he walks in on Yelena and Doctor Astrov, interrupting their unexpected moment of spontaneous passion. It's simultaneously very funny, and horribly embarrassing — a perfect Chekhov moment.

I have tackled *Uncle Vanya* several times, but the illustration on the facing page, originally created for Daniel Sullivan's 1996 production at Seattle Rep, is my favourite. It's a simple, seated portrait of the title character — only his head is a giant rose, a symbol of his dreams and infatuations. The scratchboard engraving lines give the poster a 19th-century flavour, while the surreal twist makes the poster a firmly contemporary graphic.

My scratchboard poster for The Roundabout's 2000 Broadway production featuring Derek Jacobi, Laura Linney, Brian Murray, and Roger Rees was more naturalistic. This time the title character is in a landscape with birch trees in the background; the Vanya/Yelena/Astrov triangle suggested by three rustic chairs.

UNCLE VANYA

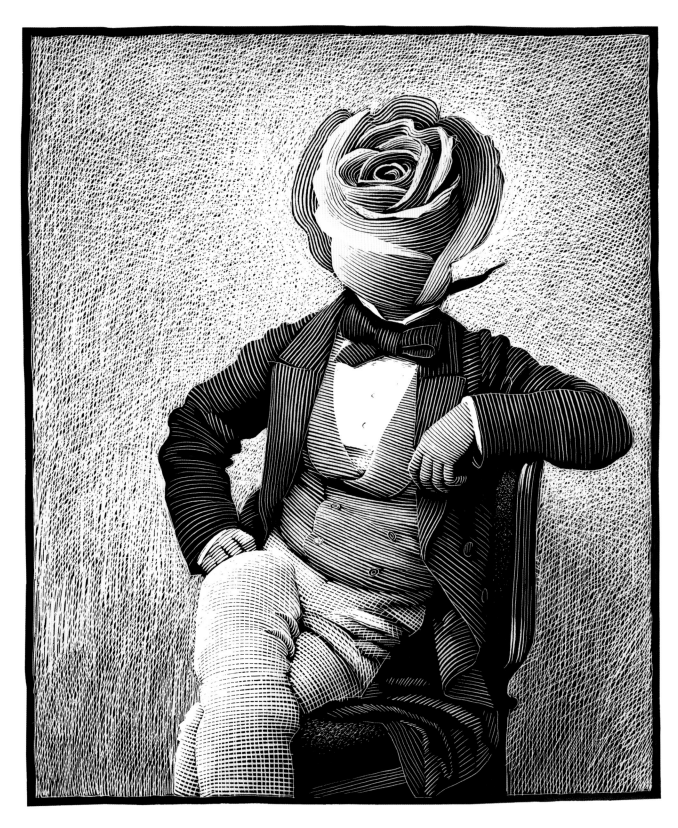

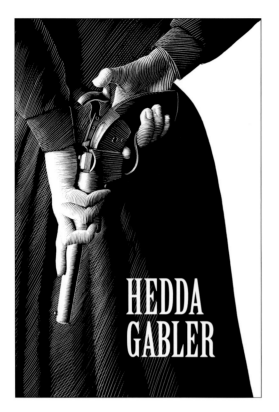

1995 POSTER FOR ARENA STAGE.

THEATRE POSTERS

One of my early posters for The Roundabout was this *Hedda Gabler* — and it's still a favourite. The production starred Kelly McGillis in the title role, and Laura Linney as Thea Elvstead.

Looking for a way to represent Hedda's inappropriate and dangerous behaviour, I started with sketches of a woman playing with matches. Fire is associated with passion, of course, and Sarah Pia Anderson, the director, loved the connection to Hedda's burning Eilert Lovborg's manuscript — which she saw as "fundamentally the most disturbing moment of the play." So it seemed we were on the right track.

Anderson wanted the poster to challenge romantic perceptions of the character, and we had long discussions about whether to go for a portrait likeness, and whether it should convey some aspect of her emotional state. I ended up representing Hedda's self-destructive nature by showing her going up in flames like a matchstick herself.

It wasn't possible for Kelly McGillis to model for this illustration, so I asked Stratford actress Lucy Peacock. Conveniently, Lucy was playing Yelena in a Stratford Festival production of *Uncle Vanya* that summer, and this stunning evening gown was one of her costumes in that show. There was even a pistol from the correct period on the *Vanya* props table.

Hedda came up again a year later at Arena Stage in Washington. I focused squarely on the pistol this time. She's holding it — caressing it behind her back — clearly hiding it from someone. I was after a hair-trigger tension, and a sense that something terrible is about to happen.

Hedda Gabler

Hedda Gabler

BY
Henrik Ibsen
TRANSLATION BY
Frank McGuinness
STARRING
Kelly McGillis

Patricia Conolly
Keith David
Jeffrey DeMunn
Bette Henritze
Laura Linney
Michael O'Keefe

DIRECTED BY
Sarah Pia Anderson

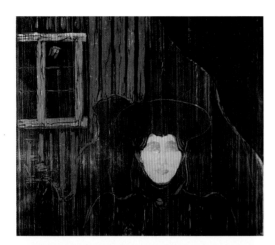

MOONSHINE, A WOODCUT ENGRAVING BY EDVARD MUNCH;
CONCEPT SKETCH FOR THE PEARL THEATRE POSTER.

THEATRE POSTERS

Ibsen wrote *Ghosts* in 1881. Like *A Doll's House*, it was deliberately sensational — a powerful and frank treatment of "taboo" issues including venereal disease, incest, infidelity, and euthanasia.

Mrs. Alving is building an orphanage as a memorial to her late husband, Captain Alving, an important and respected man in the community. This public reputation was a sham, however — and Mrs. Alving has hidden the truth: the Captain was a lying, cheating philanderer. Osvald, their son, has come home from Paris, dying of congenital syphilis. Osvald has fallen in love with the family's maid, Regina — and Mrs. Alving has to reveal that Regina is actually Captain Alving's illegitimate daughter — Osvald's own half-sister.

Osvald tells his mother that, according to his doctor in Paris, the disease manifests itself initially as "a sort of softening of the brain." I wanted my image to suggest a rotting away from the inside.

Pastor Manders, an old family friend and Mrs. Alving's spiritual advisor, has not seen Osvald for many years and mentions how he is struck by his resemblance to his father. I liked the idea that a portrait could suggest both generations.

Using Photoshop filters, I experimented with ways to soften the engraving lines over Osvald's face — as if his vitality is fading away. The idea actually came from a woodcut by Edvard Munch. I came upon this stunning image at the Bridgeman Art Library in London while doing picture research for a Shaw Festival production of Ibsen's *Rosmersholm* in 2006. I didn't have space for it in the programme at that time, but stashed it away for future reference.

This is a "ghost" image on one level — the idea connects with the title even if you don't know the play at all. But the poster becomes more powerful — and more memorable — for those who do know why he's disappearing.

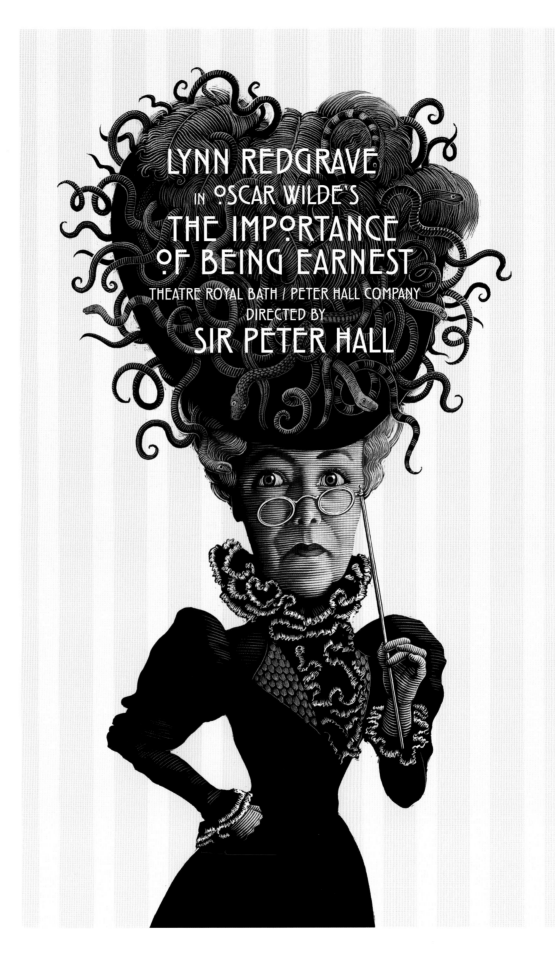

LYNN REDGRAVE
IN OSCAR WILDE'S
THE IMPORTANCE
OF BEING EARNEST
THEATRE ROYAL BATH / PETER HALL COMPANY
DIRECTED BY
SIR PETER HALL

THEATRE POSTERS

The Importance of Being Earnest is one of the most familiar and most famous comedies in the repertoire. I put Lady Bracknell on my 2005 poster for the play in Los Angeles, so I needed a fresh approach for The Pearl Theatre Company's 2008 production in New York.

Jack, the main character, does not know who his parents are because he was "found" as an infant — in a large black handbag in the cloakroom at Victoria Station. The entire plot hinges on the discovery of Jack's true identity (and especially his real name, as the title implies). He produces the infamous handbag in the final scene of the play and all is happily resolved.

Featuring the handbag in the poster image doesn't give anything away. It comes up in Jack's first interview with Lady Bracknell in Act I: "You can hardly imagine that I and Lord Bracknell would dream of allowing our only daughter ... to marry into a cloak-room, and form an alliance with a parcel? Good morning, Mr. Worthing!"

The element of surprise can be a wonderful asset to a marketing campaign. This poster worked well because it was such an unexpected solution for such a well-known play.

The Importance of Being Earnest

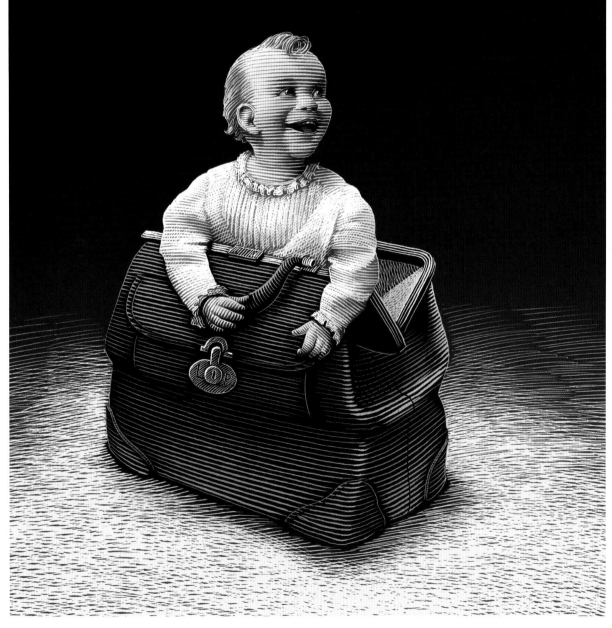

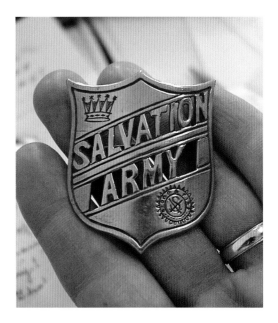

A VICTORIAN SHIELD BADGE FROM THE COLLECTION OF THE
SALVATION ARMY ARCHIVES IN LONDON — A REMINDER THAT
THE LOGO WOULD HAVE BEEN FAMILIAR TO THE PLAY'S FIRST
AUDIENCES IN 1905.

THEATRE POSTERS

I have designed publications at the Shaw Festival
for over 20 seasons — so when The Roundabout
asked me to create a poster for Daniel Sullivan's
2001 production of *Major Barbara*, featuring
Cherry Jones in the title role, I felt very lucky to
have had some prior GBS experience.

Major Barbara was written by Shaw in 1905, but
the play's debates feel more topical and more
provocative than ever. Millionaire arms manu-
facturer Andrew Undershaft and his daughter
Barbara, who runs an East End London Salvation
Army shelter, seem to be on opposite sides of
every moral, political and religious divide. The
play asks tough questions: Which is the greater
human atrocity — poverty or war? Can money
and power buy spiritual salvation?

I proposed an image of urgent, angry protest.
The charismatic and passionate Barbara is
holding a blazing torch in the dark night, and
she's screaming. The Salvation Army's motto is
"Blood and Fire" — but the torch refers equally
to Undershaft's cannons and gunpowder.

I happened to be in Toronto one day during the
early stages of this assignment, with rough ideas
for the poster floating around in my head. Wait-
ing for a red light to turn, I noticed that I was
stopped beside a Salvation Army shelter with
a huge version of the familiar red "shield" logo
emblazoned on the side of the building — and
this turned out to be the key to my poster. I real-
ized that, with a few typographic liberties, I could
simultaneously work the Salvation Army logo
and the playtitle into the illustration.

I shot reference photos of a model wearing a
period uniform and bonnet from the top of a
tall A-frame ladder; I had enlarged our doctored
logo to six-feet tall and taped it to the wall to
get the perspective right from that angle.

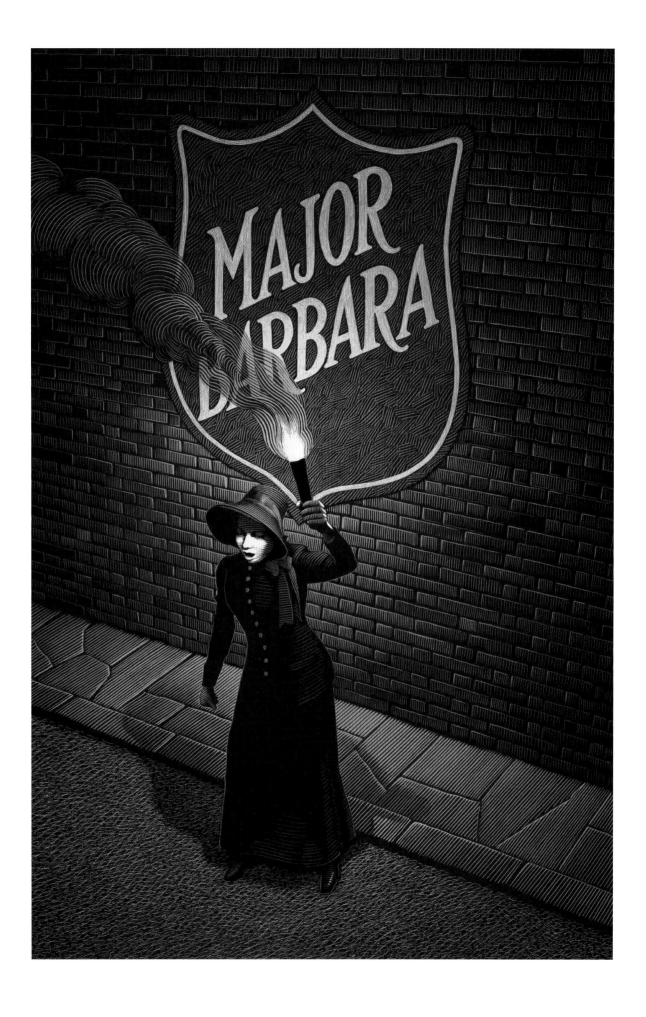

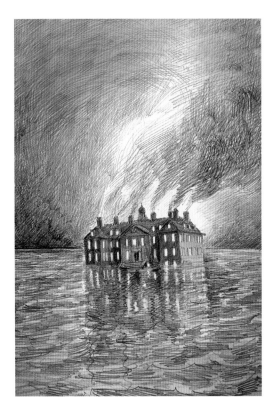

PENCIL SKETCH FOR THE FLOATING HOUSE.

THEATRE POSTERS

Heartbreak House is Shaw's apocalyptic "dream play." Captain Shotover, the central character, is an ancient mariner embodying Prospero, Lear and Leonardo da Vinci all rolled into one.

Two superb productions are still in my head. Both were mounted at the Shaw Festival and both starred Douglas Rain: Christopher Newton's unforgettable staging in 1985; and Tadeusz Bradecki's in 1999 (with costumes designed by Christina Poddubiuk). I also saw Paul Scofield play Shotover in Trevor Nunn's 1992 production in London. So I was thrilled (and a little terrified) to get the poster assignment for the Roundabout's 2006 Broadway production, directed by Robin Lefevre and starring Philip Bosco.

Shaw wrote *Heartbreak House* during the darkest days of the First World War. I think of the play as a bookend to *Major Barbara* — Shaw's challenge "dare you make war on war?" is still a message of hope in 1905. But Shotover's warning to "learn navigation" is aimed squarely at a society that has failed to do so. The architectural metaphor of the title refers to England itself.

Shaw's detailed stage directions specify that the interior of Captain Shotover's house "resemble the afterpart of an old-fashioned, high-pooped ship with a stern gallery." I combined the ship metaphor and the house metaphor and came up with a stately British mansion adrift on an inky ocean, smoke from its chimneys swirling in the dusky twilight.

The play begins in daylight but ends in darkness as a German Zeppelin passes overhead, dropping bombs. (Shaw had watched a Zeppelin fall from the sky "like a burning newspaper" over his own Ayot St. Lawrence backyard, brought down by fighter planes in October 1916.) American troops had been in Iraq for three years when this production played in New York — and I wondered what impression Shaw's anti-war message might make. I'm an optimist, so I left a glimmer of clear sky visible between the dark clouds in hope that the deadly rocks and shoals will be navigated successfully.

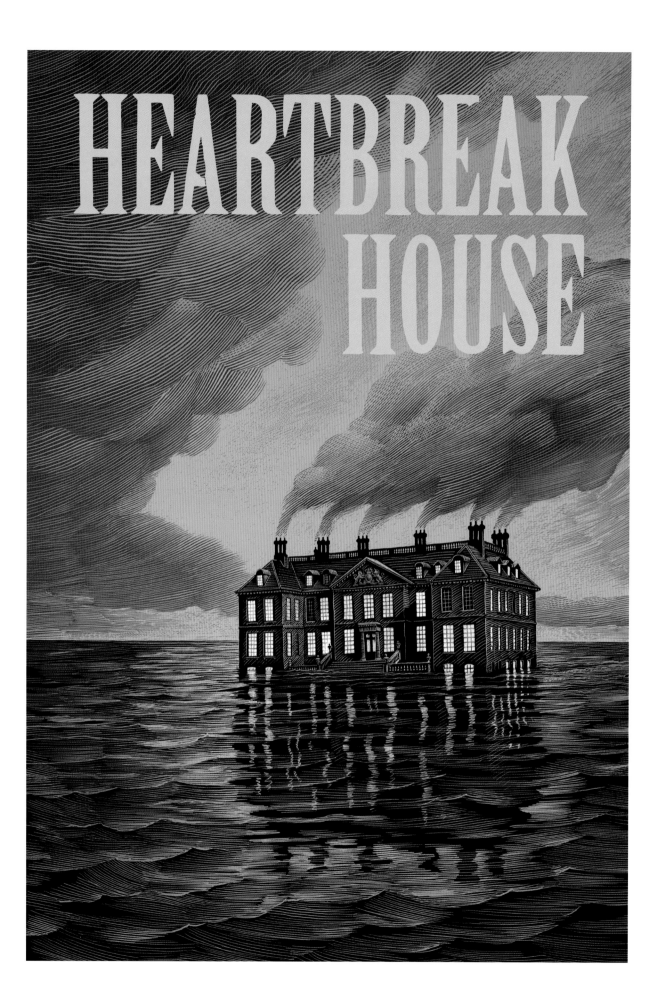

LOVE LETTERS, 1950, BY STANLEY SPENCER.
© ESTATE OF STANLEY SPENCER/SODRAC (2008).

THEATRE POSTERS

Shaw's *Candida* feels more modern than you might expect for a play written in 1895. There's a romantic triangle. The Reverend James Mavor Morell preaches in church on Sunday morning, but his true calling seems to be political lecturing and social reform. The play is set in the living room of the parsonage in North London that he shares with his wife — the title character. The Morells have befriended an idealistic young poet, Eugene Marchbanks. Both men adore Candida (in different ways, for quite different reasons), and she is attracted to them both for their very different qualities.

Marchbanks's infatuation is evident throughout the story, but I was taken with a scene in which he declares to Candida that his only desire is to say her name over and over again. The illustration conveys the young poet's obsession with Candida; the calligraphy stands in for her spoken name.

Shaw's plot echoes a messy romantic entanglement of his own. He wrote the play for the actress Janet Achurch, the wife of a friend who produced and toured the play together through British provincial theatres, in repertory with Ibsen's *A Doll's House*. Shaw described his feelings for Achurch using the same words Marchbanks feels for Candida: "I found myself suddenly magnetized, irradiated, transported, fired, rejuvenated, bewitched."

My image was inspired in part by the British painter Stanley Spencer and his painting *Love Letters*, depicting a young boy in a huge armchair with his face buried in papers. Who knows why these things stick in your head — that scene in *Candida* instantly made me think of this odd, obsessive painting.

CANDIDA

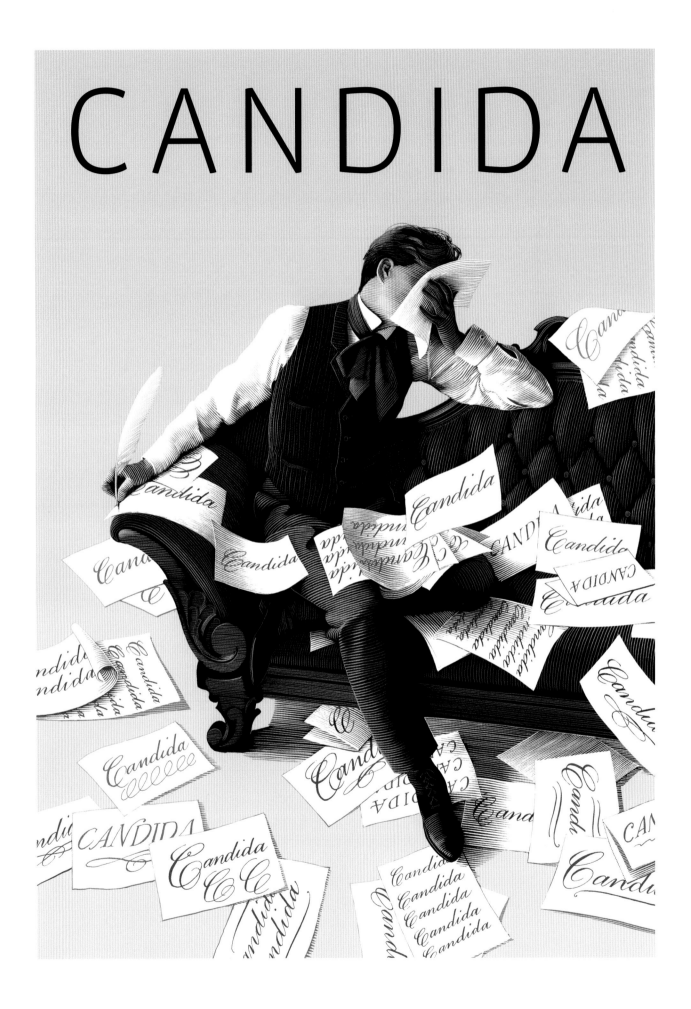

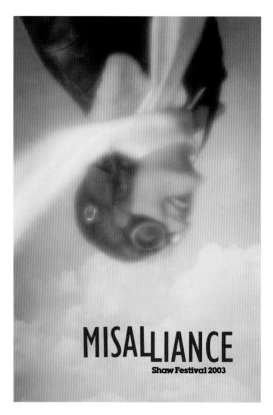

POSTER FOR THE SHAW FESTIVAL, 2003. DAVID COOPER PHOTOGRAPHED ACTOR LAURIE PATON USING A 4X5 PINHOLE CAMERA.

THEATRE POSTERS

Misalliance is such fun. Afternoon tea at the country estate of underwear tycoon John Tarleton is interrupted when an airplane crash-lands in the conservatory. The handsome young pilot runs off with Tarleton's daughter, Hypatia. His passenger turns out to be a dazzling Polish acrobat with an unpronounceable last name (Lina Szczepanowska), for whom all the men fall head-over-heels in love. The play is loaded with sexual tension. Shaw's witty dialogue covers a range of topics from relations between parents and children to the future of the British aristocracy to the role of women in a modern society.

I'm sure he didn't think of it this way, but the airplane is a gift from GBS to poster designers. It provides a perfect metaphor for this play, conveying the exhilaration of flight, speed and risk (it must have taken some nerve to climb into one of these machines in 1908!). The airplane was my starting point for several *Misalliance* posters for the Shaw Festival, and one for Arena Stage — but my point of view had always been from the ground, looking up at the plane silhouetted against the sky.

I turned the idea around in this 1996 poster for The Roundabout and showed the perspective from the plane. Looking down, we would see our own cast shadow moving across the lawn, indicating our rapidly descending altitude. We might also notice the range of indignant expressions on the faces of these proper Edwardian characters — except for the beauteous Hypatia, who has been longing for "something to happen" and welcomes the arrival of this *deus ex machina* with open arms.

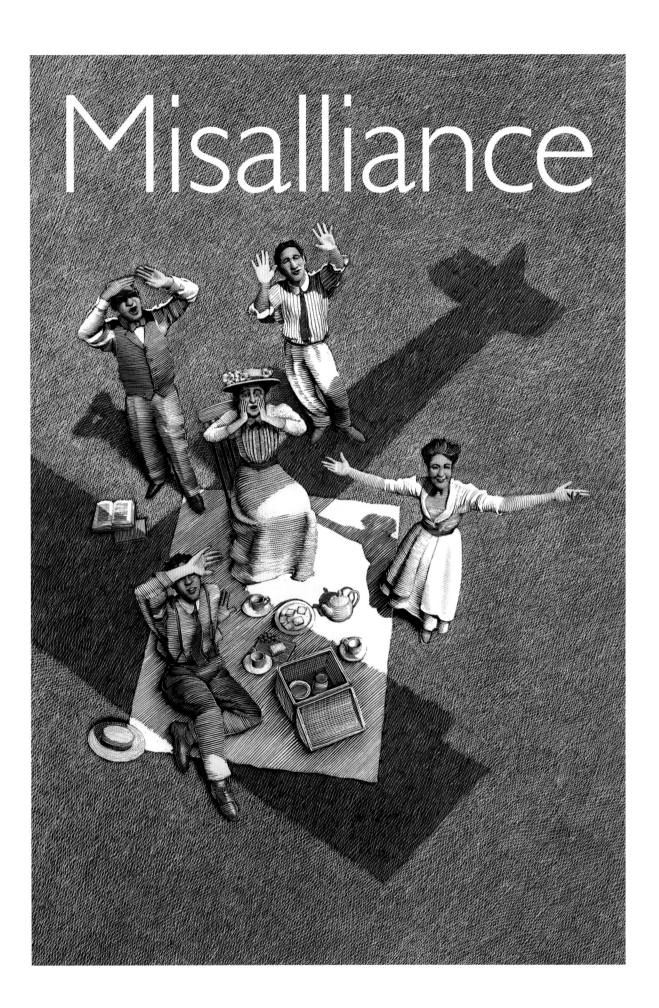

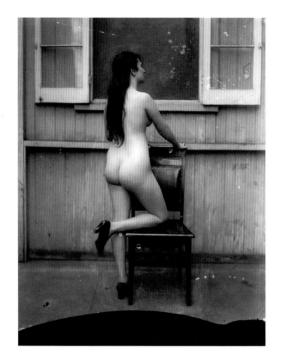

THEATRE POSTERS

As Christopher Newton observed in a Shaw Festival handbook, "this play got Shaw into a lot of trouble." Written in 1894, *Mrs. Warren's Profession* was banned from public performance in England until 1925. The first American production in 1905 was shut down and the cast arrested for "offending public decency."

Mrs. Warren's profession is the oldest one: she runs a string of brothels across Europe, and she is very good at her job. She had good looks and a good head for business and, as Shaw points out, this was about the only way a woman could employ herself and earn as much as a man.

Her daughter Vivie has won a mathematics prize at Cambridge University, and aspires to a career as an actuary. In the course of the play, Vivie is appalled to discover the source of the money that financed her education and opportunities.

A poster image for *Mrs. Warren's Profession* somehow needs to make reference to these two contrasting worlds. The common denominator between mother and daughter turns out to be — accounting! Vivie is a math whiz, and Mama, obviously, would have kept excellent records of all her clients.

I superimposed the silhouette of a young woman over a page from a Victorian ledger book, which I found in the collection of our local Stratford Archives. It came from a clothing store — the dates and prices written beside men's names were just what I was looking for. (I tried writing out the pen and ink names and numerals myself, but I could not get my hand to duplicate the character of 19th-century penmanship — so I turned to the real thing.) I experimented with colouring and layering the silhouette and the calligraphy in Photoshop, so that the final image had the right balance between the two.

My scratchboard silhouette figure is adapted from one of E.J. Bellocq's 1912 portrait photographs of prostitutes in Storyville, the red-light district of New Orleans.

MRS WARREN'S PROFESSION

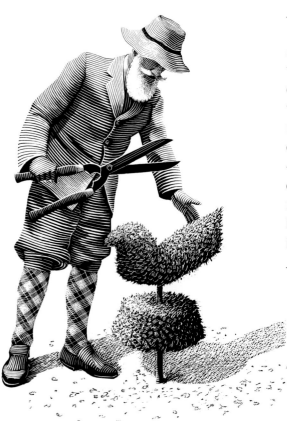

THEATRE ADVERTISING

Most of the posters in this book were created to publicize individual productions. A far more complex assignment is an advertising campaign for a festival with a dozen different productions running over an eight-month season. Ads must communicate information about individual plays — but at the same time convey a sense of the overall festival experience. With its specialized mandate (plays written during Bernard Shaw's lifetime, 1856-1950), the Shaw Festival is unique in the English-speaking theatre world.

The Shaw Festival is located in Niagara-on-the-Lake, Ontario. The first capital of Upper Canada in the 18th-century, the old town retains its historic charm and character (at least away from the crowds of tourists on the main street). The ambiance includes rambling old summer cottages, lush gardens, fruit orchards and vineyards.

In 1990, The Shaw was feeling competition from Toronto productions of shows like *Les Misérables*, *The Phantom of the Opera*, and *Miss Saigon*. It was a David and Goliath scenario — the massive advertising budgets behind the mega-musicals were far beyond our non-profit resources. We focused our efforts on defining how the Shaw Festival experience was different.

Christopher Newton always said that the gardens surrounding the Festival Theatre reflect the care put into the work on stage. Topiary, like theatre, is created by an artist with skill and imagination. Clipping and training trees goes back to Ancient Rome, but it became the particular specialty of English gardeners during The Shaw's mandate period — so the metaphor was a perfect fit. I invented a dozen different views of an imaginary topiary garden, each inspired by one of the plays on the 1990 playbill.

The season announcement ad showed a variety of characters — or at least their hats — exploring a hedge maze. The message was that a visit to The Shaw is always filled with intriguing surprises around every corner. The path leading into the maze was placed in the foreground, inviting the reader to enter.

AMAZING THEATRE

Shaw Festival 1990

MISALLIANCE • THE WALTZ OF THE TOREADORS • TRELAWNY OF THE 'WELLS' • PRESENT LAUGHTER
MRS WARREN'S PROFESSION • NYMPH ERRANT • NIGHT MUST FALL • WHEN WE ARE MARRIED
VILLAGE WOOING • UBU REX • APRIL 25 TO OCTOBER 21, NIAGARA-ON-THE-LAKE, ONTARIO

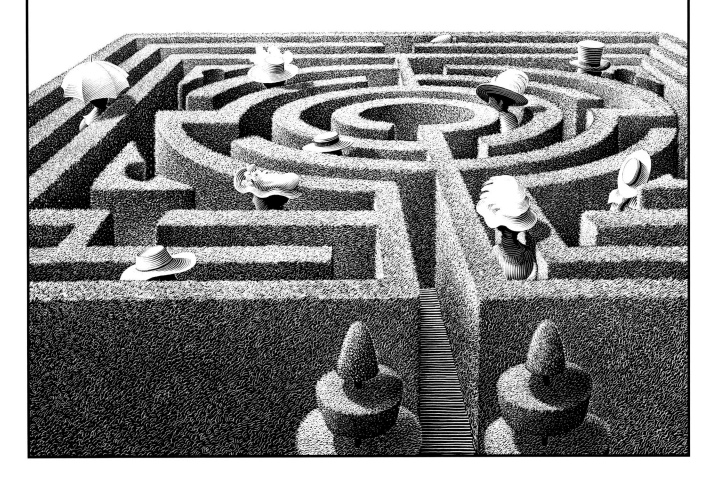

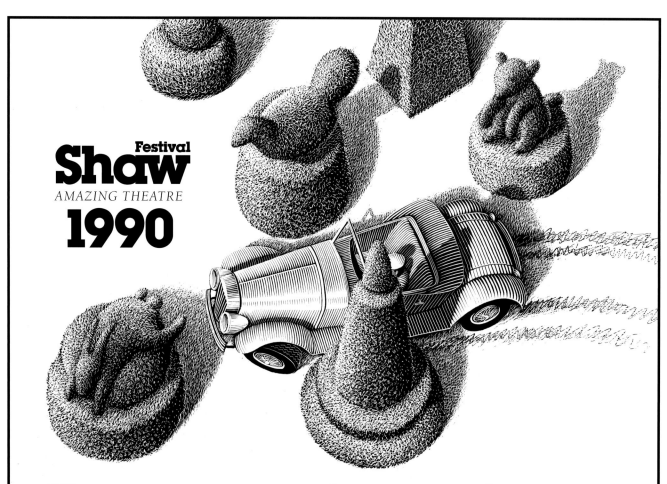

Festival Shaw
AMAZING THEATRE
1990

Present Laughter

"What is love? 'Tis not hereafter;
 Present mirth hath Present Laughter
 What's to come is still unsure:

In delay there lies no plenty;
 Then come kiss me, sweet and twenty,
 Youth's a stuff will not endure."

Who else but Noel Coward –
where else but the Shaw Festival!

Nymph Errant

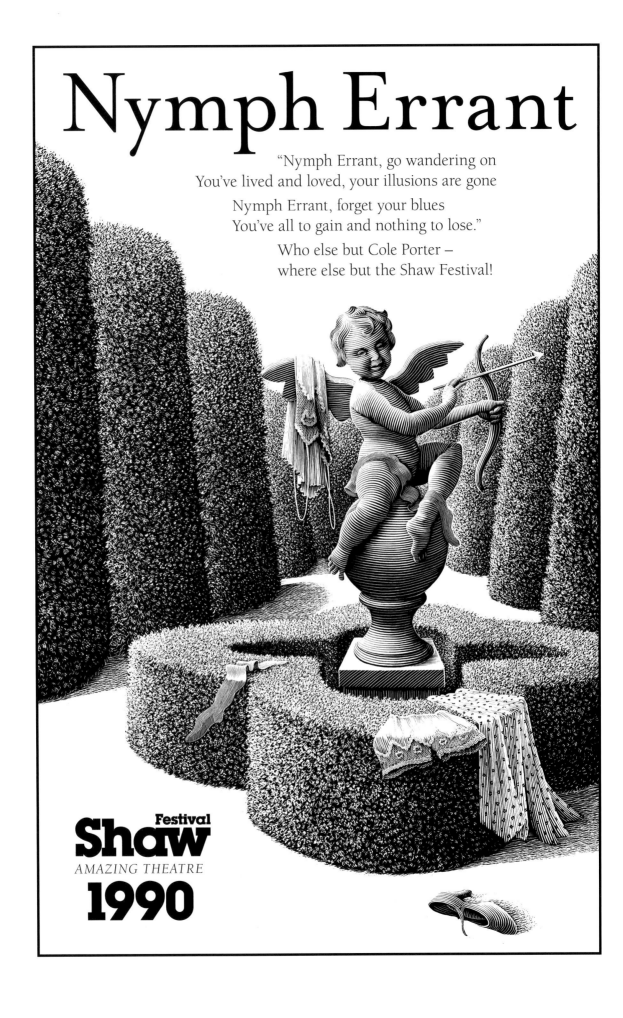

"Nymph Errant, go wandering on
You've lived and loved, your illusions are gone

Nymph Errant, forget your blues
You've all to gain and nothing to lose."

Who else but Cole Porter –
where else but the Shaw Festival!

Shaw Festival
AMAZING THEATRE
1990

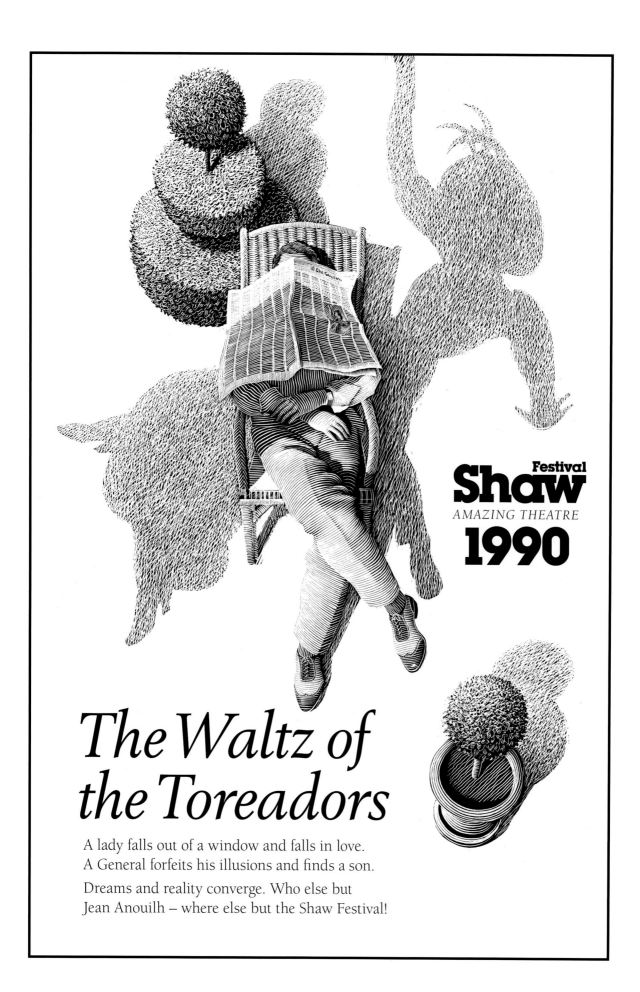

Festival
Shaw
AMAZING THEATRE
1990

The Waltz of the Toreadors

A lady falls out of a window and falls in love.
A General forfeits his illusions and finds a son.

Dreams and reality converge. Who else but
Jean Anouilh – where else but the Shaw Festival!

"Splendid...a marvelously deft ensemble performance that brought the audience cheering to its feet" THE LONDON FREE PRESS

"Rousingly funny...the evening is Newton's triumph, and what an outstanding one it is" SOUTHAM NEWS

Bravo Shaw!

"A theatrical delight in every way" KITCHENER-WATERLOO RECORD

"Stylish *Laughter* a serious success" TORONTO SUN

"Lively, funny and engaging " THE TORONTO STAR

RAVES for *PRESENT LAUGHTER*

ARMS AND THE MAN

A SERIES OF PORTRAITS OF BERNARD SHAW, FOR THE 1994 SHAW FESTIVAL.

THEATRE ADVERTISING

The Shaw Festival in historic Niagara-on-the-Lake, Ontario, is the only theatre in the world that specializes in plays by Bernard Shaw and his contemporaries. Shaw's long life began during the Industrial Revolution (1856) and ended in the Atomic Age (1950). This century forms The Shaw's mandate period: "Plays about the beginning of the modern world."

In the mid-1990s, I designed the theatre's advertising campaigns around our instantly recognizable house author. Here are three of our ad illustrations from 1994 — GBS as a swashbuckling soldier, for *Arms and The Man*; as the world's most famous detective, for *Sherlock Holmes* by William Gillette; and as a hardboiled news hawk, for *The Front Page* by Ben Hecht and Charles McArthur.

We went on to put GBS on a camel riding across the desert like Lawrence of Arabia for *Too True To Be Good*; on a beach sculpting a Galatea-like figurine in the sand for Pygmalion; dancing the Charleston for the Gershwins' *Lady Be Good*; and dematerializing into thin air for Noel Coward's *Blithe Spirit*.

Shaw loved photography (from both sides of the camera) so finding reference material for drawings is not difficult. I have assembled a large GBS file over the 20 years I have worked at The Shaw. One year, on a picture research trip for the house programmes, I had the opportunity to spend a day combing through Shaw's own personal photo collection, in the special collections room at the London School of Economics — 14 albums, plus a half dozen shoeboxes stuffed with loose, uncataloged snapshots. I made copies of many photos I have never seen in print.

Shaw was always closely involved in the production of his plays during his lifetime. His correspondence indicates that he held strong opinions about everything — and that producers usually ended up doing things his way. He posed for many publicity photos with a twinkle in his eye, so I don't think he would have objected to our ad campaigns. Still, I'm just as glad he wasn't around to offer his opinion.

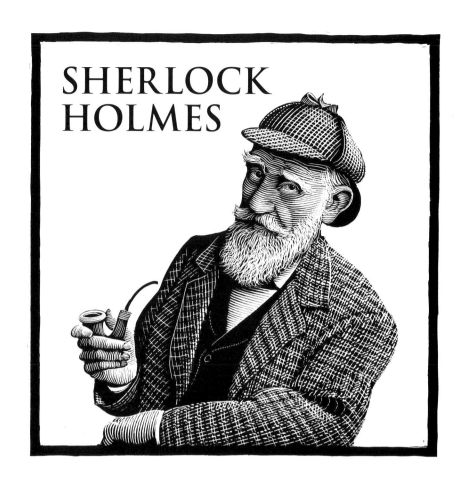

SHERLOCK
HOLMES

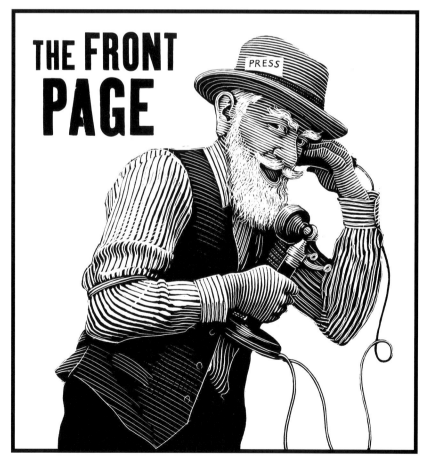

THE FRONT
PAGE

PRESS

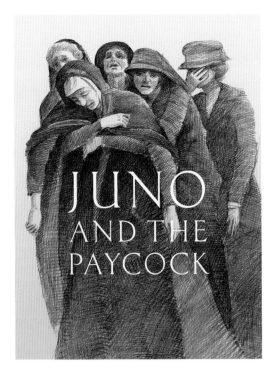

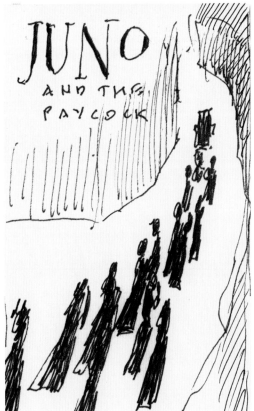

EARLY CONCEPT SKETCHES FOR *JUNO*. THE GROUP OF WOMEN IS BASED ON THE FIGURES IN A 1450 *CRUCIFIXION* BY ANDREA MANTEGNA, WITH THE CLOTHING UPDATED TO THE 1920S. THE FUNERAL PROCESSION, SEEN FROM THE PERSPECTIVE OF AN UPPER WINDOW (AS THE CHARACTERS IN THE PLAY DO IN ACT II) WAS MEANT TO FEEL LIKE A GREEK CHORUS.

THEATRE POSTERS

I love working with theatre directors who have a strong vision for a project — who know where they're going with a show. This poster reflects John Cowley's strong feelings about the Irish Civil War, "the archetypal Irish tragedy" and the criteria behind his powerful production.

In 2000, Crowley had staged the play at the Donmar Warehouse in London, where he was associate director. In a phone chat several weeks before starting rehearsals in New York, he told me that it was essential to get the world of 1924 Dublin "exactly right," but warned that the poster image should avoid any parochial "shamrockery" and go for the larger universal themes, which are timeless.

If there was going to be a human figure, Crowley thought it should probably be female. "The men fire the bullets; the women have to pick up the pieces" was how he summarized "the troubles" in Ireland throughout the 20th century.

Religious iconography, especially statues (specifically the *Pietà*) came up repeatedly. Crowley had seen a photograph of a statue of the Virgin Mary defaced with bullet holes, and which created a tension between the violent and the eternal. He suggested that a rich area of the play to mine for images was in Act II, when old Mrs. Tancred interrupts the mirth of the Boyle's party as she leaves for her son's funeral. She berates the guests for their unfeeling behaviour, and prays aloud "Sacred Heart of Jesus, take away our hearts of stone and give us hearts of flesh." Her words are echoed precisely by Juno at the end of the play as she leaves to identify the body of her own son.

From half a dozen different pencil sketch ideas, Mr. Crowley picked this one — a weeping classical statue wearing a crown of stars (both Juno and the Virgin Mary are "the Queen of Heaven"). The play's title started out in Roman type with formal serifs, but ended up as a hand-drawn graffiti-like scrawl, more scratchy and violent.

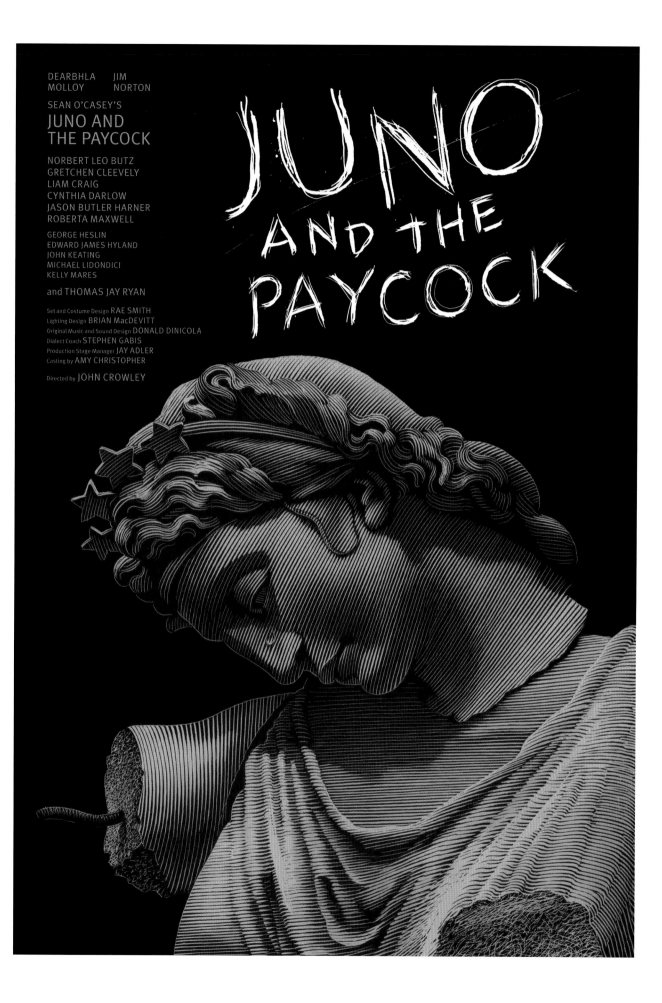

DEARBHLA JIM
MOLLOY NORTON

SEAN O'CASEY'S
JUNO AND
THE PAYCOCK

NORBERT LEO BUTZ
GRETCHEN CLEEVELY
LIAM CRAIG
CYNTHIA DARLOW
JASON BUTLER HARNER
ROBERTA MAXWELL

GEORGE HESLIN
EDWARD JAMES HYLAND
JOHN KEATING
MICHAEL LIDONDICI
KELLY MARES

and THOMAS JAY RYAN

Set and Costume Design RAE SMITH
Lighting Design BRIAN MacDEVITT
Original Music and Sound Design DONALD DINICOLA
Dialect Coach STEPHEN GABIS
Production Stage Manager JAY ADLER
Casting by AMY CHRISTOPHER

Directed by JOHN CROWLEY

JUNO
AND THE
PAYCOCK

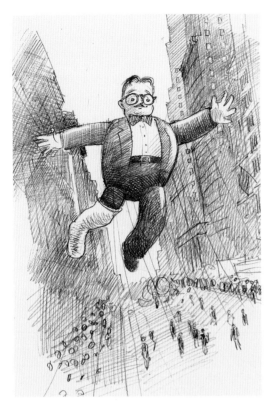

AN ALTERNATE SKETCH FOR THIS POSTER TURNED SHERIDAN
WHITESIDE/NATHAN LANE INTO A MACY'S THANKSGIVING
DAY PARADE BALLOON. THE MACY'S PARADE HAS BEEN AN
ANNUAL TRADITION IN NEW YORK CITY SINCE 1924 — THE
GIANT HELIUM BALLOONS SEEMED A GREAT METAPHOR FOR
WHITESIDE'S OVERSIZED EGO.

THEATRE POSTERS

The Man Who Came To Dinner, written in 1939
by Moss Hart and George S. Kaufman, remains
one of the most famous comedies of Broadway's
golden age. Sheridan Whiteside, the star of a
national radio show, is visiting the home of Mr.
and Mrs. Stanley in Mesalia, Ohio. The dinner
party turns into a nightmare for the hosts when
Whiteside slips on some ice and breaks his hip.
He becomes an unwilling houseguest for six
weeks of convalescence. The obnoxious, insult-
ing Whiteside takes over the house, announces
that he plans to sue Mr. Stanley for $150,000, and
proceeds to turn everyone's lives upside down —
to hilarious effect.

Kaufman and Hart based Sheridan Whiteside on
Alexander Woollcott, the famous (and feared)
drama critic for *The New York Times* and one of
the first radio stars in America. Woollcott had a
vast circle of celebrity pals — so does Whiteside.
Noel Coward, Harpo Marx and others drop by to
cheer up the invalid. Whiteside receives phone
calls, telegrams and Christmas presents from
an absurdly wide range of celebrities including
Alfred Lunt and Lynn Fontanne, Gertrude Stein,
Somerset Maugham, Salvador Dali, Mahatma
Gandhi, and Shirley Temple. Admiral Richard E.
Byrd, the first man to fly over the South Pole,
sends Whiteside a crate of live penguins as a
Christmas present in Act III.

Woollcott, known for his acid wit, was a member
of the celebrated Algonquin Round Table — an
influential group of New York writers, actors, and
critics (including George S. Kaufman and Harpo
Marx) who gathered for lunch every day at the
Algonquin Hotel on West 44th Street. They dub-
bed themselves "The Vicious Circle."

I combined the Algonquin Round Table with
Admiral Byrd's penguins in this poster for the
Roundabout's Broadway revival in 2000, starring
Nathan Lane. Whiteside is the oversized emperor
penguin at the centre of the group; Kaufman,
with his mop of curly hair, is the penguin at the
bottom left.

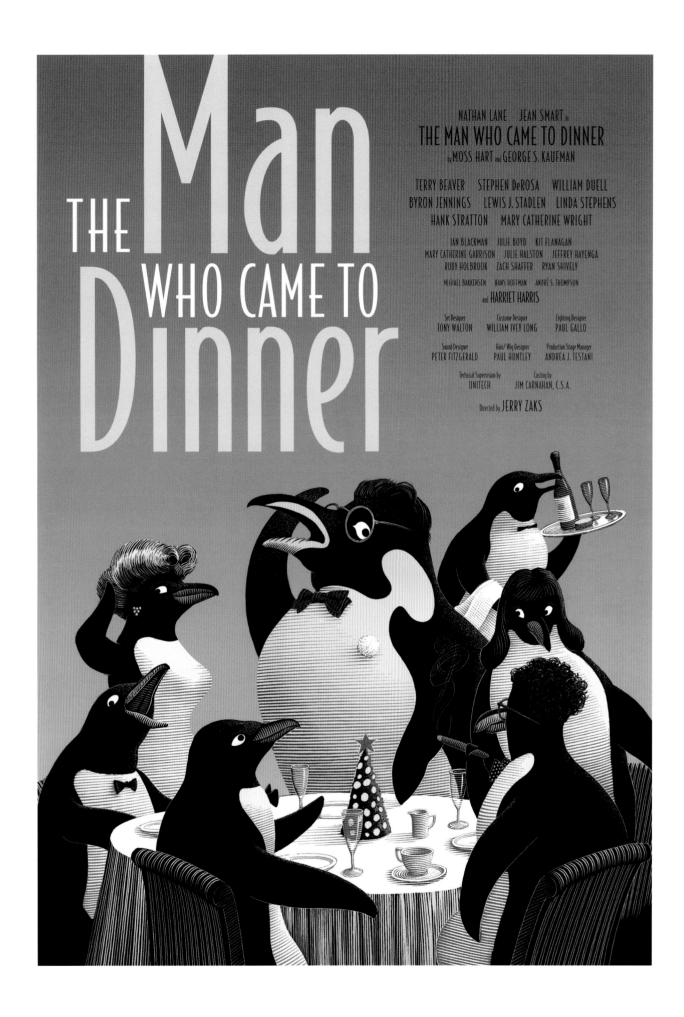

NATHAN LANE JEAN SMART in

THE MAN WHO CAME TO DINNER
by MOSS HART and GEORGE S. KAUFMAN

TERRY BEAVER STEPHEN DeROSA WILLIAM DUELL
BYRON JENNINGS LEWIS J. STADLEN LINDA STEPHENS
HANK STRATTON MARY CATHERINE WRIGHT

IAN BLACKMAN JULIE BOYD KIT FLANAGAN
MARY CATHERINE GARRISON JULIE HALSTON JEFFREY HAYENGA
RUBY HOLBROOK ZACH SHAFFER RYAN SHIVELY

MICHAEL BAKKENSEN HANS HOFFMAN ANDRÉ S. THOMPSON
and HARRIET HARRIS

Set Designer	Costume Designer	Lighting Designer
TONY WALTON	WILLIAM IVEY LONG	PAUL GALLO

Sound Designer	Hair/Wig Designer	Production Stage Manager
PETER FITZGERALD	PAUL HUNTLEY	ANDREA J. TESTANI

Technical Supervision by	Casting by
UNITECH	JIM CARNAHAN, C.S.A.

Directed by JERRY ZAKS

THEATRE POSTERS

Noel Coward called *Blithe Spirit* "a light comedy about death." It was written in 1941 at the height of the Blitz, as Londoners lived under the nightly threat of bombs crashing through their roofs. London theatregoers desperately needed something to lift their spirits, and Coward's play became an instant hit.

The central character is Charles Condomine, a writer. In order to get background material for his next novel, he has invited Madame Arcati, a dubious and eccentric local spiritualist, to give a séance. Charles is a skeptic — he doesn't take any of this very seriously — until the ghost of his glamorous first wife Elvira wafts in, conjured from the great beyond.

The title of this play comes from the first line of Percy Bysshe Shelley's poem *To a Skylark* (1820) — but Noel Coward's famous title spirit is anything but blithe. Elvira has been finding eternity rather boring, and her scheme is to steal Charles away from his second wife, Ruth.

Staging the play requires some special effects — a real challenge for a set designer's ingenuity and a production department's budget. Several scenes call for objects on the set to be moved by ghosts unseen by the audience. Happily, it's much easier to generate paranormal activity in an illustration. For this 1996 poster at Arena Stage in Washington DC, I decided to suggest a comic "haunting" by animating the living room furniture and decor. I don't keep many of my own originals framed on the walls of my house, especially from so long ago — but this is one I never get tired of.

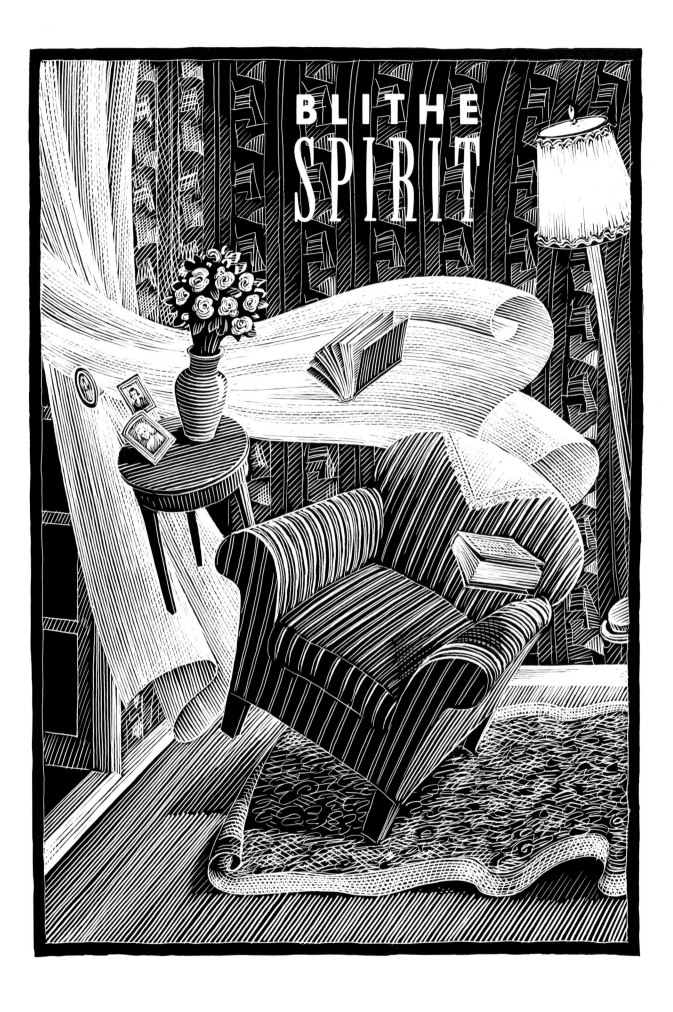

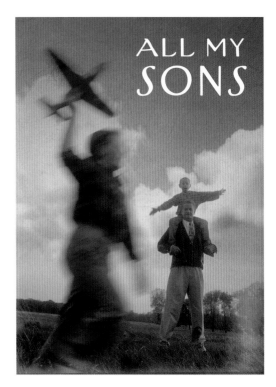

ALL MY SONS

1999 POSTER IMAGE FOR *ALL MY SONS* AT THE SHAW FESTIVAL.
DAVID COOPER'S PHOTOGRAPH FEATURED ACTOR NORMAN
BROWNING AS JOE KELLER.

THEATRE POSTERS

Arthur Miller's *All My Sons* — a tragedy as power-ful as anything by Sophocles or Shakespeare — is set in a pleasant suburban American backyard in 1947. Miller examines questions of wartime profiteering, family loyalty, moral responsibility and the myth of the American dream.

Joe Keller runs a manufacturing plant that sold airplane parts to the military during the Second World War. He allowed defective cylinder heads to be shipped out, resulting in the deaths of 21 pilots. Keller was arrested but managed to evade responsibility, while his business partner was convicted and sent to prison.

Keller's two sons both went off to war. Larry, a fighter pilot, died in a crash shortly after the news broke of his father's arrest. The idealistic Chris is in love with his brother's girlfriend. The past starts to catch up with the present — lies are exposed and family secrets come to light. Joe is forced to take responsibility not only for Larry's death, but also for the other airmen who lost their lives through his actions; and he com-mits suicide in the final moments of the play.

Chris idolizes his father, but is horrified when he learns the truth about Joe's actions. A father-son relationship seemed the right idea for a poster image, except that I wanted to include Larry — and he is dead long before the play starts.

I came up with the concept of showing Mr. Keller with both his sons, at an earlier, happier time in their lives. The boys are flying paper airplanes — suggesting that dad has inspired a love of avia-tion from an early age. As an ominous thunder-cloud rises in the distance, a toy plane is about to smash into the ground, foreshadowing events to come.

This concept originated in 1997 for a poster at the Roundabout Theatre in New York. I recycled the idea in 1999, reinterpreting the image as a photograph for a Shaw Festival season brochure. This third iteration, for the Denver Center Theatre Company in 2005, was part of a series of silhou-ette posters.

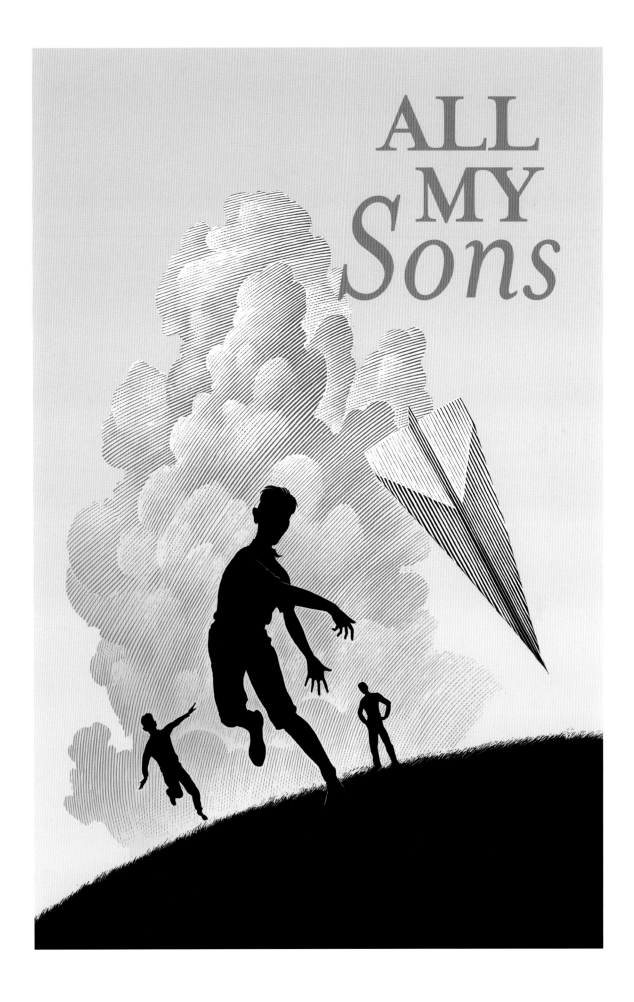

Jean Anouilh's plays are stylish, sparkling, and entertaining in the Boulevard theatrical tradition in France — but they have a darker, tougher side as well. Anouilh often pits bored, wealthy, cynical, aristocratic characters against a single, innocent young woman of striking purity and goodness. In *Ring Round the Moon*, a pair of twins — the cold, manipulative playboy Hugo, and his sensitive brother Frédéric — engage in an emotional tug-of-war over Isabelle, a lower-class outsider that Hugo has invited to a ball disguised as an aristocratic beauty.

The Rehearsal feels a little like *Les Liaisons Dangereuses* set in the 1950s. It's a play-within-a-play — a Count and Countess are preparing for a dinner-party production of Marivaux's 18th-century comedy *The Double Inconstancy*. Hero (the ironically named main character) plays a sinister, erotic game of cat-and-mouse with Lucile, a guileless outsider of a lower social class, who has been invited to play the ingénue role in the Marivaux. The Count tells her, "I don't need to explain that part to you, mademoiselle. You have only to be yourself."

Jeremy Sams observes in the introduction to his English translation of the play: "*The Rehearsal*, like the Marivaux play it contains, is the elegant anatomy of a crime. Stylish, yes, but brutal. In a sterile world, love flowers briefly, before it is systematically trampled to death."

The Anouilh characters talk about the costumes and wigs they wear as their Marivaux characters — which put into my head this idea of a surreal dressmaker's mannequin coming to life. Nicholas Martin, the director of this production at The Roundabout, loved the idea because he was using several "judys" on stage as part of the set. The mannequin stand merges the two time periods (1950s and 18th-century) into one image. Teresa Bendall, a Punch & Judy graphic designer for a dozen years, modeled for the drawing.

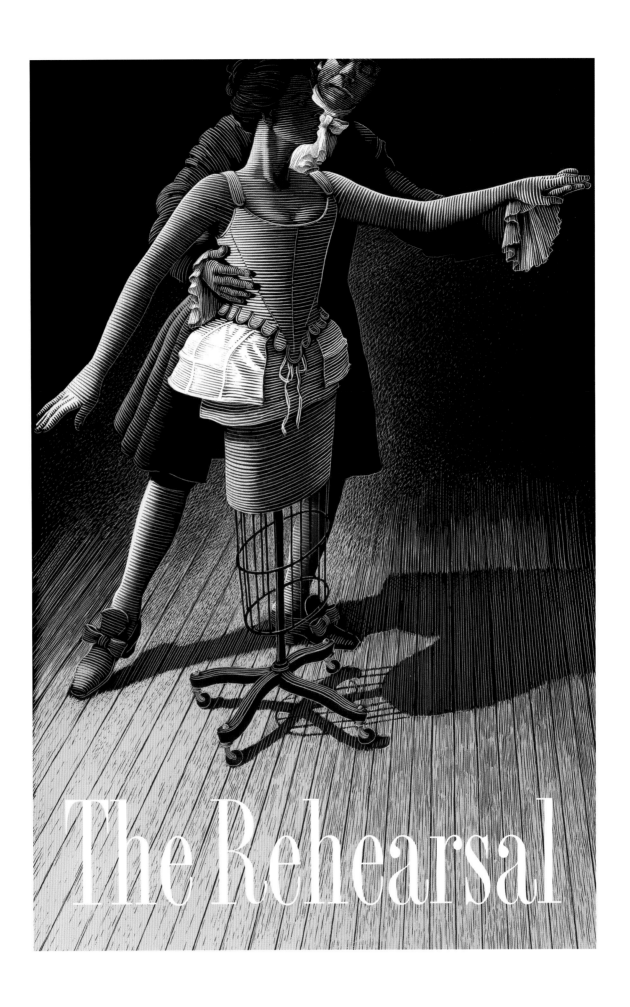

The Rehearsal

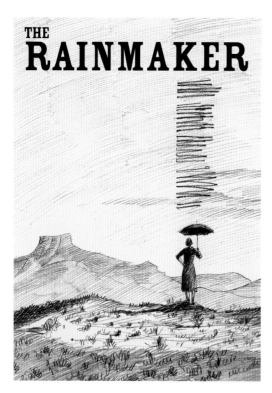

EARLY CONCEPT SKETCH SHOWING LIZZIE WONDERING
HOW LONG THE DRY SPELL CAN CONTINUE.

THEATRE POSTERS

The Rainmaker is a Cinderella story set in the Dust Bowl during the 1930s. Lizzie Curry, a spinsterish farm girl, hopes and dreams of finding a man who will "stand up straight" — but her hopes and dreams are drying up as rapidly as the watering hole for the cattle on their struggling ranch. Bill Starbuck, a con man and lost soul at the end of his own road, promises to conjure up rain if the Curry family will part with $100 (which they can ill afford). Two droughts end during the last scene of the play — the real one that threatens the livelihood of the farm, and the spiritual one that envelops these two characters.

My first sketches for this 2000 Roundabout Theatre poster all showed Lizzie in a flat, dry Western landscape. In several, she's incongruously holding an umbrella, and waiting for a miracle. But I shifted my focus to Starbuck, as he's the catalyst for change.

In the play, Starbuck has a "magic" staff, but I changed this into a Y-shaped twig to signify dowsing — or divining — the mysterious ability to find water or hidden treasures in the earth.

My friend Antony John was the model for Bill Starbuck — he loved the idea of standing in for Woody Harrelson. As I shot reference photos to draw from, Antony told me of his own experience with a water dowser.

Antony was planning to dig a pond on his farm near Stratford. He saw an ad in the local paper for a dowser and, hoping to take the guesswork out of an expensive excavation, took a chance. The dowser showed up at the farm and started walking over the fields, lightly holding two brass rods. Eventually the rods did cross, and dowser said, definitively, "Dig here." Antony put a stake into the ground to mark the spot and paid the guy $100 (just like in the play). The backhoe arrived and, at a depth of seven feet as predicted, hit running water. The dowser was right — except that what he found was an old field drain channeling water away from the farm, not the hoped-for spring bringing water towards it!

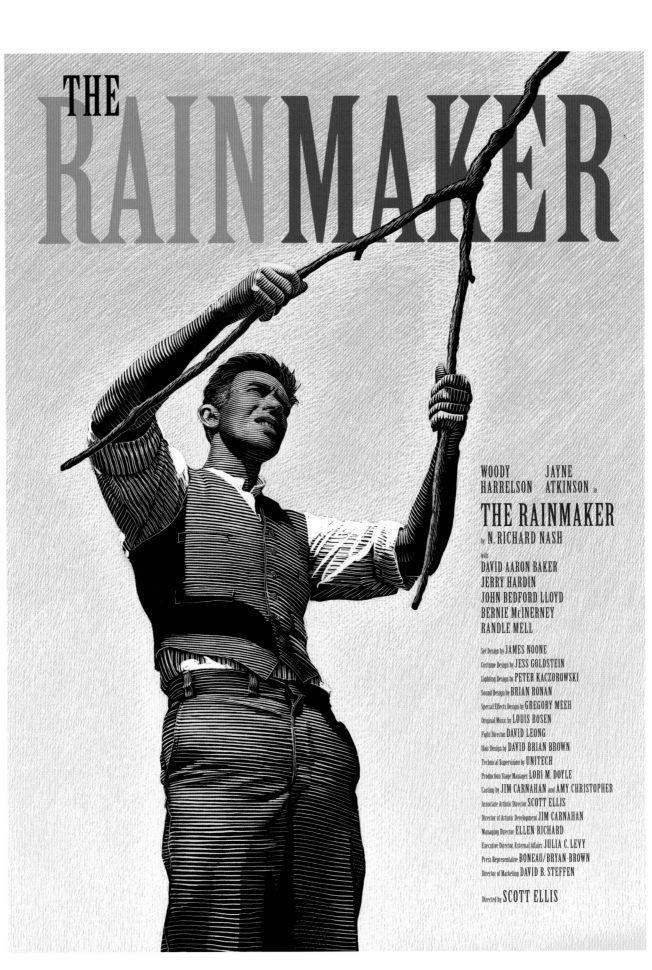

THE RAINMAKER

WOODY HARRELSON JAYNE ATKINSON in

THE RAINMAKER
by N. RICHARD NASH

with

DAVID AARON BAKER
JERRY HARDIN
JOHN BEDFORD LLOYD
BERNIE McINERNEY
RANDLE MELL

Set Design by JAMES NOONE
Costume Design by JESS GOLDSTEIN
Lighting Design by PETER KACZOROWSKI
Sound Design by BRIAN RONAN
Special Effects Design by GREGORY MEEH
Original Music by LOUIS ROSEN
Fight Director DAVID LEONG
Hair Design by DAVID BRIAN BROWN
Technical Supervision by UNITECH
Production Stage Manager LORI M. DOYLE
Casting by JIM CARNAHAN and AMY CHRISTOPHER
Associate Artistic Director SCOTT ELLIS
Director of Artistic Development JIM CARNAHAN
Managing Director ELLEN RICHARD
Executive Director, External Affairs JULIA C. LEVY
Press Representative BONEAU/BRYAN-BROWN
Director of Marketing DAVID B. STEFFEN

Directed by SCOTT ELLIS

THEATRE POSTERS

Neil Simon's *Hotel Suite* is a repackaging of hotel episodes from earlier plays — two scenes from *California Suite* (1976), and one each from *London Suite* (1995) and *Plaza Suite* (1968). The four scenes are cleverly paired — two snapshots each of two separate marriages — but all these stories take place in different cities, in different time periods. I could see only two elements holding the evening together: luxury hotels, and Mr. Simon himself.

Neil Simon really is a giant of American theatre, so it didn't seem too much of a stretch to portray him, larger-than-life, peeking into his characters' private lives in their hotel suites. This production took place in New York in 2000, so the obvious hotel for the illustration was The Plaza.

I knew I would need very specific reference for both famous landmarks in order to combine them into a convincing illustration. I had neither the time nor budget to fly to New York, but I did have a cousin working in midtown Manhattan. Camera in hand, she talked her way into an office tower on Fifth Avenue, photographed The Plaza and 59th Street from the perspective I needed, and sent me two rolls of colour prints.

Mr. Simon liked my rough sketch, and agreed to make himself available for reference photos at his Los Angeles office. We hired a local photographer who — bless him — took the time to mock up the "hotel" using a large cardboard box.

The world has changed a lot since 2000. My cousin would never be allowed into a corporate office tower with her camera without extensive security clearance, and the Plaza Hotel itself has been converted to condominium suites (but that's a different play altogether).

A happy postscript came in November 2008 when a special "Hollywood at Home" issue of *Architectural Digest* featured Mr. Simon's New York pied-à-terre. I noticed my poster framed on the wall of the playwright's study, beside his Tony Awards, *Time* magazine cover, and Hirschfeld cartoons.

NEIL SIMON'S
HOTEL SUITE

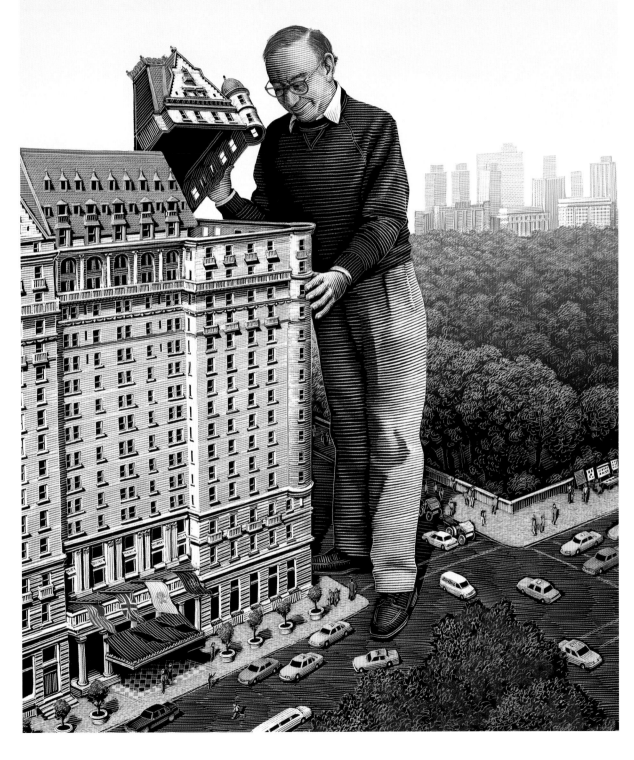

REFERENCE ILLUSTRATION FROM AN OLD FREDERICK'S OF HOLLYWOOD CATALOGUE.

THEATRE POSTERS

Beneath the satirical, campy, theatrical fun of *The Mineola Twins*, Paula Vogel traces the arc of women's issues in American society over 40 years — from the Eisenhower era, through the Nixon administration, to the Reagan and Bush years. Myrna and Myra are identical twins with opposing views on virginity, Vietnam and Family Values — and Vogel calls for them to be played on stage by the same actress (in this production, the remarkable Swoosie Kurtz).

Here's the cheeky play description from the back cover of the script: "A comedy in six scenes, four dreams and seven wigs. There are two ways to produce this play: 1) with good wigs; or 2) with bad wigs. The second way is preferred."

Myrna starts out winning homemaker awards in high school and dreaming of marriage and family. Over the years she becomes an embittered house-wife, an outspoken opponent of birth control and homosexuality, a rabidly right-wing talk show host and plots to bomb an abortion clinic.

Myra sleeps with the entire Mineola football team, gets suspended from high school, and hangs out in Greenwich Village. She becomes a cocktail waitress in "a roadside tavern of ill repute" and a Vietnam War protester. She does time for a bank robbery — but later pulls herself together and settles down with her same-sex partner, ending up as the direc-tor of a Long Island Planned Parenthood office.

A running gag through the play is that the twins are identical except in bra sizes. Myrna, the "good" girl is "stacked"; Myra is flat as a pancake.

Director Joe Mantello wanted the poster to be pulpy, sexy and funny. I combined the mythology of Barbie — every little girl's role model for adulthood — with that of Frederick's of Hollywood. Christina still has her childhood Barbie (the right vintage!), which I used as a model in order to get those impossibly long-legged proportions. The primary colour scheme for the production was pink, but Mantello men-tioned that the town water tower in Mineola, Long Island, is painted aqua green, and I went with that.

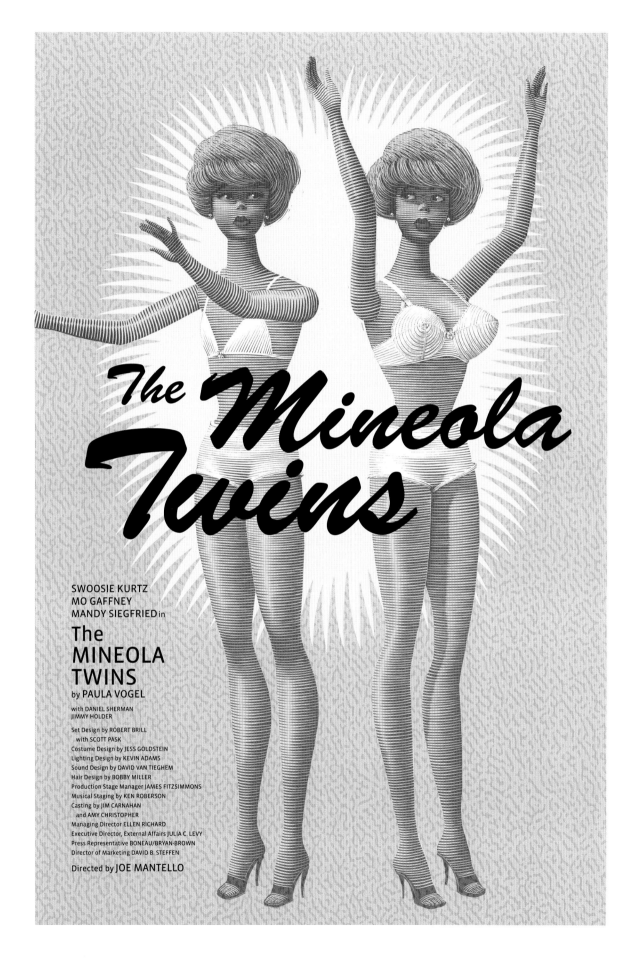

The Mineola Twins

SWOOSIE KURTZ
MO GAFFNEY
MANDY SIEGFRIED in

The
MINEOLA
TWINS
by PAULA VOGEL

with DANIEL SHERMAN
JIMMY HOLDER

Set Design by ROBERT BRILL
 with SCOTT PASK
Costume Design by JESS GOLDSTEIN
Lighting Design by KEVIN ADAMS
Sound Design by DAVID VAN TIEGHEM
Hair Design by BOBBY MILLER
Production Stage Manager JAMES FITZSIMMONS
Musical Staging by KEN ROBERSON
Casting by JIM CARNAHAN
 and AMY CHRISTOPHER
Managing Director ELLEN RICHARD
Executive Director, External Affairs JULIA C. LEVY
Press Representative BONEAU/BRYAN-BROWN
Director of Marketing DAVID B. STEFFEN

Directed by JOE MANTELLO

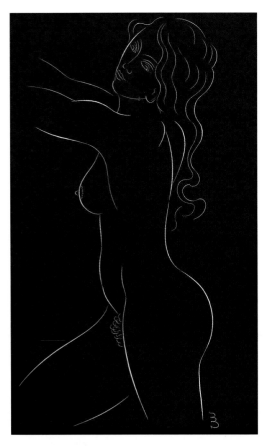

WOOD ENGRAVING BY ERIC GILL, FROM HIS BOOK *25 NUDES*,
PUBLISHED IN 1938.

THEATRE POSTERS

Betrayal, written in 1978, is Harold Pinter's deconstruction of a romantic triangle. Jerry, a literary agent, is the lover of Emma, who runs an art gallery and is married to Robert, a publisher — who is Jerry's best friend. The scenes unfold in reverse chronological order — the play begins two years after the relationship between Jerry and Emma has ended; it ends eight years earlier as their affair is just beginning. As the play progresses, we are more and more aware of what lies ahead for the characters. We also realize that none of the trio sees the whole picture.

I worked up several sketches for this Fall 2000 production at The Roundabout, directed by David Leveaux and starring Liev Schreiber, John Slattery and Juliette Binoche. Everyone liked this silhouette of a nude woman peering through a window covered by Venetian blinds — it seemed both elegant and sexy, and also somehow about hiding dark secrets. The concept was approved and I completed the final art.

Then, the project took an unexpected turn. The way it was explained to me was that Ms. Binoche proposed using a fashion photographer friend of hers in Los Angeles to create a portrait for the poster image. The Roundabout, with more seats to fill in their new American Airlines Theatre on 42nd Street, and keenly aware of the marketing value of their movie star casting — happily took up Ms. Binoche on her suggestion.

Although the image was never used to promote the show, it remains a favourite drawing. I love the work of the British sculptor, wood engraver and typeface designer Eric Gill (1882-1940). I drew this figure from a model using the louvered blinds in my bathroom, but the style was inspired by Gill's elegant, confident woodcuts. This image was something of a forerunner to my series of silhouette posters for the Denver Center Theatre Company in 2005-07.

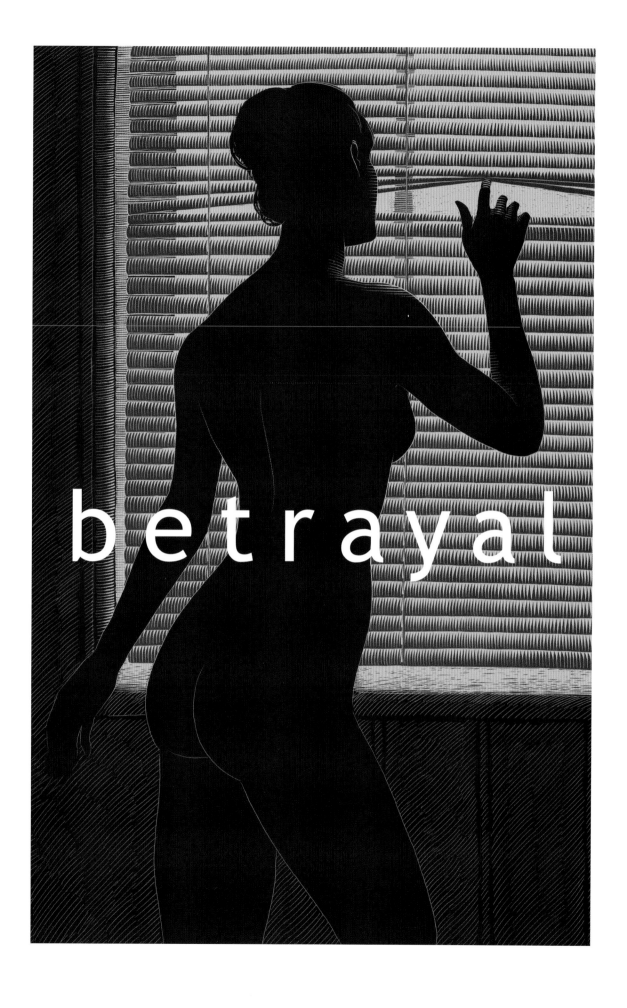

betrayal

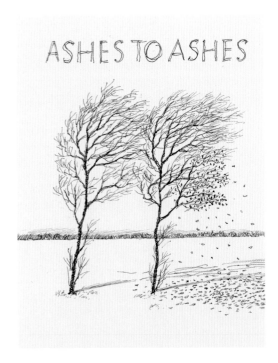

PRELIMINARY PENCIL SKETCH FOR *ASHES TO ASHES*
REPRESENTING THE TWO MAIN CHARACTERS AS TREES.

THEATRE POSTERS

Harold Pinter's cryptic *Ashes to Ashes* is a dense, poetic, challenging 45-minute one-act play. It was written in 1996; The Roundabout produced it in New York in 1999.

Karl Reisz, the director, gave me the following synopsis of the action when we first spoke by phone: "It's about a couple, who has been married. He tries to get through to her, but is unable. They say unforgivable things to each other — then it's over." It was indeed baffling on first reading, but I found that on a second or third reading it began to unfold and it seemed like this compact text was addressing huge universal themes. Rebecca describes having witnessed atrocities that conjure up the Holocaust or ethnic cleansing in Eastern Europe. Suddenly the play is about dominance and submission, victims and victimizers, on a larger social scale as well as on the intimate scale of a marriage.

I faxed off several pencil sketch concepts — all abstract interpretations of the play — to Mr. Reisz in London. He responded a few days later with a disarmingly simple suggestion from Mr. Pinter himself: "Two figures sitting in chairs — they should be sophisticated, literate, elegant people — together in the same room but looking away from each other. And she should be 'within herself'." My personal moment of Pinter clarity.

I visualized this from an overhead angle so that the chairs would look like islands floating on the page. This production starred Lindsay Duncan and David Strathairn. I knew it would not be possible for these actors to pose for the illustration themselves, and the high angle made it easier to substitute models.

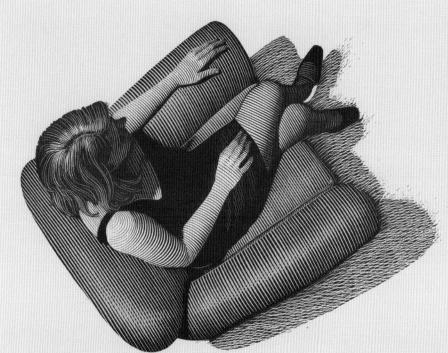

LINDSAY DAVID
DUNCAN STRATHAIRN in

ASHES to ASHES
by HAROLD PINTER

Set and Costume Design by TONY WALTON
Lighting Design by RICHARD PILBROW
Sound Design by TOM CLARK
Dialect Coach NADIA CHIGEROVITCH
Production Stage Manager JAY ADLER
Casting by JIM CARNAHAN
Managing Director ELLEN RICHARD
Executive Director, External Affairs JULIA C. LEVY
Press Representative BONEAU/BRYAN-BROWN
Director of Marketing DAVID B. STEFFEN

Directed by **KAREL REISZ**

ASHES to ASHES

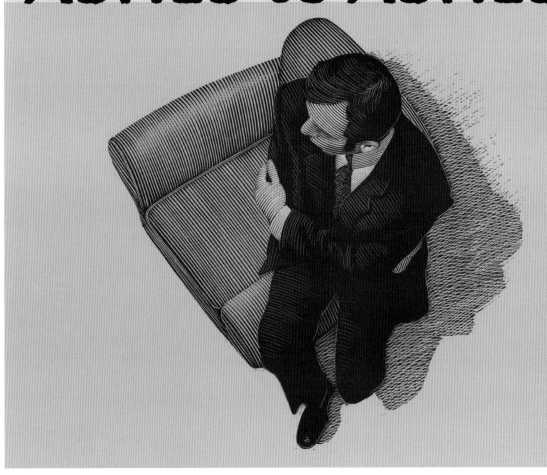

AN EARLY SKETCH SHOWING ONE OF THE CHARACTERS LOOK-
ING OUT AT THE WORLD THROUGH A BOARDED UP WINDOW.
THE FEELING OF LIVING BEHIND A BARRICADE ACTUALLY
EMPHASIZES THE PLAY'S INTERIOR SETTING.

THEATRE POSTERS

The Caretaker was Harold Pinter's breakthrough
success in 1960. Reading the text, it's easy to see
how the description "Pinteresque" has come to
mean something ambiguous and disturbing.

On the surface, *The Caretaker* is the story of two
brothers, Aston and Mick, and a homeless derelict
named Davies. The setting is Mick's junk-filled
London apartment. The power struggles between
the three characters have been interpreted as an
allegory for the shifting demographics of British
society in the early sixties. The *New York Times*
review of this 2005 production at The Round-
about suggests interpretations ranging from
Christian symbolism (British playwright Terrence
Rattigan thought the characters represented the
holy trinity) to the psychoanalytical (to the critic
Kenneth Tynan, they represented the ego, the su-
perego and the id). Pinter has always said that he
was more interested in the human relationships
than in symbolism.

I illustrated the contents of Mick's junk shop of
a bedroom (almost all of these objects are speci-
fied in the text) floating menacingly above a man
asleep in bed. This nightmare might belong to any
of the three characters in the play, so I was care-
ful to leave the identity of the figure ambiguous.

THE CARETAKER

PATRICK STEWART
KYLE MacLACHLAN
AIDAN GILLEN in

THE CARETAKER
by HAROLD PINTER

Set Design by
JOHN LEE BEATTY

Costume Design by
JANE GREENWOOD

Lighting Design by
PETER KACZOROWSKI

Sound Design by
SCOTT LEHRER

Hair & Wig Design by
PAUL HUNTLEY

Production Stage Manager
MATTHEW SILVER

Casting by
JIM CARNAHAN, C.S.A.

Technical Supervisor
STEVE BEERS

General Manager
SYDNEY DAVOLOS

Directed by
DAVID JONES

SUNDAY IN THE PARK
with GEORGE

DOT MODELS FOR GEORGE IN SEVERAL SCENES IN ACT I, SO
THE FIRST PENCIL SKETCH IDEAS SHOWED ARTIST AND MODEL
WORKING TOGETHER IN THE STUDIO.

THEATRE POSTERS

If any show comes with built-in, prerequisite visuals for the poster, it would be *Sunday in the Park with George*, Stephen Sondheim's Pulitzer Prize-winning musical about artists and art. This poster was created for Doug Wager's 1997 season at Arena Stage in Washington DC.

The musical juxtaposes the stories of two artists working in different centuries. The first act, set in Paris in the 1880s, is about Georges Seurat and the creation of his great masterpiece *Sunday Afternoon on the Island of La Grande Jatte*. Seurat was obsessed with the newest discoveries in the perception of colour and light. The impressionists had produced glowing canvases by placing brush strokes of complimentary colours in close proximity — but they had worked intuitively. Seurat approached this idea like a scientist. His images are meticulously constructed with tiny brush strokes of complimentary colours — red/green, violet/yellow, blue/orange. He even theorized that colour combinations could be used to produce harmony and emotion in a painting in the same way that a composer produces harmony in music (providing Sondheim with plenty of inspiration for his brilliant, complex music and lyrics).

The second act takes place a century later (I added skyscrapers shimmering like a mirage in the distance). We meet an American artist, also named George, who makes sound-and-light sculpture installations called chromolumes. (Seurat called his theory of art *chromolumiarism*.) The two acts — and the two artists — are linked through the character of George's elderly grandmother Marie — who is the daughter of Dot, Seurat's model and lover in the first act, and the main figure in *La Grande Jatte*.

I wanted a clean, fresh take on Seurat and his famous masterpiece. The first and last line of the script is "White. A blank page or canvas." George (rendered in scratchboard lines) is painting Dot (rendered in dots) — the use of different media is intended to contrast the show's three-dimensional, human characters with the two-dimensional ones who inhabit Seurat's canvas.

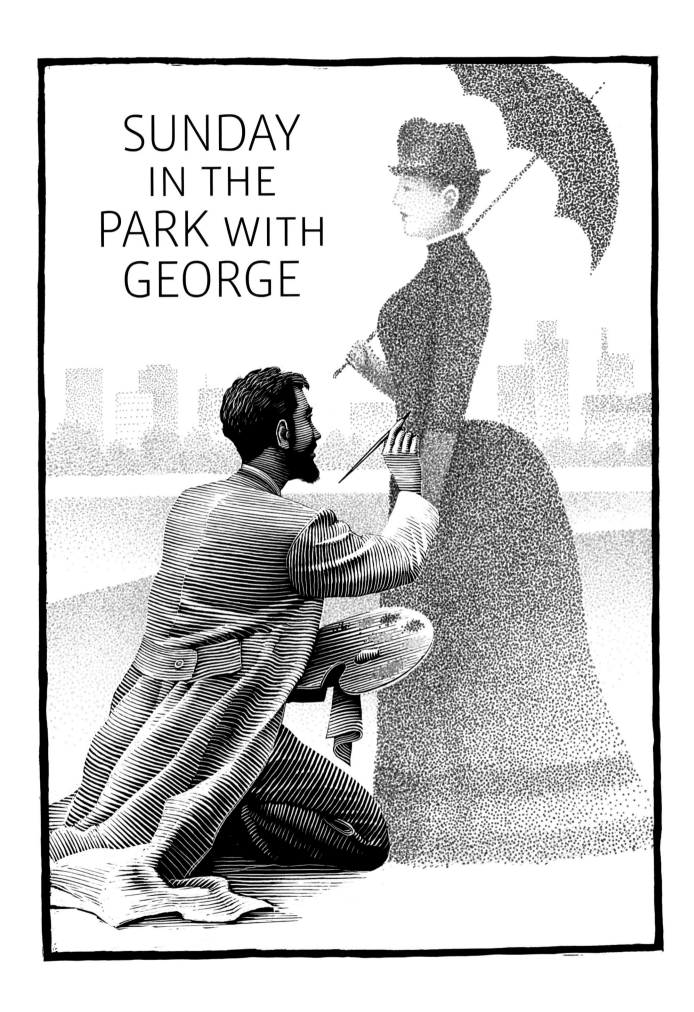

SUNDAY
IN THE
PARK WITH
GEORGE

AN EARLY PENCIL SKETCH SHOWING ARTIE IN A MORE NATU-
RALISTIC INTERIOR, WITH POP ART WALLPAPER INTENDED TO
EVOKE A 1960S FLAVOUR. THE WALLPAPER EVOLVED INTO AN
OPEN SKY, WITH THE FLOATING SHEETS OF MUSIC FEELING
LIKE LITTLE WHITE CLOUDS.

THEATRE POSTERS

John Guare's "tragic farce" *The House of Blue
Leaves* is set in Artie Shaughnessy's living room
in Queens in 1965, on the day the Pope is visiting
New York City. Artie works at the Central Park
Zoo, feeding the animals — but dreams of mak-
ing it big in Hollywood as a popular songwriter.
His songs are painfully bad — he can't even win
an amateur night contest at his neighbourhood
bar — but he remains optimistic and undeterred.
Artie's wife, a depressed, delusional woman
nicknamed Bananas, is the most sane, articulate,
sympathetic character in the play.

I didn't know the play prior to this assignment,
but I was familiar with James McMullan's iconic
poster for Lincoln Center Theatre's production
in 1986 — Artie playing an upright piano and
singing with a mix of euphoria and desperation.

I was (obviously) anxious to stay as far away from
the McMullan poster as possible, and presented
initial rough sketches with no figures at all. But
Artie's insane optimism is the energy that drives
the whole show, and we kept coming back to
him. Also, the client wanted to feature the actor
playing the role so I flew down to New York for
a reference photo session with John Pankow.

Thinking how to introduce a comic element, I hit
upon the idea of Artie playing a toy piano. His
enjoyment in playing and singing is completely
serious and genuine — but the absurdity of a
man sitting on the floor with a child's toy sums
up the level of his songwriting talent.

I seem to have this thing about flying sheets of
paper — I add them into a lot of theatre images.
I wanted a dreamy, surreal feeling here, and the
animated sheets of music turn Artie's songs (all
written for the show by Mr. Guare) into a meta-
phor for his impossible American Dream.

The focus of that dream throughout the play is
Hollywood, as imagined from the characters'
New York perspective. Ironically, this production
— the first major revival since the Lincoln Center
production 22 years before — took place in Los
Angeles, at the Mark Taper Forum in Fall 2008.

THE HOUSE OF
BLUE LEAVES

THEATRE POSTERS

The Beauty Queen of Leenane, A Skull in Connemara, and *The Lonesome West* make up Martin McDonagh's Leenane Trilogy — three *very* black comedies written in 1996-97, all set in rural Ireland.

The Leenane churchyard is overcrowded. To make room for new arrivals, the local priest hires Mick Dowd for a week every autumn to disinter old coffins and dispose of the bones. This autumn, it's time to start on the south side of the yard — where Mick's wife lies buried, killed in a car crash while he was drunkenly at the wheel. Officially it was a tragic accident, but local gossip has it that foul play may have been involved, and the question of Mick's possible guilt is debated by the play's other three characters — a poteen-fueled bingo queen, an eager but inept local police officer, and his younger brother, a "professional dimwit." McDonagh's morbid, wicked dialogue is outrageously funny — I don't recall ever laughing so hard reading a script.

EARLY SKETCHES EXPLORING THE IDEA OF THE GRAVEDIGGER.

The action takes place in a claustrophobic interior with shabby furniture and a crucifix — but floating above the set for Gordon Edelstein's 2001 production at The Roundabout, mounted upside down on the ceiling, were rows of grave plots and tombstones. The evening took on a Halloween-like atmosphere before the play even started. Once it did, Mick and his sidekick, wielding mallets, gleefully smashed their way through a new set of prop skulls at every performance. Bone fragments flew everywhere, including into the first few rows of the audience.

This macabre scenario immediately calls to mind the Gravediggers in *Hamlet* — I tried a few "Alas poor Yorick" pencil sketches (with the Prince of Denmark looking more like a soccer hooligan). I ended up with a cross-section of earth with a buried skull, weirdly glowing, and laughing out at us.

KEVIN CHRISTOPHER
TIGHE EVAN WELCH

CHRISTOPHER ZOAUNNE
CARLEY LeROY

**A SKULL IN
CONNEMARA**

by MARTIN McDONAGH

Set Design DAVID GALLO
Costume Design SUSAN HILFERTY
Lighting Design MICHAEL CHYBOWSKI
Sound Design STEPHEN LeGRAND
Original Music MARTIN HAYES
Dialect Coach STEPHEN GABIS
Fight Director J. STEVEN WHITE
Production Stage Manager JAY ADLER
Casting by AMY CHRISTOPHER, C.S.A.
and LAURA RICHIN CASTING

Directed by GORDON EDELSTEIN

A SKULL IN CONNEMARA

THEATRE POSTERS

Martin McDonaugh's 2003 play *The Pillowman* won the Olivier Award for best new play in London, and several Tony Awards in New York. It's a stunning black comedy about crime and punishment, childhood fears we never really outgrow, and the power of storytelling itself.

The play's protagonist, Katurian, writes Brothers Grimm-like fantasy stories about young children being killed in a variety of bizarre and gruesome ways. In the opening scene, two police detectives are interrogating Katurian about a string of child murders that seem to mirror his stories. The synopsis includes sexual abuse, torture, severed fingers and heads, premature burial and summary execution. Not a play for the faint of heart.

Which brings up a marketing challenge. A theatre poster needs to convey accurately what the play is about — if the play is disturbing, the poster could be too. But the point of the exercise is to sell tickets, not to frighten people away!

One of Katurian's nightmarish stories is about a 9-foot-tall man made of pillows "with two button eyes and a big smiley face." The Pillowman's sad job is to visit men and women who have had a terrible life and who are about to end it all by committing suicide. He comforts them. Then he takes them back in time and convinces them to avoid the years of pain ahead by taking their own lives as children. I wanted to use this ghastly, perversely compassionate fantasy creature — but my first sketches looked like the Michelin Man, or the giant marshmallow man from *Ghost Busters*.

Christina solved it: An innocuous smiley face painted on a pillowcase seems innocent enough. But the shape of the hood over a man's head evokes those images of Abu Ghraib, and the rope around his neck and the cast shadow on the wall suggest the claustrophobia and terror of a prison interrogation. The smiley face is the colour of blood. It needed a different texture so I painted it with a brush, scanned it and layered it over the scratchboard lines. A tear seemed like the right finishing touch.

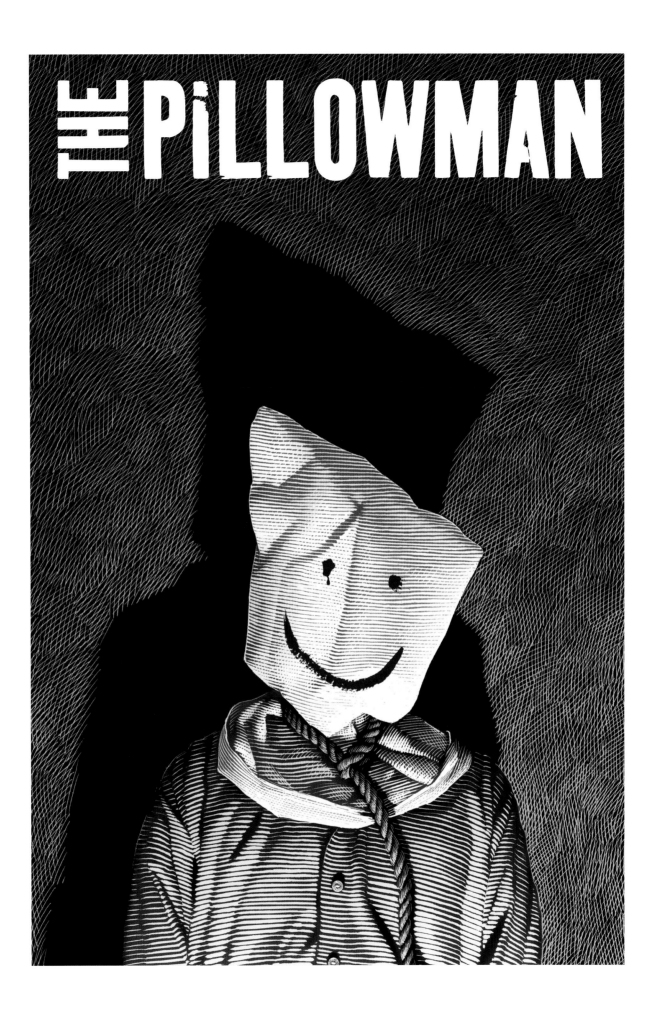

TRAVEL PHOTO BY DAVID COOPER FROM THE SHAW FESTIVAL
2000 SEASON BROCHURE. THE LUGGAGE WAS USEFUL AS
REFERENCE FOR THE *TRAVELS WITH MY AUNT* ILLUSTRATION.

THEATRE POSTERS

British author Graham Green wrote his novel *Travels with My Aunt* in 1969. Its hero is Henry Pulling, a conventional and not very charming bank manager who has taken early retirement, and plans to spend it tending his dahlias. He meets his eccentric and totally charming septuagenarian Aunt Augusta for the first time at his mother's funeral. They have nothing in common, but form a bond — and Henry is drawn into Aunt Augusta's world of travel, adventure and romance. He first accompanies her on a trip to Brighton, where he begins to learn of her unconventional past. Eventually they travel together from Paris to Istanbul on the Orient Express, and finally to South America.

Giles Havergal created the stage adaptation at the Glasgow Citizens' Theatre in 1989. There are 25 characters in the cast (16 male, 9 female) — all played by only four actors (all males), dressed identically in dark suits and bowler hats.

I thought immediately of Magritte — as the playwright had obviously intended from the wardrobe directions. A mountain of luggage seemed to get the idea of travel and adventure across in a theatrical, comic way.

For years I had played with this concept in brochure images for the Shaw Festival. Niagara-on-the-Lake is a travel destination, and tourism has always been part of the marketing equation there. In 2000, David Cooper and I created a mountain of luggage for a photo shoot with actors in period travelling costume. We used every vintage trunk and suitcase in the props warehouse — and that photo came in handy as a reference for this project. I think the idea works better as an illustration than as a photo — there's a precariousness here that defies gravity (to say nothing of health and safety standards).

THEATRE POSTERS

Kent Thompson programmed Sarah Ruhl's acclaimed play *The Clean House* as part of his first season at Denver Center Theatre Company. I already knew the play, having art directed and designed the poster for the world premiere production in 2004 at Yale Repertory Theatre.

Here's the play description from the Yale Rep brochure: "A family is forced to face its buried dysfunction when they hire a Brazilian maid who loves to tell jokes but hates to clean. *The Clean House* is a serious comedy about laughter we don't understand, feelings we can't explain, events we can't control, and houses we can't keep tidy despite our best intentions." The Yale Rep poster image, a black and white photograph by David Cooper, shows two women scrubbing a filthy wall with buckets of soapy water and long-handled brushes. The brush strokes were intended (subtly) to invoke comedy and tragedy — laughter and tears.

Scratchboard illustration seemed to invite a more abstract approach to the play. In one scene, a character (who is fighting cancer) goes apple picking. She picks far too many, brings them home and begins to eat them — and any apple that is not flawless she throws into the sea. Apples are a perfect symbol of life and well-being. I considered the idea of an apple with a worm in it, to suggest rot from within. That idea evolved into apples falling from the sky — manna from heaven — and a woman holding her skirt open to catch them. There's a sense of accepting what life throws at you — the good with the bad — and a surreal quality that seems to fit Sarah Ruhl's moving play.

POSTER FOR THE WORLD PREMIERE PRODUCTION OF *THE CLEAN HOUSE* AT YALE REPERTORY THEATRE, 2004, WITH A PHOTO BY DAVID COOPER; PENCIL SKETCHES FOR THE DENVER POSTER.

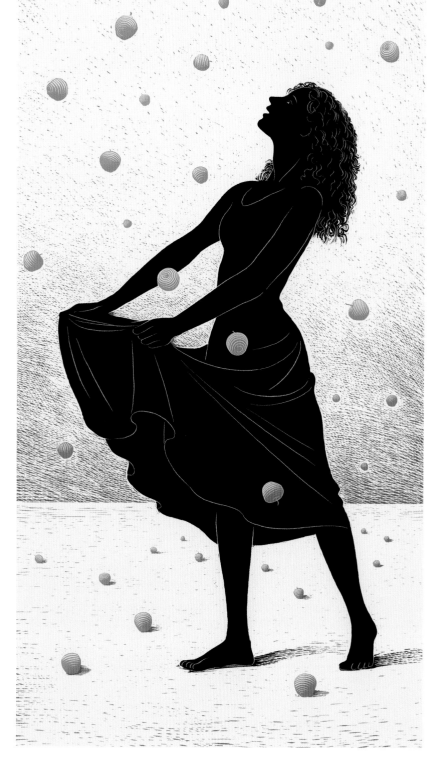

THE SIMONIAC POPE, ILLUSTRATION BY WILLIAM BLAKE FROM DANTE'S *DIVINE COMEDY* (THE INFERNO), 1824-27.

THEATRE POSTERS

Set in Pittsburgh in 1904, *Gem of the Ocean* is the first play in August Wilson's 10-play cycle about the Black experience in America throughout the 20th century.

Citizen Barlow, a young black man recently arrived from the South, has stolen a bucket of nails from the local mill. A riot has started, and Citizen watches as another man — accused of the theft but protesting his innocence — jumps into the river and drowns. Convinced that he is responsible for another man's death, Citizen seeks out Aunt Ester, a 285-year-old former slave and "cleanser of souls." (Her age corresponds with the arrival of the first slave ships to America.) In the play's most unforgettable scene, she guides Citizen on a spiritual journey to the mythical "City of Bones" at the bottom of the Atlantic — without leaving her kitchen.

A powerful figure underwater — he might be swimming or drowning — seemed to connect with the dark, allegorical themes of this story.

Slavery — America's "original sin" — underpins every aspect of the play. Aunt Ester's bill of sale from a slave auction becomes the folded paper boat on which Citizen's metaphysical journey begins. The figure in the poster has shackles on his ankles — but the chains are broken.

The play is also full of poetry, spirituals and biblical and literary allusions. I borrowed the pose from one of my favourite William Blake illustrations to Dante's *Inferno* — the inverted, tormented figure in *The Simoniac Pope*. The classical literary reference seemed appropriate, as well as the theme of crime and punishment; and Blake's mysticism is at least as powerful as Aunt Ester's.

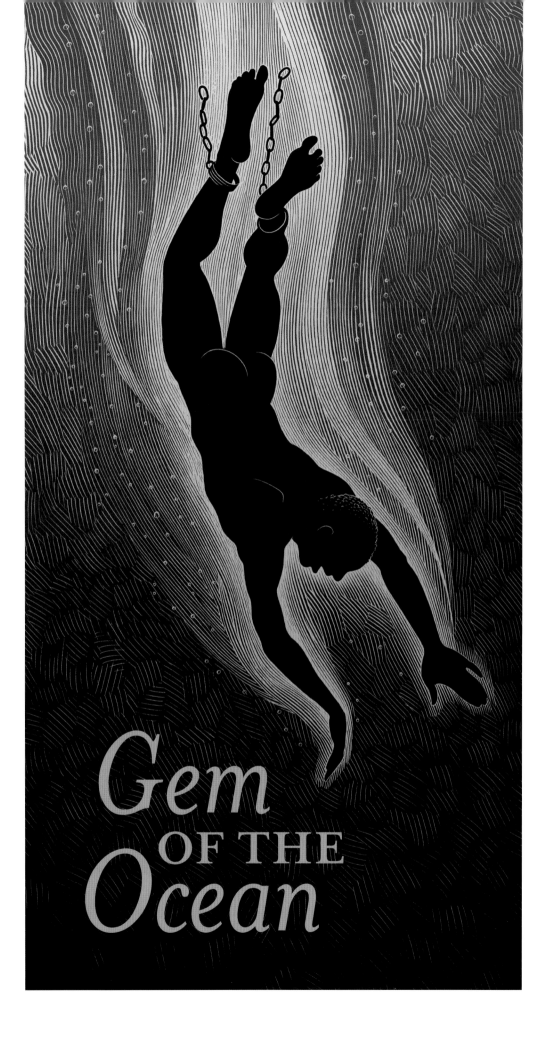

Gem
OF THE
Ocean

SILHOUETTES BY AUGUST EDOUART FROM A 2005 EXHIBITION
AT THE NATIONAL PORTRAIT GALLERY IN LONDON.

THEATRE POSTERS

I have always been drawn to the graphic strength of the silhouette. Everyone is familiar with the oval-framed profile portraits in Victorian parlours — but silhouettes have been cut by artists with sharp scissors (and sharp eyes!) for more than three centuries. While in London in March 2005 we saw a marvellous exhibition of silhouettes at the National Portrait Gallery. Christina whispered "you have to try something with these in scratchboard!"

That opportunity came along a few months later when Kent Thompson commissioned twelve posters for his inaugural season at Denver Center Theatre Company. I knew that silhouette images would work well for the plays with historical settings, but they seem to work for plays with contemporary themes as well.

Jason Grote's *1001* is a postmodern riff on the classic *A Thousand and One Nights*. The action shifts fluidly between ancient Baghdad and post-9/11 New York City, with costume changes in full view of the audience. So the first challenge was to come up with a concept that would represent both time periods. The actors playing Scheherazade and the bloodthirsty King Shahriyar double as Dhana, a Palestinian grad student at Columbia University, and her Jewish boyfriend, Alan. Above all, some reference to the magic and fantasy of the original source material seemed essential.

Toward the end of the play there's a massive explosion on stage, and the implication of a terrorist attack. I brought the ancient and modern worlds together in an image of a girl holding an antique lamp — from which a huge, frightening Genie is exploding.

In addition to marketing materials for the world premiere production, the illustration was used on the cover of the published script.

THEATRE POSTERS

The American theatre director Bill Rauch has never been afraid of updating the classics. I created poster images for several of his productions at Yale Rep including *Medea/Macbeth/Cinderella* — his audacious overlapping and interweaving of Euripides, Shakespeare, and the Rodgers and Hammerstein musical.

Rauch directed J.M. Barrie's *Peter Pan* at Great Lakes Theater Festival in 2000, setting the story not in Victorian London but in present-day Cleveland, the city in which this production took place. It was important for the poster to signal this production concept — we didn't want audiences to come expecting a traditional production. I proposed the idea of a figure in modern clothing soaring over the Cleveland skyline.

The flying figure is borrowed from a 1929 poster for the famous Sergei Eisenstein film *Battleship Potemkin*, by the Russian Constructivist poster artists Vladimir and Georgii Stenberg. Their figure is dressed in a naval uniform, and the context could not be more unrelated to *Peter Pan* — but I loved the unexpected angle.

In addition to promoting this production, the illustration also appeared on the cover of Great Lakes Theater Festival's season brochure, an invitation to Cleveland audiences to engage their imaginations at this theatre all year long.

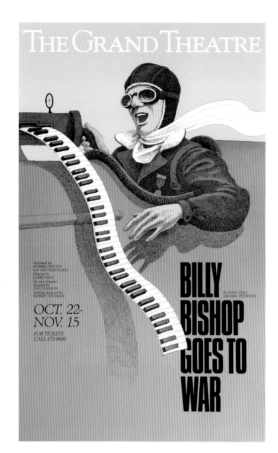

THE GRAND THEATRE

Performed by
MORRIS PANYCH
with KEN McDONALD
Directed by
LARRY LILLO
Set and costumes
designed by
PAUL JOHNSON
Lighting designed by
ROBERT THOMSON

OCT. 22-
NOV. 15
FOR TICKETS
CALL 672-8800

BILLY
BISHOP
GOES TO
WAR

By JOHN GRAY
with ERIC PETERSON

"PRE-SCRATCHBOARD" PEN-AND-INK POSTER ILLUSTRATION
FOR BILLY BISHOP GOES TO WAR, ANOTHER MUSICAL BY
JOHN GRAY. THIS 1986 PRODUCTION WAS ALSO DIRECTED
BY LARRY LILLO.

THEATRE POSTERS

The Grand Theatre, an ambitious regional company in London, Ontario, hired me in 1984 to create posters and marketing materials for eight productions each season. It was my first real job as a resident theatre poster artist. Initially I used pen-and-ink line drawings, but found that the weight of the pen lines — even with cross-hatching to build up the density — too delicate to achieve the graphic strength I wanted.

Scratchboard is the graphic opposite of pen-and-ink — white lines drawn on a black background instead of black lines on white — so I began to experiment with this new (to me) medium, hoping to improve the visual impact of my posters. These examples from The Grand are some of my earliest scratchboard illustrations.

John Gray's musical *Rock and Roll* tells the story of a popular Maritime rock band during the group's formative years in the early '60s, and two decades later at a reunion concert. The band's guiding force is a sort of "spirit of rock and roll" figure called Screamin' John McGee.

I had planned to draw the actor playing Screamin' John, playing a guitar, in the back seat of a vintage Chevy, and scheduled a reference photo session at the theatre on a Saturday morning.

But everything went wrong. The owner of the car called to cancel. The actor never showed up at all. Just as all seemed lost, Larry Lillo, Artistic Director of The Grand, appeared. There had been an opening night party the night before and Larry looked like he had not had much sleep. The black leather jacket he was wearing was kind of perfect. So was his hair. I realized that Larry would make a better model than the actor I had planned on, and handed him the guitar. This poster combined two icons of Canadian theatre — Gray and Lillo — and became something of a collector's item.

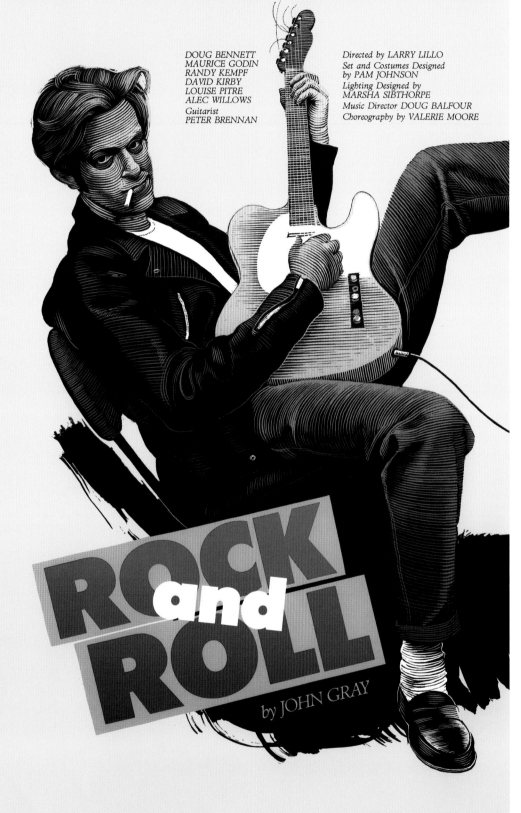

THE GRAND THEATRE

LONDON, ONTARIO

DOUG BENNETT
MAURICE GODIN
RANDY KEMPF
DAVID KIRBY
LOUISE PITRE
ALEC WILLOWS
Guitarist
PETER BRENNAN

Directed by LARRY LILLO
Set and Costumes Designed
by PAM JOHNSON
Lighting Designed by
MARSHA SIBTHORPE
Music Director DOUG BALFOUR
Choreography by VALERIE MOORE

ROCK and ROLL

by JOHN GRAY

THEATRE POSTERS

I based my *Jacques Brel* poster on a lucky photo from a holiday in Paris. I was returning to my hotel (the Recamier, in Place St. Sulpice) when I noticed a young couple on a bench, lost in the enjoyment of each other's company. I captured their moment from my fourth-floor window — without their permission, I admit — but interrupting them to sign a release seemed, at the time, the greater intrusion. The poster assignment from The Grand Theatre came along a year later, in 1990, and I knew I already had the perfect romantic Paris image for this famous show.

Athol Fugard's 1989 apartheid drama *My Children! My Africa!* is the story of two promising high school students, one black and one white, and their black teacher — three smart, well-intentioned, highly likeable characters — overtaken by violent change in South Africa.

The black teacher, Mr. M. arranges for Thami, a Bantu, to team up with Isabel, a student from a privileged white high school, for a literary competition. You almost expect that Fugard is setting up an adolescent love story — but the real conflict becomes a generational one between Mr. M., who still believes that the apartheid system can be dismantled peacefully, and the increasingly radicalized Thami, who wants change right now.

A *Washington Post* review of a production in 2007 called the play "a lamentation about the pain and the cost, both self-inflicted and imposed from outside, on those who had the most to gain in ending a benighted system — and who lost the most in trying."

The old schoolyard game "Rock/Paper/Scissors" is used — like a coin-toss — to settle disputes. I used hands representing the three characters, in the gestures of the three elements in the game. The "rock" gesture, a closed fist, is also a symbol of defiance, used for years by the South African Congress Alliance of Anti-Apartheid movements. And of course the v-shaped "scissors" gesture is also the familiar symbol for peace.

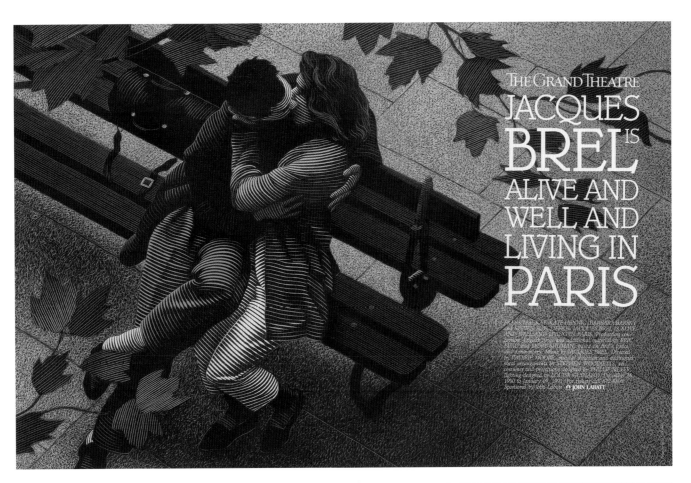

THE GRAND THEATRE
JACQUES
BREL IS
ALIVE AND
WELL AND
LIVING IN
PARIS

FRANK MACLAY, KATE HENNIG, BARBARA BARSKY and STEPHEN OUIMETTE in JACQUES BREL IS ALIVE AND WELL AND LIVING IN PARIS. Production conception, English version and additional material by ERIC BLAU and MORT SHUMAN, based on Brel's lyrics and commentary. Music by JACQUES BREL. Directed by PATRICK MOORE, musical direction and additional vocal arrangements by STEPHEN WOODJETTS, set, costumes and projections designed by PHILLIP SILVER, lighting designed by LOUISE GUINAND. December 18, 1990 to January 16, 1991. For tickets call 672-8800. Sponsored by Tobb Labatt. ⟨⟩ JOHN LABATT

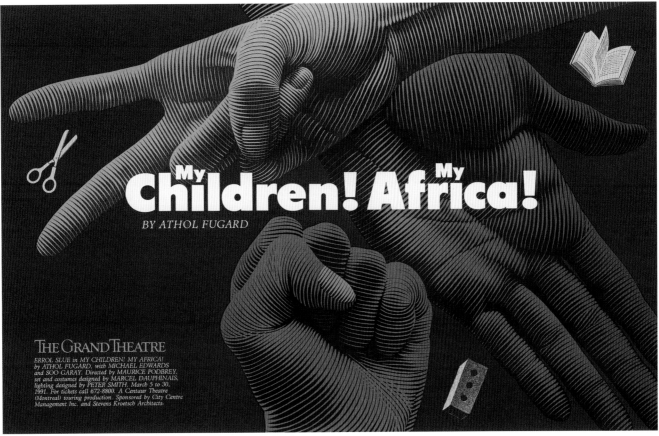

My
Children! Africa! My

BY ATHOL FUGARD

THE GRAND THEATRE
ERROL SLUE in MY CHILDREN! MY AFRICA! by ATHOL FUGARD, with MICHAEL EDWARDS and SOO GARAY. Directed by MAURICE PODBREY, set and costumes designed by MARCEL DAUPHINAIS, lighting designed by PETER SMITH. March 5 to 30, 1991. For tickets call 672-8800. A Centaur Theatre (Montreal) touring production. Sponsored by City Centre Management Inc. and Stevens Kroetsch Architects.

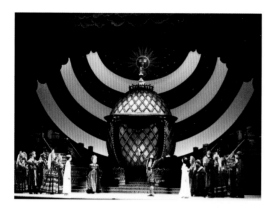

PRODUCTION PHOTO OF THE SUGAR PLUM FAIRY KINGDOM BY LYDIA PAWELAK; *NUTCRACKER* BILLBOARD IN DOWNTOWN TORONTO.

BALLET POSTERS

Marketing images for ballet often employ photography — especially when it's important to feature a principal dancer, or capture a moment that conveys the style of choreography. So it was great fun to go against expectations and create a scratchboard illustration for The National Ballet of Canada's production of *The Nutcracker*.

James Kudelka set his version of the popular classic in the Russian world of Tchaikovsky rather than the usual German setting of E.T.A. Hoffman, who wrote the original story in 1816. Instead of Clara and Fritz, and their mysterious godfather Herr Drosselmeyer, we have Marie and Misha and their Uncle Nikolai. The Nutcracker Prince battles mice in Cossack uniforms, and the Sugar Plum Fairy lives in a gigantic Fabergé egg.

The Act I Christmas Eve party takes place in a huge barn on a Russian country estate. Kudelka's choreography includes a little segment for two bears skating on a frozen pond (the dancers inside the bear suits are on roller blades, allowing them to glide convincingly).

The bear is the archetypal Russian national symbol, so Kudelka's ice skating bears seemed an ideal subject for the poster illustration. I based their *pas de deux* pose on a reference photo of National Ballet Principal Dancers Rex Harrington and Greta Hodgkinson in *Giselle*.

For additional richness, and a folk-art flavour, I adapted 19th-century Russian cut-paper designs into a border. The row of the dancing mice was inspired by the silhouetted rodents on Arthur Rackham's 1934 cover for *The Pied Piper of Hamelin*.

All the type was hand-drawn in scratchboard. Initially I created only the letters required for the title and National Ballet wordmark — but had to expand the font to a complete alphabet to typeset dates, box office phone numbers, and additional headlines for ads and signage in the theatre lobbies. The dancing bears have become an effective "brand" for this production — you see them everywhere in Toronto during the holiday season.

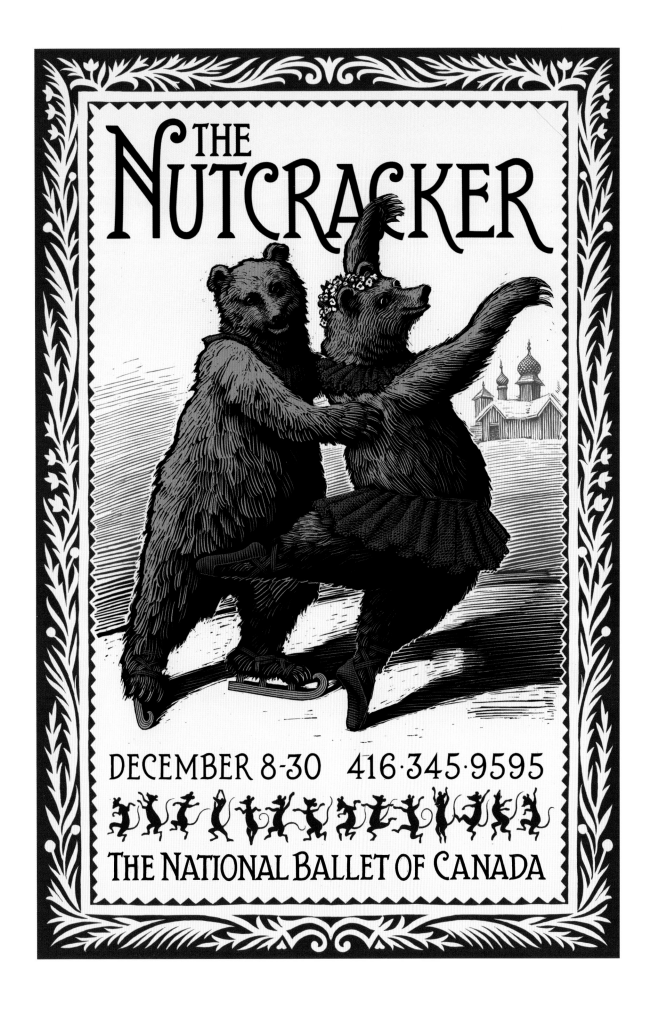

NADAR ELEVATING PHOTOGRAPHY TO THE HEIGHT OF ART,
LITHOGRAPH BY HONORE DAUMIER, 1862 (STAPLETON
COLLECTION/BRIDGEMAN ART LIBRARY).

BALLET POSTERS

In 2005, James Kudelka choreographed a full-length ballet version of *An Italian Straw Hat* to an original score by American composer Michael Torke. Based on Eugene Labiche's 1851 farce, the production lavishly recreates 19th-century Paris with sets and costumes designed by Santo Loquasto. The dizzying plot revolves around a wedding that almost doesn't happen.

Ferdinand, an elegant young man about town, is about to be married to Hélène. During a stroll in the park, Ferdinand's horse spies a very expensive and unattended Italian straw hat — and eats it. This is a calamity for the hat's owner, Anaïs — she is married, but at this moment having a tryst with her lover, the handsome soldier Emil — and they fear that their affair will be discovered if Anaïs returns to her husband without her hat. All these characters begin a mad chase through Paris to find a replacement for the straw hat, before Ferdinand's wedding can take place.

About a year before Kudelka's new production existed, I was asked by Julia Drake, the company's Director of Marketing, to devise an illustration for the season brochure. Santo Loquasto's set model featured hot-air balloons of the period floating through almost every scene (including a life size one that whisks Ferdinand and Hélène away in the finale). This called to mind a cartoon by Honoré Daumier showing the famous Parisian photographer Nadar in a balloon (Nadar had made the world's first aerial photograph, from a balloon, in 1858). Ever the satirist, Daumier's caption reads "Nadar elevating Photography to the height of Art."

I don't know if Daumier and Labiche knew each other in Paris, but they must have shared a similar sense of humour. Daumier's caricatures take us straight to the heart of this crazy story. I hope I captured a bit of that spirit when I added a few more characters to that balloon gondola.

MUSIC POSTERS

The complete plays of William Shakespeare are referred to as "the canon"; the quartets of Ludwig von Beethoven are known collectively as "the cycle." The Juilliard String Quartet performed this holy grail of the chamber music world in a year-long series of five concerts in each of six cities across the U.S. in 1989-90. One of the venues, the Wharton Centre for Performing Arts at Michigan State University, happens to be in my hometown — and I was asked to create a poster for the event.

My very first impulse was to put Beethoven on a bicycle, making a visual pun on the title. I thought this might be just too corny — until I realized that the joke is not anachronistic at all. Beethoven lived until 1827, so he would certainly have seen early velocipedes rattling down the cobblestone streets of Vienna. Given his reputation as an unconventional eccentric, I would be surprised if he never tried one out for himself.

This poster poked gentle fun at a "serious" classical music icon. If you picture what Beethoven looked like, do you not think of a marble bust of the composer scowling down at you from the top of the piano? As a marketing tool, the image was intended to dispel any notion of chamber music being stuffy or boring.

It was a good image for a tour, as well. Beethoven loved the countryside, so I put him in a pastoral landscape with the quartet manuscripts under his arm. We printed posters for the other venues, imprinted with local dates and information, and shipped them out to New York, Boston, and Pasadena; the higher quantities made the printing costs more economical. I'm told that the Quartet liked the poster very much — I received a copy signed by the four musicians, a great keepsake from a very happy early assignment.

BEETHOVEN QUARTET CYCLE

JUILLIARD STRING QUARTET
COMPLETE QUARTETS OF LUDWIG VAN BEETHOVEN
WHARTON CENTER FOR PERFORMING ARTS
MICHIGAN STATE UNIVERSITY 1989-1990

MUSIC POSTERS

Forty Part Motet, Janet Cardiff's magical sound sculpture from 2001, is based on the Thomas Tallis motet *Spem in Alium*, composed around 1570. Cardiff recorded a British choir singing this famous work using one microphone per singer. The work consists of 40 speakers, arranged at "ear level" in a large circle, and a computer that plays back the music on a 14-minute loop. A listener can stand in the middle of this circle and hear a beautifully balanced "virtual choir" — or move close to individual speakers to hear the line of each single voice. I had seen the work at the National Gallery of Canada, and again at the Museum of Modern Art in New York and loved the juxtaposition of ancient music and cutting-edge technology.

Stratford Summer Music presented *Forty Part Motet* as the centrepiece of its 2008 season. I was asked to create a poster illustration, and began thinking about a visual representation of Cardiff's deconstruction of Tallis.

Christina came up with a simple concept that maps the structure of Cardiff's installation: a circle of trees and in each tree a singing bird.

I started looking at imagery contemporary with the music. The richly decorated scenes in Renaissance tapestries are woven from single threads of various colours. This seemed a great metaphor for Tallis's intricate polyphony made up of individual vocal lines.

The famous Unicorn Tapestries at the Metropolitan Museum of Art in New York came to mind because of their natural woodland settings with birds and animals. The unforgettable Unicorn Tapestries at the Musée de Cluny in Paris depict allegories themed around the five senses — taste, sight, touch, smell and hearing.

The tapestries and the Tallis motet have a powerful sense of mystery in common. I tried to evoke this in the illustration by borrowing the flattened, vertical perspective of Renaissance forms — balanced by a contemporary aesthetic in the drawing.

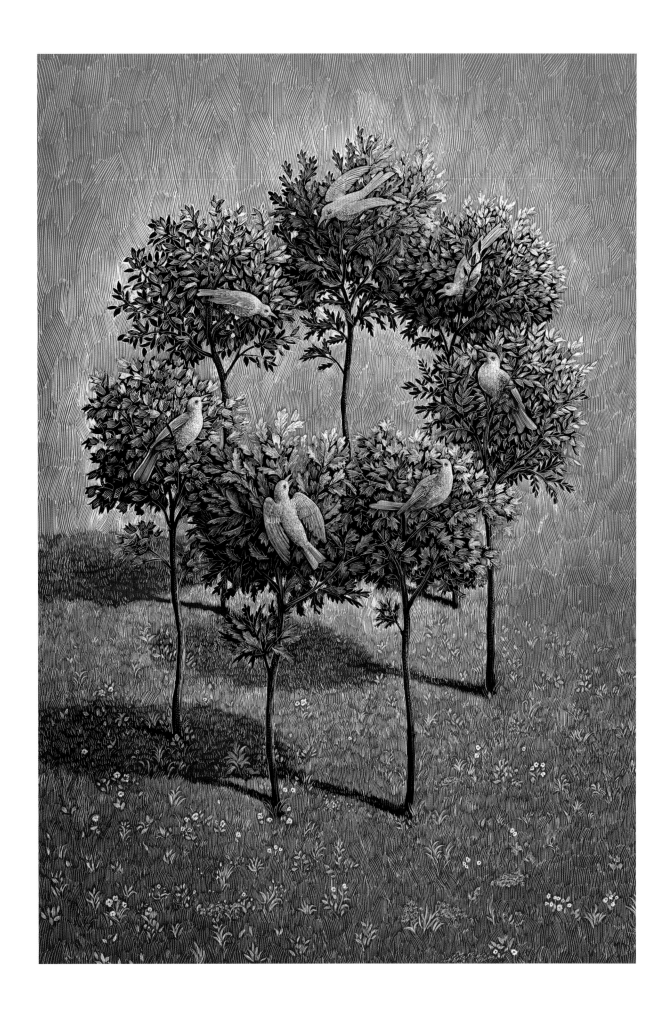

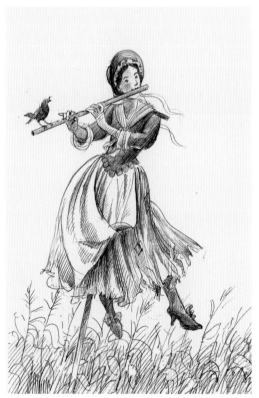

PENCIL SKETCHES FOR THE MUSICAL SCARECROWS.

MUSIC POSTERS

My own musical tastes tend to be stuck (quite happily) in the 17th- and 18th-centuries, so it was a real pleasure to take on the assignment of creating a new graphic identity for the Grand River Baroque Festival. Their concerts are performed in a truly idyllic setting — a 150-year-old barn overlooking stone farmhouses and rolling fields.

I was looking for a solution that would make a connection with the rural agricultural traditions of the region. We talked about doing a photo shoot with a farmer in period costume, playing his violin instead of plowing his field.

Then Christina suggested the idea of a scarecrow, dressed in tattered 18th-century clothing, playing a violin for an audience of birds.

We were already thinking that this would work even better as a little series. The companion image for 2007 was a female scarecrow playing a baroque flute, and for 2008 an operatic soprano.

I chose the font Vista Sans for the Festival's wordmark because the italic *Q* has a baroque flavour — flamboyant and elegant — but the overall feeling of the poster is still clean and contemporary.

A cherished summer getaway for the past decade or so has been a trip to Glimmerglass Opera in the Finger Lakes region of New York State. Part of the fun of that annual excursion is to spot the latest poster by Milton Glaser for the Cooperstown Chamber Music Festival. His ongoing series of musical cows — playing string quartets in white tie and tails — is truly inspired, and provides a great example of how classical music can be marketed with a sense of freshness and wit.

GRAND RIVER
BAROQUE
FESTIVAL

KEVIN MALLON,
ARTISTIC DIRECTOR

JUNE 16 & 17
2006
BUEHLOW BARN
AYR, ONTARIO
www.grbf.ca

GRAND RIVER
BAROQUE
FESTIVAL

KEVIN MALLON, ARTISTIC DIRECTOR

JUNE 15, 6 & 17
2007

BUEHLOW BARN
AYR, ONTARIO

WESLEY UNITED CHURCH
CAMBRIDGE, ONTARIO

www.grbf.ca

GRAND RIVER
BAROQUE
FESTIVAL

KEVIN MALLON, ARTISTIC DIRECTOR

AYR AND CAMBRIDGE, ONTARIO
JUNE 13, 14 & 15
2008
www.grbf.ca

 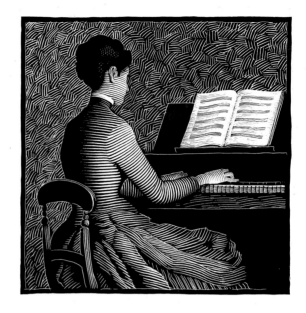

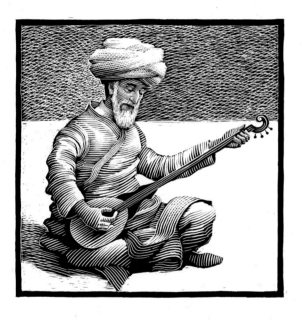 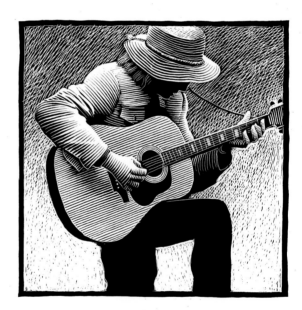

THIS PAGE: CHAPTER HEAD ILLUSTRATIONS FOR *A MUSIC LOVER'S DIARY*, PUBLISHED BY FIREFLY BOOKS IN 1996.

OPPOSITE: COVER FOR *A BOOK LOVER'S DIARY*, PUBLISHED BY FIREFLY BOOKS IN 1996.

A BOOK LOVER'S DIARY

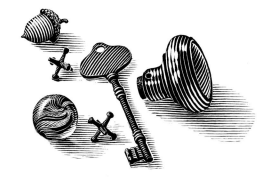

BOOK COVERS

One never knows quite how these things come about, but in 2003 I received a phone call from Karen Nelson, art director at Sterling Publishing in New York, asking if I might be interested in working on a series of children's classics they were about to publish. Six years later, we are up to 28 titles. It has been a very happy collaboration.

On the list that first year was Mark Twain's *Tom Sawyer*, published in 1876. Every chapter in the book takes us off on some new exploit with Tom and his cohorts along the Mississippi River.

The idea of vaulting a fence had a nice energy — it seems just what Tom would do (most well-brought-up boys would walk around to the gate). I liked the idea of making reference to the most famous scene in the book (whitewashing the fence) without actually showing it. More importantly for a cover, it invites young readers to follow Tom off on his next adventure. My model was an 11-year-old in our Stratford neighbourhood with a sly grin and exactly the right spirit for the character.

The interior drawings were to be black and white "spot illustrations." I illustrated the contents of Tom's pockets throughout the book, all specified in Twain's text, in a series of little still lifes — a tin soldier, a dog collar, a brass doorknob, an apple, marbles, three fish hooks, six firecrackers. I left out the dead rat and the kitten with only one eye. But I had to include the "pinch bug" — a black beetle with "formidable jaws," kept in a percussion cap box, with which Tom gleefully interrupts a Sunday morning sermon in church.

THE ADVENTURES OF
TOM SAWYER

MARK TWAIN

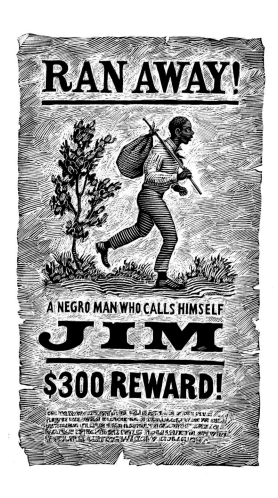

BOOK COVERS

Sterling Publishing initially assigned 10 books in 2003, including *Tom Sawyer, Treasure Island, Little Women, The Call of the Wild, Anne of Green Gables* and *Black Beauty*. I was given almost a year and a half to complete them, but it was still a hugely ambitious task. Looking back, there are a few drawings here that I wish I had spent more time with, before calling them finished. The series continued with four more books assigned each year — a more manageable workload.

Mark Twain's *Adventures of Huckleberry Finn* is widely acknowledged as the great American novel of the 19th-century. Throughout the story, Huck is in moral conflict with the received values of society in the post-Civil War South. Twain said, "a sound heart is a surer guide than an ill-trained conscience." Huck makes his choices based on his own valuation of Jim's friendship and human worth — usually in direct opposition to the things he has been taught.

The cover had to be a "journey" idea reflecting the huge scale of the novel. The central image of the raft was almost obligatory — the white boy and the black man drifting down the river together — but they had to feel dwarfed by the vast landscape. I tried an aerial view, but the raft was too small to see any detail. From art history classes at University, I remembered George Caleb Bingham (1811-1879), who painted scenes of everyday life along America's western frontier (which in those days was Missouri). I have an old book on Bingham, which became my principal reference for the river scene on the cover.

With only four books to do each year (instead of 10), I started to expand the interior spot illustrations. Here, I depicted a series of 19th-century advertising handbills, all relating to scenes in the story. Runaway slave posters were common in the period. I imagined there would be some kind of public notice after Huck fakes his own death in order to escape from his drunken father. Twain provides the exact wording of handbills printed up by the "Duke" and the "King" to publicize their con-artist schemes.

126

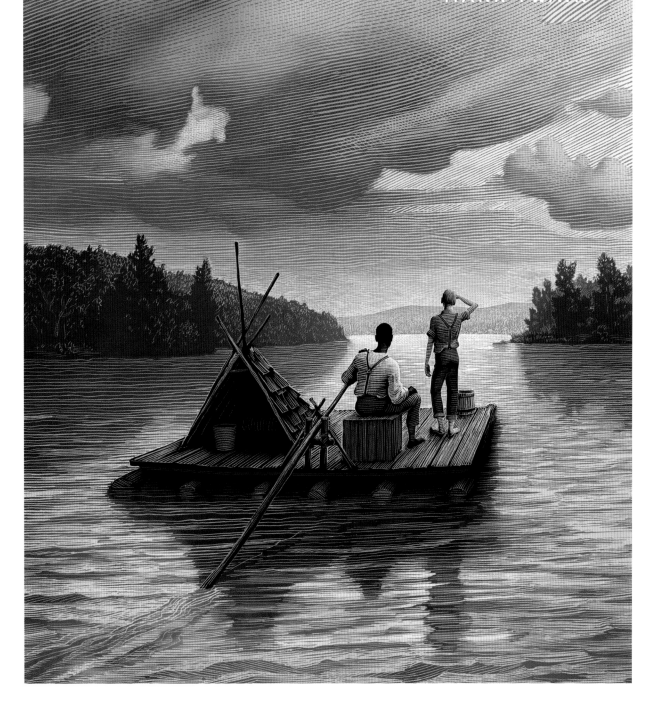

ADVENTURES OF

HUCKLEBERRY FINN

MARK TWAIN

BOOK COVERS

A visit to Deyrolle, the extraordinary 19th-century taxidermy shop on Rue du Bac in Paris, inspired my version of Alice's fall down the rabbit hole. The atmosphere of a dusty old museum of natural history recalled Lewis Carroll's description of Alice falling past cupboards and bookshelves. Instead of empty jars of orange marmalade, the shelves at Deyrolle were crowded with a surreal menagerie of stuffed birds, butterflies, fossils, and skeletons. I explored each room, coming face to face with lions, polar bears, pelicans, flamingos, zebras, a moose and a giraffe peeking around the upper corner of a 10-foot doorway. I swear I saw a white rabbit disappearing down the corridor.

I sent a rough concept sketch to Karen Nelson, the Art Director at Sterling Publishing in New York, afraid that they would find my approach too dark for the Children's Classics section at Borders or Barnes & Noble. I was delighted to be mistaken on this one — they gave me a green light to proceed.

I needed detailed costume reference for this complex pose. Christina designed Alice's dress and we hired a cutter from the Stratford Festival wardrobe shop to build it for our 11-year-old model.

Perched on top of a tall A-frame ladder in a darkened rehearsal hall, I shot reference photos looking straight down at the model laying on her back on an exercise mat. I had positioned floodlights at floor level at one end of the room — if you can visualize this horizontal composition as a vertical, you can imagine the illusion of a light source overhead as Alice falls through space.

A PEN-AND-INK SKETCH FROM DEYROLLE; CHRISTINA PODDUBIUK'S COSTUME SKETCH FOR ALICE'S DRESS.

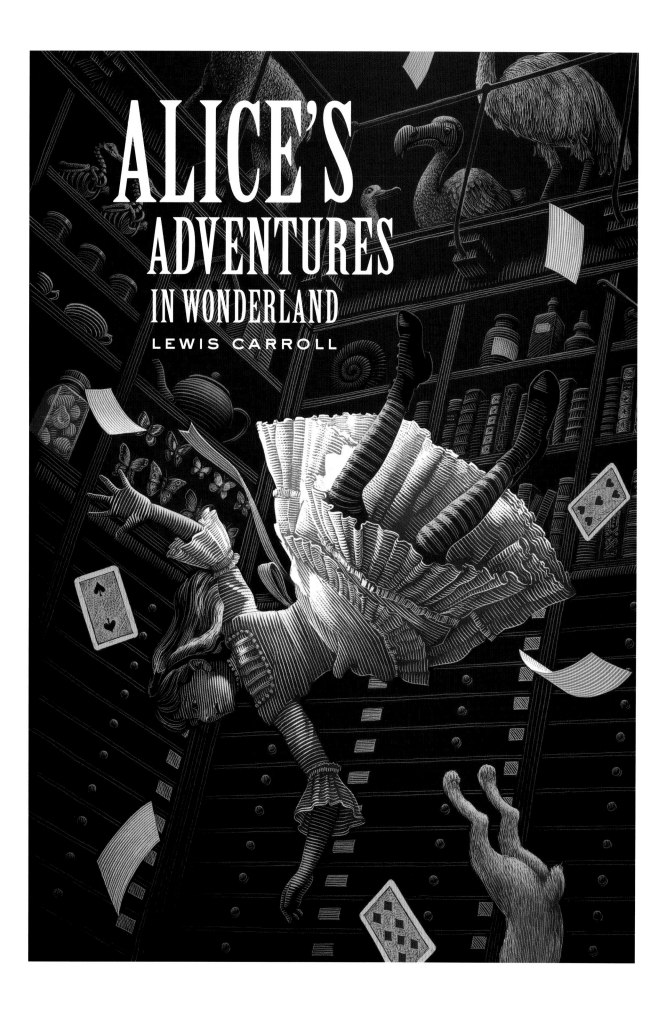

ALICE'S
ADVENTURES
IN WONDERLAND
LEWIS CARROLL

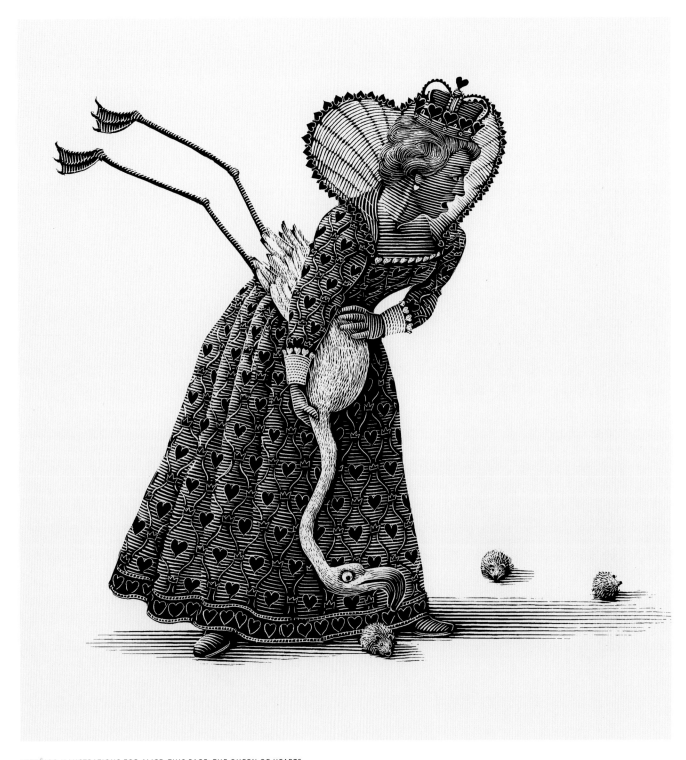

INTERIOR ILLUSTRATIONS FOR *ALICE*. THIS PAGE: THE QUEEN OF HEARTS
PLAYING CROQUET WITH BABY HEDGEHOGS AND A FLAMINGO. OPPOSITE:
THE CHESHIRE CAT, THE WHITE RABBIT, AND BILL THE LIZARD.

PENCIL STUDY OF DOROTHY FOR THE COVER

BOOK COVERS

Most of the books in this Sterling classics series have been adapted into films. Illustrators can usually ignore this fact and focus on the original text — but it's not so easy with *The Wizard of Oz*, one of the most beloved movies of all time. We automatically visualize Judy Garland as Dorothy, Ray Bolger as the Scarecrow, Jack Haley as the Tin Man and Bert Lahr as Cowardly Lion. I tried very hard to put the film version out of my head — especially when visualizing these characters.

L. Frank Baum published his famous tale in 1900. He had failed in a long string of career choices, but he adored children and had a gift for story-telling. His mother-in-law, an influential leader of the women's suffrage movement (and Baum's intellectual mentor) encouraged him to start writing his stories down in order not to forget them — a farsighted suggestion, as it turned out.

Baum's book opens with the cyclone that picks up Dorothy's house from a dusty farm in Kansas and carries her to the Land of Oz. Like Alice's fall down the rabbit-hole, Dorothy's journey begins with a dramatic and surreal "first step." Putting this moment on the cover seemed like a great way to draw readers into the story.

I drew the house upside-down, hoping that readers would rotate the book to see the correct perspective. The gingerbread came from one of the gables on my house in Stratford.

Christina designed Dorothy's dress. We persuaded one of the tailors in the Stratford Festival wardrobe department to construct the dress — but only because Lily, the 10-year-old model, was her daughter. "Normally," she said, "I don't do frills and ruffles!"

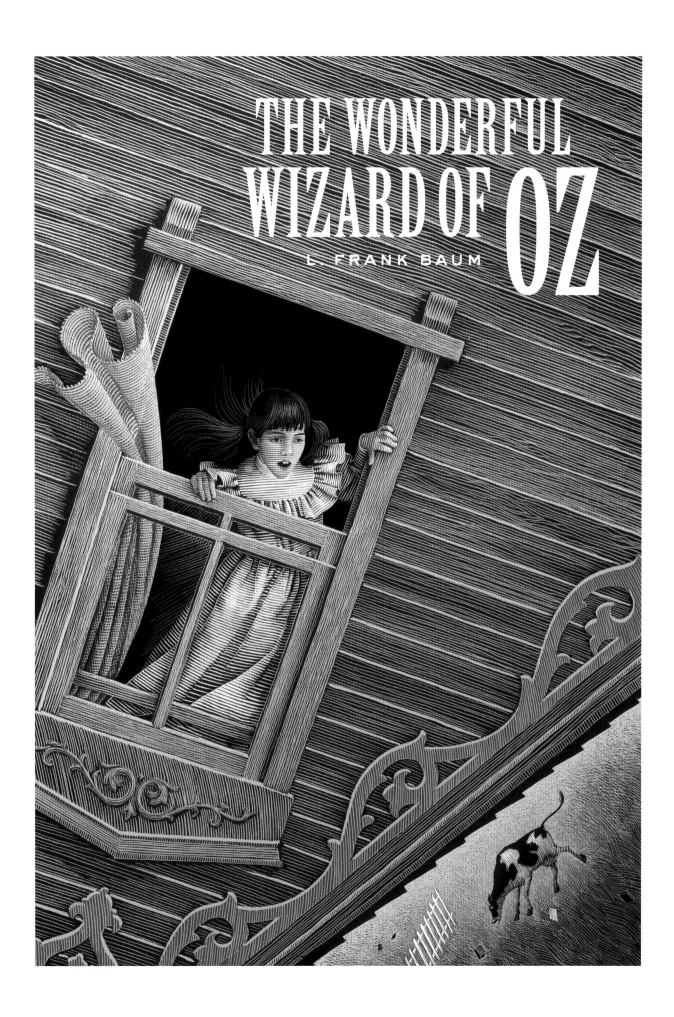

INTERIOR ILLUSTRATIONS FOR *THE WIZARD OF OZ*. THIS PAGE: THE KING OF THE MONKEYS, AND THE WITCH. OPPOSITE: THE SCARECROW, THE TIN WOODSMAN, AND THE COWARDLY LION.

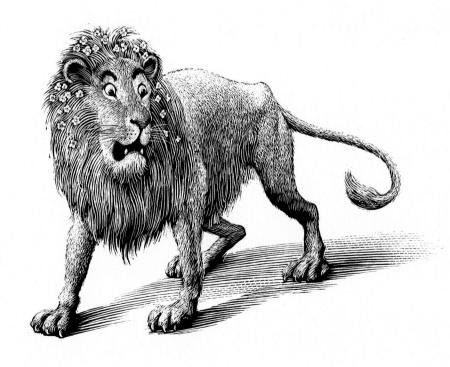

SCOTT MCKOWEN, ROWING FOR POLAROID LIGHTING TESTS BEFORE THE ACTORS ARRIVED; DAVID COOPER'S PHOTO OF JIM MEZON AND CATHERINE MCGREGOR FROM THE SHAW FESTIVAL'S 2003 SEASON HANDBOOK BROCHURE.

BOOK COVERS

"Believe me, my young friend, there is nothing — absolutely nothing — half so much worth doing as simply messing about in boats." Ratty's credo in the opening chapter of *The Wind in the Willows* pretty much set the theme and tone for my cover illustration. I grew up messing about in sailboats on Lake Michigan and Lake Huron — it wasn't exactly the Thames, but I can certainly identify with Ratty's point of view.

I realized that I had great reference material for this illustration at my fingertips. For the Shaw Festival's 2003 season brochure, I had art-directed a series of photo illustrations showing members of the acting ensemble enjoying various recreational pursuits in and around Niagara-on-the-Lake. One shot featured two actors in a rowboat. This theatre specializes in plays by Bernard Shaw and his contemporaries — so the rowboat had to be a vintage wooden boat with real character.

Gill Bibby, a boat builder near Hamilton, Ontario, kindly loaned us a gorgeous 16-foot double-ended skiff. We found an idyllic location on Martindale Pond, famous for the annual Royal Canadian Henley Regatta, in St. Catharines. Photographer David Cooper perched on a small bridge to get the high angle shot looking down into the boat.

My only concern, two years later when I adapted David's photo for this illustration, was how these actors might feel about being turned into Ratty and Mole. (They were very gracious about it.)

A nice coda was that *Communication Arts*, the prestigious graphic design magazine in Menlo Park, California, not only included my cover in its 2006 Illustration Annual — they used it on the Call for Entries and promotional materials for the 2007 edition as well.

THE WIND IN THE WILLOWS

KENNETH GRAHAME

The handsomely produced Sterling Classics volumes sell for ten dollars each — an amazing bargain — but this does impose limitations on the illustration budget. The main emphasis is on the cover, but several black and white interior spot illustrations are also part of the assignment.

For *The Wind in the Willows*, the obvious choice was to portray Mole, Ratty, Badger and Toad of Toad Hall. But how to approach them in a fresh way? It's impossible to think of these characters without picturing Ernest H. Shepard's famous illustrations, first published in 1931, which he developed in consultation with Kenneth Graham. And I adore the Arthur Rackham illustrations of these characters, published in 1940.

I remembered a book in Christina's costume reference library — *Jocks and Nerds: Men's Style in the Twentieth Century* by Richard Martin and Harold Koda. The authors approached men's fashion thematically, through archetypes such as The Rebel, The Cowboy, The Military Man, Joe College and The Businessman. I borrowed this whimsical system of organization to give Mole, Ratty, Badger and Toad their own distinct character through what they were wearing. Mole is the perfect Nerd; Ratty falls somewhere between The Worker and The Sportsman; Badger is The Man About Town; Toad is surely The Dandy.

TOP: ONE OF E.H. SHEPHARD'S ORIGINAL ILLUSTRATIONS FOR
THE WIND IN THE WILLOWS, 1931.

BOOK COVERS

I wonder why the main characters in so many classic children's books are orphans — there's Oliver Twist, Dorothy in *The Wizard of Oz*, Mary Lennox in *The Secret Garden*, Sara Crewe in *A Little Princess*, Tom Sawyer, and Anne Shirley out there on Prince Edward Island. Orphaned children must fend for themselves in the world; they are more vulnerable, so the obstacles and dangers facing them seem greater than ours. When they succeed against all odds, it seems more significant, even noble. But these stories were written for children — as soon as parental protection (and rules) is removed from the equation, a juvenile imagination would naturally soar.

In 1880, Johanna Spyri added a little Swiss girl named Heidi to this peculiar list. She is an extraordinarily active, energetic child. Spyri tells us that she often "jumped for joy," or "ran backwards and forwards with delight." The wind roaring through the fir trees "filled her heart so full of gladness that she skipped and danced around the old trees as if she were experiencing the greatest pleasure of her life." I don't think a cartwheel is specifically mentioned, but it felt like something she might do in the company of her beloved goats in a sunny Alpine meadow.

The interior illustrations are based on *scherrenschnitte* — traditional Swiss/German folk-art pictures created with a sharp pair of scissors. This stylized approach was appealing for several reasons. It provided a refreshing alternative to the process of setting up scenes from the story with child models in costume. It felt more authentic because the style actually comes from Swiss villages in the 19th century. Since each drawing had a full page to itself, this book was distinctive within the Sterling series.

INTERIOR ILLUSTRATIONS FOR *HEIDI*: A MOUNTAIN SCENE WITH HEIDI, HER GRANDFATHER, AND PETER THE GOATHERD; AND DORFLI VILLAGE. OPPOSITE: PETER, HEIDI AND KLARA; AND A CHAPTER HEAD.

HEIDI

COVER FOR *A LITTLE PRINCESS*.

BOOK COVERS

Frances Hodgson Burnett's 1909 classic *The Secret Garden* tells the story of a dormant, overgrown garden in a remote corner of Yorkshire, nurtured back into vitality by three children — Mary Lennox, her cousin Colin, and their friend Dickon Sowerby who "has a way with plants and wild animals." Mary and Colin are sickly, spoiled, disagreeable children — but as the garden begins to blossom and thrive, they do too.

I liked the idea of depicting on the cover a moment of discovery for both the character and the reader. Mary has found the key to the hidden door; this is her first glimpse inside. Opening a door into a special place invites the reader to follow (perhaps by purchasing the book!).

Burnett wrote *A Little Princess* in 1905. Seven-year-old Sara Crewe, raised in India by her affluent, adoring father, is sent to Miss Minchin's boarding School in London. Impressed by Captain Crewe's fortune, Miss Minchin allows Sara preferential treatment, and luxuries such as a personal maid, a pony, private rooms and extravagant clothes — the sort of thing any little girl would adore. Sad news arrives from India that Captain Crewe has died and a business partner has absconded with his fortune. Sara is now a penniless orphan — and her fortunes at the school are dramatically reversed. Kept on as a servant, she lives in a dingy room in the attic, deprived of adequate food and clothing. The wheel of fortune turns again when Captain Crewe's mysterious business partner appears and restores Sara's fortune, and all ends happily.

Sara has a doll, her special friend and confidante, given to her by her father in the opening chapter of the story. I wanted to show both extremes of Sara's life at the school by making the doll into a double of Sara — dressed in a lacy white dress, while Sara herself is dressed in rags.

THE SECRET GARDEN

FRANCES HODGSON BURNETT

BOOK COVERS

Everyone has his or her own idea of what the world's greatest detective looks like. Arthur Conan Doyle described him very much as he appeared in *The Strand* magazine, illustrated by Sidney Paget. William Gillette played him on stage until 1932, when he was 79 years old. You can take your pick from many film and television incarnations — John Barrymore, Basil Rathbone, Peter Cushing, Christopher Plummer or Jeremy Brett.

My instinct was to avoid portraiture altogether because, inevitably, some readers would disagree with my choices — and elect *not* to buy the book because of its cover.

For many years now, Christina and I have made an annual picture research trip to England, hunting for historical images to illustrate the coming season's Shaw Festival Theatre Programme. We always spend a day at the Mary Evans Picture Library in Blackheath Village, and one year I came across a series of Edwardian lantern slides of twilight scenes along the Thames Embankment. They were haunting — figures silhouetted in the fog, the familiar lanterns reflected on the wet paving stones. I recalled these images when this assignment came along, and adapted one of them in scratchboard for this cover.

The Sterling edition contains 23 Holmes stories — but I was only contracted to do five interior illustrations. I combined animals with connotations of "mystery" with traditional Holmes props — a snake slithering over Holmes' violin, a black cat among the glassware of his chemistry lab, an owl on a pile of books, a rat stepping over a revolver and a raven with a pocket watch in its bill.

SHERLOCK HOLMES

ARTHUR CONAN DOYLE

BOOK COVERS

Sometime in 2006, a friend asked what I was working on. When I mentioned this assignment, the immediate and genuine response was "Oh, I love The Jungle Book!" Then my friend slipped into a creditable Louis Prima imitation singing "I Wanna Be Like You" — and I realized that it's the animated Disney *film* that most people connect with this title. I remember it fondly, too, but it has nothing to do with Rudyard Kipling. King Louie, Disney's swinging orangutan, does not exist in Kipling's original — although in 1967 (like most kids in the audience) I neither knew this, nor cared.

Kipling wrote *The Jungle Book* in 1894 — a series of seven fables, each paired with a song relating to the action or characters: "Hunting Song of the Seeonee Pack," "Road Song of the Bandar-Log," and "Parade Song of the Camp Animals." John Lockwood Kipling, Rudyard's father, illustrated the first edition. *The Second Jungle Book* followed in 1895; the Sterling edition combines both books — 15 stories in total.

Kipling's stories use the animal kingdom of the Indian jungle to teach moral lessons. The Law of the Jungle is a set of rules for the survival of individual, family and community. "Nature, red in tooth and claw" is the deadly serious tone throughout — the animals greet each other not with "good morning," but with "good hunting."

Eight of the chapters tell the story of Mowgli (although not in chronological order) from infant "man cub" to manhood. In the final chapter, "The Spring Running," Mowgli, now 17, leaves the jungle forever, deeply torn between the family of animals he knows and loves, and feelings for the outside world, which he doesn't fully understand. I was tempted to put Mowgli on the cover — but that would exclude half of the stories in the book in which he doesn't appear. Nature itself is the common denominator. I decided on Hathi, the wise old elephant who appears in several of the stories, representing order, dignity and obedience to the Law of the Jungle.

RIKI TIKI TAVI

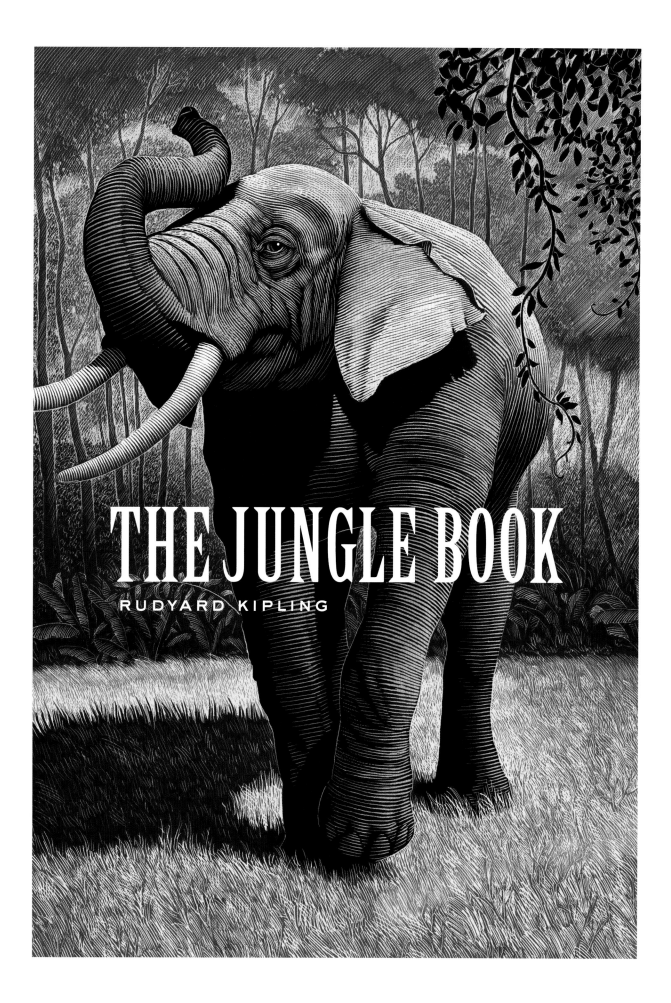

THE JUNGLE BOOK

RUDYARD KIPLING

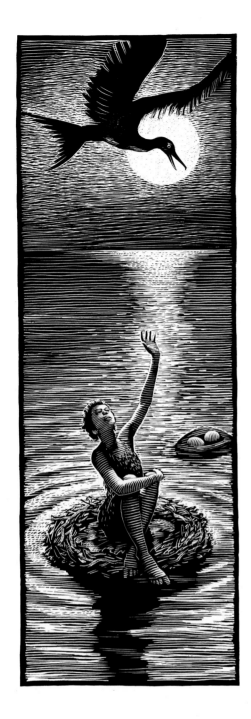

BOOK COVERS

Peter Pan was invented by J.M. Barrie in 1896, to entertain some children he had met while walking his dog in Kensington Gardens. His stories of fairies, children who could fly, birds who could talk and pirates shipwrecked on the island in the Serpentine, the lake in the centre of the park, were published in 1902 as *The Little White Bird, or Adventures in Kensington Gardens*. These fantasy stories evolved into the play *Peter Pan* in 1904. Barrie wrote the novel *Peter and Wendy* in 1911 to follow up on the sensational success of the stage version.

I had created posters for several theatre productions of *Peter Pan*, traditional and otherwise (for example for the Great Lakes Theater Festival in 2000) — but here at last was the novel itself. The cover idea somehow had to be about the joy of flying. It's so much easier to defy gravity in a drawing than with real actors on stage!

The famous scene in the nursery in which Peter teaches Wendy, John and Michael how to fly is heart-stopping to read — Barrie calls the chapter "Come away, come away!" I shied away from it only because the children in their nightgowns are almost too familiar. Instead, I went back to Kensington Gardens and the day Peter Pan was born. Barrie, the magnetic storyteller, is Peter, cavorting in mid-air. The earthbound Darling children stand in for all of us who long to fly away to the Neverland. Wendy's tiptoe gesture expresses her yearning to join Peter.

Michael, John and Wendy wear everyday clothes, which convey the Edwardian setting. The golden atmosphere is disturbed, however, by cumulonimbus clouds building up in the distance, hinting at the darker side of the adventures to come.

The interior illustrations are all eccentric shapes. I showed four scenes from the story in tall, vertical rectangles; the fifth, the crocodile, is a long horizontal, based on a sketch I made in the reptile house at the Jardin des Plantes in Paris.

BOOK COVERS

Like everyone, I love *A Christmas Carol* for its humanism, its social conscience, and the hope it inspires of redressing the mistakes of your life. I marvel that these themes are still as potent today as they were in 1843 when Dickens first published it (at his own expense — his publisher didn't think it would sell).

When I first encountered the book as a child, however, it was simply as a terrific ghost story. Dickens' descriptions of the spirits are vividly cinematic — one thinks immediately of the many film versions of the story, but Dickens was writing fifty years before the earliest movie camera existed. My favourite comes when Marley's ghost walks through the bedroom door: "His body was transparent, so that Scrooge, observing him, and looking through his waistcoat, could see the two buttons on his coat behind."

Scrooge relives his entire life in one night, including a frightening vision of his own death, miser-able and alone, if he does not mend his evil ways. I wanted the cover to be as spooky as possible.

Scrooge is haunted in bed — the one place that he should feel most secure and safe. The bed (and the bed curtains) are mentioned dozens of times in the text — the final terrifying vision in the graveyard ends as the Phantom's hood "shrank, collapsed, and dwindled down into a bedpost."

I expanded on my earlier theatre poster idea of showing Scrooge's reaction to seeing a ghost — rather than the ghost itself — only this time we see the entire bed. The walls of the room have dissolved away to reveal a moonlit sky, suggesting the breadth of Scrooge's supernatural journeys through time and space.

I used Cecil Beaton's 1927 photo of Edith Sitwell in her great four-poster as my reference for the bed, and the British painter Atkinson Grimshaw (1836-1893) for the cloudy, glowing sky.

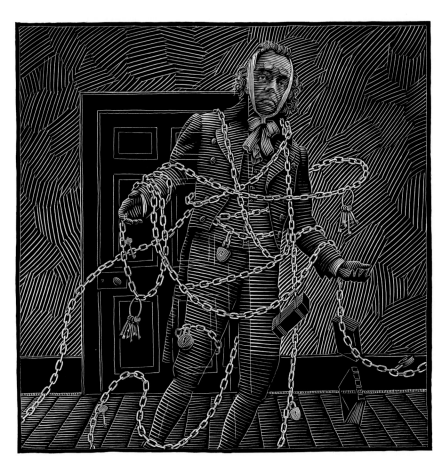

MARLEY'S GHOST

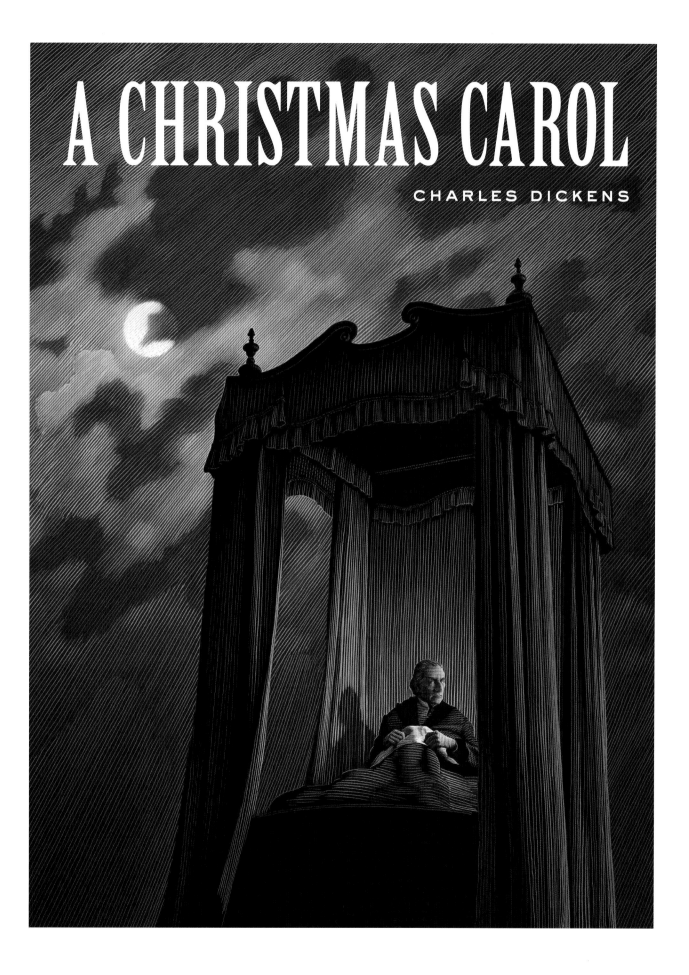

A CHRISTMAS CAROL

CHARLES DICKENS

BOOK COVERS

Charles Dickens puts his young orphan hero through an awful lot in this sprawling saga. Young Oliver is starved ("Please sir, I want some more"), threatened, beaten, wrongfully arrested, rescued, then abducted and then forced to take part in a robbery attempt in which he receives a life-threatening gunshot wound. He is at the centre of a sort of melodramatic tug-of-war between forces of good and evil in Victorian London.

He receives food, shelter, comfort and companionship from the Artful Dodger, Fagin and his gang of petty criminals — with no idea of the trouble and danger that this path leads to. He is rescued, nursed back to health, protected and shown kindness and love for the first time in his young life by his benefactor Mr. Brownlow and by the Maylie Family.

I imagined Oliver reaching up to take an unidentified outstretched hand. That hand might belong to Fagin or Mr. Bumble or the brutal Bill Sikes — or it might be Mr. Brownlow or Doctor Losberne. I like the ambiguity of the moment. Oliver doesn't know whether taking this hand will lead to good or bad — and neither do we.

I knew I wanted a crowd of figures in the background. The extended helping hand makes more sense if Oliver seems lost on a crowded street. A crowd scene also makes reference to Dickens' huge cast of characters, and it helps establish the period setting through the clothes. The novel dates from 1838 — for costume reference I used a series of superbly detailed ink drawings of crowd scenes by the French caricaturist J.J. Grandville (1803-1847).

I wanted my background figures to disappear into the gloom, but fog is very soft and scratchboard lines are just the opposite. I tried to achieve an atmospheric effect by lightening and graying out the black lines as the figures recede into the distance.

DETAIL FROM *PAUSE ENTRE DEUX DANSES*, 1829-30, BY J.J. GRANDVILLE; SCOTT'S PENCIL STUDY FOR THE COVER.

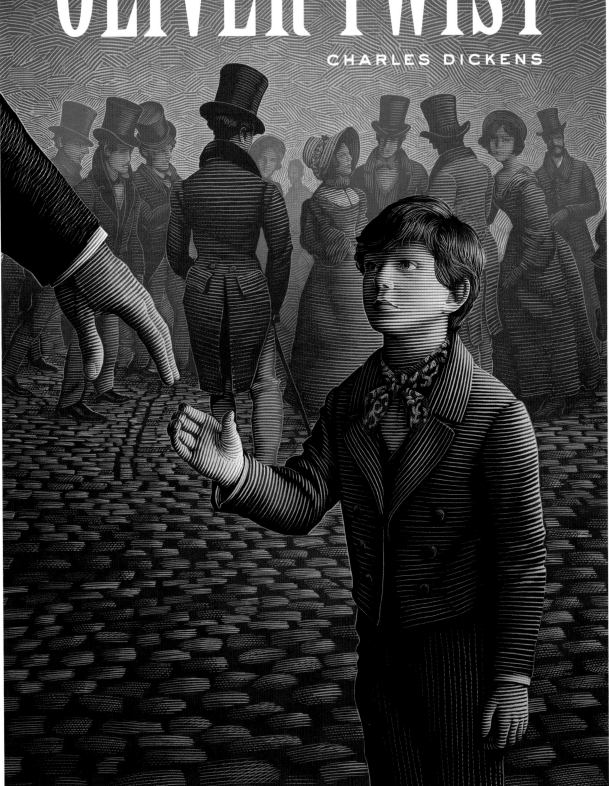

INTERIOR ILLUSTRATIONS FROM *OLIVER TWIST*. THIS
PAGE: BILL SIKES. OPPOSITE: NANCY, AND FAGIN.

BOOK COVERS

The 19-year-old Mary Shelley and her husband Percy spent the rainy, cold summer of 1816 on Lake Geneva with their pal, Lord Byron. They amused themselves by reading German ghost stories, then challenged each other to write their own tales of the supernatural. Mary's entry in this cozy gothic contest was *Frankenstein*.

Her subtitle, *The Modern Prometheus*, refers to the Greek myth of the ambitious and rebellious Titan who plays with fire and gets burned when Zeus catches up with him. Written in the early years of the Industrial Revolution, Shelley's story is a cautionary tale of modern man's "overreaching" his place in nature.

Victor Frankenstein is the gifted young scientist who discovers the secret of galvanism — returning a corpse (in this case, an assemblage of body parts) to life. From the moment Victor successfully imbues his Creature with life, he realizes that he has gone too far. I wanted the cover to suggest Victor's horror at what he has done.

I also wanted to hint at the troubled relationship between Victor and his creation — so the Creature had to be present as well. They spend much of the book playing cat-and-mouse — the Creature seems to be lurking around every corner as Victor travels across Europe — hence the idea of "shadowing" or stalking. I wanted to avoid giving away on the cover what "the monster" actually looks like, so we see Victor from the Creature's point of view.

PENCIL SKETCH FOR THE COVER; *THE WANDERER ABOVE THE SEA OF FOG*, 1818, BY CASPAR DAVID FRIEDRICH.

I played with overlapping the two shadows on the ground to suggest a deformed figure — in one early sketch Victor's arm and the shadow arm on the ground are intentionally mismatched.

The novel begins and ends on a ship frozen in Arctic ice fields, and the big confrontation scene takes place in a dramatic Alpine landscape. When I think of mysterious, atmospheric, Romantic vistas, Caspar David Friedrich comes immediately to mind — he was my principal reference for the landscape, including the bare trees and crows.

FRANKENSTEIN

MARY SHELLEY

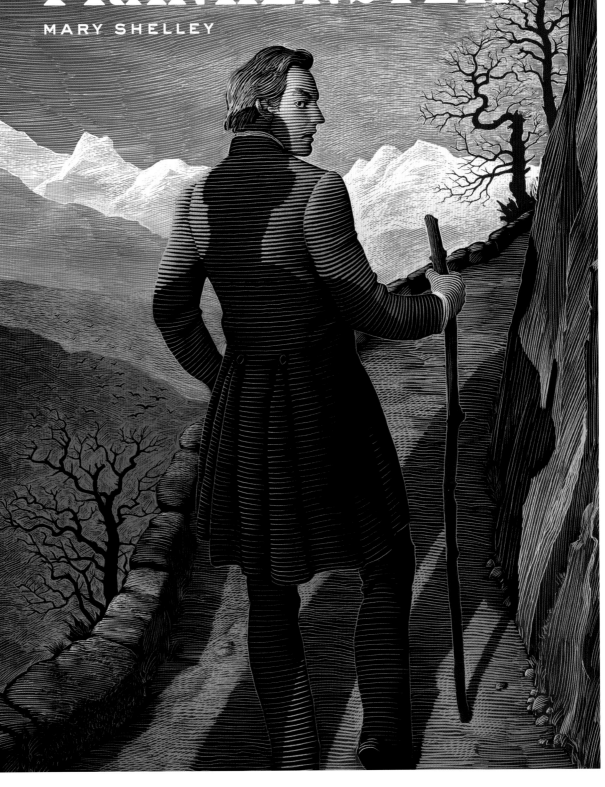

BOOK COVERS

When the assignment came in for *Around the World in Eighty Days*, my first thought for a great cover was that famous scene in which Phileas Fogg crosses Europe in a hot-air balloon.

When I read the Jules Verne novel, however, I was taken aback to discover that scene does not exist! Fogg travels from London to Paris and across Europe by rail in a single, uneventful paragraph. The hot-air balloon was an invention of the popular 1956 film starring David Niven, the young Shirley MacLaine, and a host of celebrities in cameo roles. Back to the drawing board.

A trip around the world in 80 days would have seemed an impossibility in 1872, but Phileas Fogg accepts this challenge on a £20,000 wager (equivalent to £2,500,000 in today's currency). His race against the clock is crowded with obstacles. The rail line across India turns out to be unfinished, so Fogg purchases an elephant and sets off through the jungle. A sledge rigged with a sail saves the day when a train connection is missed in snowy Nebraska. The steamer crossing the Atlantic

runs out of coal, so the masts, decks and cabins are dismantled and burned to keep pressure in the boilers. But none of these episodes is longer than a couple of pages — so putting any one scene on the cover seemed to miss the arc of the whole story.

I took this cover in a more playful direction than others in the Sterling series — Fogg is literally dashing around the world, pocket watch in hand, on a gigantic Victorian library globe. (I picture a globe like this one in the corner of the reading room at the Reform Club, where the wager begins and ends.) Fogg is circling the globe from west to east — a little clue to the ingenious happy ending that Jules Verne springs on the reader (and Fogg himself) in the final chapter of the story.

PENCIL STUDY OF
ACTOR LORNE KENNEDY
AS PHILEAS FOGG.

AROUND THE WORLD
IN EIGHTY DAYS

JULES VERNE

INTERIOR ILLUSTRATIONS FROM *AROUND THE WORLD IN EIGHTY DAYS*.
THIS PAGE: THE SLEDGE CROSSING THE PRAIRIE. OPPOSITE: BY ELEPHANT
THROUGH THE INDIAN JUNGLE; AN OBSTACLE TO THE PACIFIC RAILROAD.

COVER FOR *20,000 LEAGUES UNDER THE SEA.*

BOOK COVERS

The Sterling Classics series includes Jules Verne's famous subterranean and submarine adventure stories.

Voyage au centre de la Terre was published in 1864, inspired by a scientific publication the previous year entitled *Geological Evidences of the Antiquity of Man.* Verne's story concerns a professor and his nephew who decipher an ancient, coded, message written by a legendary Icelandic alchemist who claims to have discovered a passage to the centre of the earth. Following these instructions, they descend into the crater of an extinct volcano in Iceland, with a resourceful local hunter as their guide. They encounter strange and wonderful phenomena, become separated and reunited, run out of water, but tap into an underground river. They discover a vast underground sea, build a raft and set sail, and observe prehistoric plants and animals (sometimes too close for comfort) — before finally being shot out of a live volcano in southern Italy.

I wanted my cover to convey the dramatic scale of the underground landscape, and a sense of adventure and danger. The three explorers use Rhumkorff induction coils as their underground light source — an early form of portable electric lamp invented only a few years before the story was written. Verne tells us that the lights are extremely bright — so I imagined three silhouetted figures at the top of the page, descending into darkness.

This underground light source reminded me of the descriptions of the brilliant searchlight of Captain Nemo's famous, fantastic submarine *Nautilus,* in *20,000 Leagues Under the Sea,* which was assigned a year before *Journey.* Here again the protagonists are a trio of Europeans. The narrator of the story is Professor Arronax, a famous marine biologist; his faithful assistant Conseil and a hot-tempered Canadian master harpooner accompany him on the adventure.

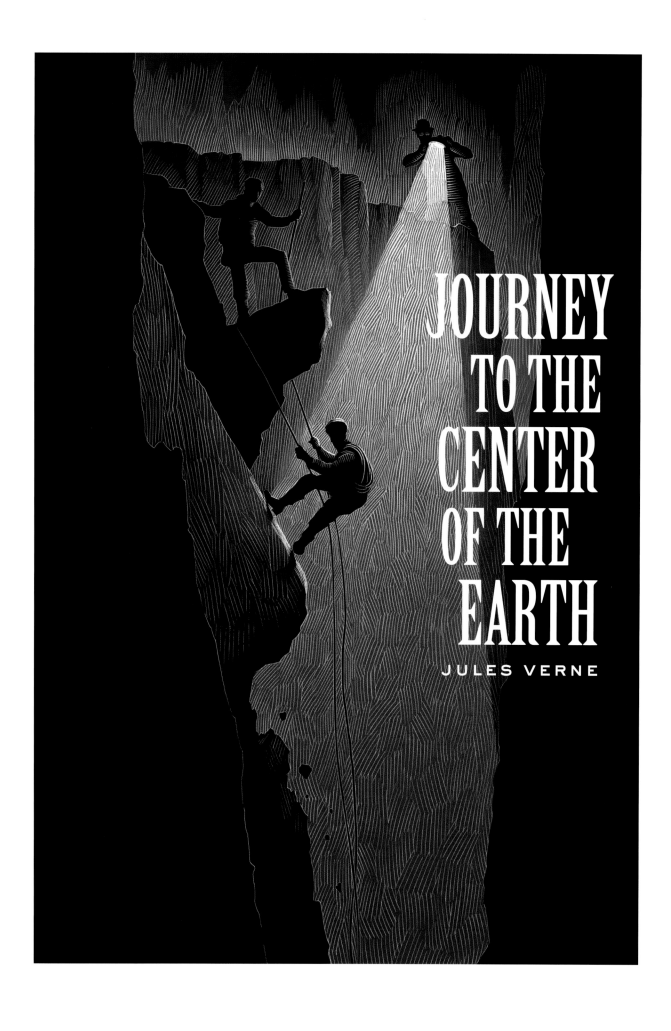

JOURNEY TO THE CENTER OF THE EARTH

JULES VERNE

BOOK COVERS

Gulliver's Travels follows Jonathan Swift's title character through four fantastic "voyages" to parts of the earth that were highly exotic in the 18th-century imagination. The title page of the 1726 first edition reads: *Travels into Several Remote Nations of the World, In Four Parts, By Lemuel Gulliver, First a Surgeon, and then a Captain of Several Ships.*

Everyone knows the first voyage — to Lilliput, where the inhabitants measure no higher than Gulliver's ankles. The illustration possibilities with this contrast of scale are endless. And irresistible — almost all the cover illustrations for the various editions throughout the book's history focus on a scene from Lilliput.

Looking for a road less travelled, I decided that I didn't want a Lilliput scene for my cover. But which of the other voyages to use? In Brobding-nag the scale device is reversed — Gulliver is six inches tall in a world of giants. The flying island of Laputa is inhabited by magicians devoted to mathematics and music, but utterly unable to apply their learning to any practical use. In the country of the Houyhnhnms, Gulliver encounters a utopian civilization of horses (they have no word in their language for lying) — and a race of humans in their basest form, called "Yahoos," who are kept as servants and livestock.

My little moment of epiphany came when I gave up trying to choose between them. I realized that I could combine elements from all four voyages on the cover. The idea for this came from the text: Swift gives us an introduction in the form of letters from Captain Gulliver. The premise is that they were written by the elderly Gulliver years after the four voyages — like the structure of Coleridge's *The Rime of the Ancient Mariner*.

I went for the fantastical — a towering figure too large to fit on the page. Gulliver is a complex work that gets darker and bleaker as it progresses. Young readers will certainly enjoy their visit to Lilliput; the satire of the third and fourth voyages will be waiting for them when they're a little older.

INTERIOR ILLUSTRATION FOR LILLIPUT.

GULLIVER'S TRAVELS

JONATHAN SWIFT

BOOK COVERS

If anyone could be considered the Father of American Illustration, it would be Howard Pyle (1853-1911). In a letter to his brother Theo, Vincent van Gogh mentioned that Pyle's work "struck me dumb with admiration" (quoted by David Michaelis in *N.C. Wyeth: A Biography*). An Anglophile, Pyle wrote and illustrated four volumes of Arthurian stories, plus *The Merry Adventures of Robin Hood*, and a story of knighthood under Henry VI called *Men of Iron*. Pyle's text has a certain charming staginess — "Know, thou unkind knight, that I have come hither for no other purpose than to do battle with thee" — but feels concordant with his brilliant, stylish drawings. To me, the Victorian text and pictures are inseparable; being asked to "reillustrate" Pyle seemed a dubious task.

That being said, the opportunity to work on this material was a thrill — I have loved these stories since I was a kid. *The Story of King Arthur and his Knights* is a lengthy book (Sterling shortened the title for this edition, but not the text). I was limited to just five interior illustrations, and placed drawings of the main characters where they best illustrated the text. Pyle includes a memorable scene in which Arthur receives his legendary sword, *Excalibur*, from the mystical Lady of the Lake. This seemed ideal for the cover.

Throughout the book, Pyle details the heraldry on the shields of the knights from the many fiefdoms and minor kingdoms, which are unified for the first time under Arthur's reign. Pyle tells us that *Excalibur* is beautifully and elaborately decorated with gold and precious stones. I imagined the mythical sword blazoned with "the arms of the realm."

To draw convincing water reflections, I needed very specific reference. I called my friend David Cooper in Vancouver and he photographed his daughter in a swimming pool, her arm raised out of the water holding a broom handle!

It was a very enjoyable project — I only hope I did not cause old Mr. Pyle to turn over in his grave.

BOOK COVERS

Alice Borchardt's fantasy novels *The Dragon Queen*, and its follow-up, *The Raven Warrior*, are subtitled "The Tales of Guinevere." We're a long way from *Camelot*, however — Borchardt's Guinevere is a young warrior princess, and her Lancelot is a half-man, half-wolf shape-shifter.

Guinevere (or "Guynifar" as her name is spelled here) is the first-person narrator of the story. Her pagan tribe, "the painted people," suggests fabulous possibilities for Celtic body decoration. Borchardt endows her with magic "fairy armour" — her skin appears to be covered with delicate vine-like tattoos, but when she battles monsters or evil soldiers (which happens every few pages), the tattoos morph into a protective steel mesh that repels swords and spears. I thought that a girl covered with dragon tattoos would make a pretty cool cover.

Borchardt makes it clear in the text that Guinevere runs around wearing her magic armour and nothing else. One always tries to be faithful to the author's intentions — but my first pencil sketches looked more like an erotic tattooed lady in a carnival sideshow. Dave Stevenson, the art director at Random House, requested that we give her a little tunic to keep this book on the shelves available to readers of all ages. To convey the Ancient Britain setting, I devised a Celtic knot motif of two intertwined dragons on a separate panel running up the left side of the cover, adjacent to the spine.

Guinevere's first-person narrative continues in *The Raven Warrior*. Scenes alternate between the young Queen's efforts to prove herself to her warlords and gain their acceptance, and the exploits of her childhood companion Black Leg, who becomes romantically involved with the Lady of the Lake. He can turn himself into a wolf — but calls himself the Raven Warrior. Eventually he turns himself into Lancelot.

This was to be a trilogy, and presumably all these plot lines would have woven back together in a third volume. Sadly, Borchardt passed away in 2007 before completing *The Winter King*.

COVER ILLUSTRATION FOR *THE RAVEN WARRIOR*; PRELIMINARY SKETCH FOR *THE DRAGON QUEEN*.

BOOK COVERS

Ursula Marlow, the heroine of Clare Langley-Hawthorne's recent series of "Edwardian" mystery novels, is an Oxford graduate, an aspiring journalist and devoted suffragette. Somehow I was not surprised that she's a headstrong Belgravian heiress and stunningly beautiful, to boot.

Consequences of Sin is set in 1910, but the plot revolves around relationships and events set in motion two decades before the story opens. Ursula discovers a lost diary full of dark family secrets; there's a lot in the text about dreams and nightmares, which suggested a surreal collage of these fragments from Ursula's past — the cover illustration became a visual puzzle containing clues to the mystery.

The diary contains details about an ill-fated expedition to Venezuela in 1888, and Ursula ends up travelling to South America herself — so the collage includes a steamship. As an experiment,

I drew some of these components separately and overlapped them in Photoshop, allowing the layers to interact with each other in ways I could never achieve in a single drawing.

The second title in the series, *The Serpent and the Scorpion*, is loaded with symbolism, and it was tempting to include these animals in the illustration — but the author presumably meant them to represent human characters in the book. The story begins in Egypt, so I decided to use the Sphinx as my focal point — symbol of mystery and riddles, wisdom, vigilance and strength. The human head and animal body represent the union of intellectual and physical powers — kind of perfect for an Edwardian mystery!

Ursula is dressed this time for the warm climate, with hard shadows suggesting the hot sun. The composition is built around the great pyramid in the distance, exactly centred in the square frame.

GIRL MAKING A GARLAND BY HANS SUESS VON KULMBACH, 1508.

BOOK COVERS

In early 2003 I received an out-of-the-blue phone call from Nick Lowe, a young editor at Marvel Comics, asking if I might be interested in illustrating eight covers for a graphic novel by Neil Gaiman. I had not read a comic book since I was 10 years old, and I had to ask — why on earth would he pick me for a project like this?

Nick said that he had noticed my Roundabout Theatre posters in New York, and thought that my engraving lines would evoke the historical setting of this story. Also, scratchboard is a medium rarely employed in the comic book world, and he wanted this high-profile series to have a distinctive look. I said yes immediately.

Gaiman's saga is set in the year 1602. The characters are 17th-century versions of familiar Marvel superheroes — Spider Man, the Fantastic Four, the X-Men, Daredevil, Captain America. Sir Nicholas Fury and Dr. Strange are courtiers in the service of Queen Elizabeth I (who died in 1603). I looked at a lot of period engravings in preparation for this project — Jacques Callot and Stefano della Bella were especially useful for their flamboyant storm scenes and threatening skies.

Renaissance paintings and graphics sometimes include images of scrolls or banners floating in mid-air, with commentary about the scene, or words a character might be speaking. (Historical precedent for comic book dialogue balloons, perhaps?) I suggested a floating scroll on each cover as a logo device for the series. Because *1602* is a short title I treated the type as a juxtaposition — clean, reverse letterforms placed over the scroll, rather than a trompe l'oeil rendering of the numerals on the scroll.

The scroll became a different element in each cover — sometimes a flag, sometimes a banner. For *Part Three* it's the ribbon attached to a portrait miniature of Elizabeth — in the clutches of the story's principal villain, Otto Von Doom.

DETAIL OF A MAP OF VIRGINIA FROM 1618; PENCIL STUDY
OF ACTOR SCOTT WENTWORTH AS SIR NICHOLAS FURY

BOOK COVERS

Neil Gaiman wanted the cover of the final chapter
to signal that the story shifts from Europe to the
New World. I researched 17th-century maps of
Virginia and decided to incorporate their delight-
fully naive topographic decoration — hills, trees,
animals and sailing ships, all completely out of
realistic proportion — into my illustration.

I was fascinated by the place names: a crazy mix
of Latin, Dutch, French and English, reflecting the
colonial demographics of the time and place. All
the names and spellings on this cover come from
period sources — including the names of the
Native American Indian nations used to describe
regions and territories.

The focal points of period maps are elaborate,
decorative compass roses with lines radiating out
to the far corners of the earth. I thought it would
be very cool to use a compass rose to make refer-
ence to the rip in time at the centre of the story
— a glittering point of light that Neil calls "the
singularity." I wanted to transform a compass
rose into a mysterious light source shining on
the three principal characters. A surreal "glow"
created with a feathered brush in Photoshop
enhanced the effect. I usually try to avoid sub-
jecting scratchboard lines to electronic special
effects, but if ever there was a project to
throw caution to the wind, this was it.
I made pencil studies of the figures with
separate light sources; then composited them
to look as if they were standing on the map.

I found models based on who might have the
right look for a certain character. Stratford Festi-
val actor Scott Wentworth seemed ideal for this
Elizabethan incarnation of Nick Fury — but I was
a little nervous about asking a leading actor in
North America's largest classical theatre com-
pany to model for a comic book project. I got my
nerve up and called him — and I couldn't believe
my luck: Scott is a long-time comic fan and collec-
tor, and was thrilled to play one of his all-time
favourite Marvel characters!

BOOK COVERS

For the dust jacket of the hardcover edition, I couldn't resist one more art history reference. England under Elizabeth I lived with laws against Catholicism — but when King James VI of Scotland succeeded Elizabeth as James I of England, many Catholics worried that they would face even more severe persecution. A small group of politically influential Catholics plotted to assassinate the King by blowing up the House of Lords on the opening day of Parliament — November 5, 1605.

The plot was discovered, and the traitors were all captured and executed for treason. The most famous of the "Gunpowder Plot" conspirators was Guy Fawkes — whose name is still attached to the annual tradition of lighting bonfires in England on the fifth of November, in celebration of the monarchy.

An engraving of the conspirators was made in 1605 — the Jacobean equivalent of a front-page newspaper photo of the crime of the century. The engraving is reproduced larger-than-life-size in one of the London Underground "tube" stations near where the events took place. Since the superheroes of *1602* are "outlaws" from King James' point of view, I used this image as the basis for a composition of Neil's characters.

The original is a grouping of eight men, which suited my purposes. In the middle of the group I added Virginia Dare — the young girl at the centre of the whole saga. She was the first child born in the Americas to English parents (in the short-lived colony on Roanoke Island, in 1587). For me, Neil Gaiman's real masterstroke in *1602* was building the entire story around this intriguing historical character.

A year-end review in *Time* magazine proclaimed *1602* "the worst comic of 2003" — yet it won the 2005 Quill Book Award for best Graphic Novel, and was nominated for the 2004 Will Eisner Award for Best Cover Artist.

GUY FAWKES AND THE GUNPOWDER PLOT CONSPIRATORS FROM *VERRATHEREN IN ENGLAND*, 1606.

MAGAZINES

In 1993, Francis Tanabe, art director for *Book World* at *The Washington Post*, asked me to illustrate a review of a new anthology of 19th-century American poetry, edited by John Hollander and published by the Library of America.

Reviewer David Lehman liked the two-volume anthology very much, calling it "comprehensive, wide-ranging, and judiciously fair... all the major poets and minor prophets are represented, in proportions both ample and calculated to reflect degrees of greatness." Walt Whitman gets the most pages (220), but Emily Dickinson has the longest list of titles.

Later in the review, Lehman cites a particularly effective pairing of poems by these two great masters, and he contends: "As the 20th century comes to an end, it seems increasingly clear that Dickinson and Whitman were our grandparents, the father and mother of modern American poetry, a truly odd couple."

This led to the idea of this pair of portraits, and to underscore Lehman's connection between them, I linked the drawings by giving Whitman a volume of Dickinson, and vice versa.

The client was very happy, and the illustrations appeared with the published review — but that was not the end of the story. A little controversy played out over subsequent weeks in letters to the editor. One letter from a reader, published in February 1994, complained that my portraits "create the misconception that Whitman and Dickinson were aware of and influenced by each other's poetry. They were not." And the letter went on to cite proof. Mr. Lehman responded in print: "To call Walt Whitman and Emily Dickinson our poetic grandparents is to employ a metaphor. The point is that modern American poetry seems the product of a fusion of their two distinctive sensibilities and styles. I do not mean to imply that the two poets knew each other in the biblical sense or any other." Mess with America's literary icons and boy, you're going to hear about it!

A CARTOON BY WILLIAM CHARLES (1776-1820), SHOWING JAMES MADISON SPARRING WITH KING GEORGE III, REFERS TO AN AMERICAN NAVAL VICTORY DURING THE WAR OF 1812 — THE DEFEAT AND CAPTURE OF *HMS BOXER BY USS ENTERPRISE*; AN ENGRAVING SHOWING NASSAU HALL IN 1764.

MAGAZINES

Americans seem to love rankings. In January 2008, a special issue of *Princeton Alumni Weekly* ranked the 25 most influential alumni from the University's 261-year history. The editor admitted that the list was completely subjective and the selection criteria suspect — but the point of the exercise was to highlight the accomplishments of Princeton's most illustrious graduates.

The "winner" was James Madison — class of 1771. Fourth president of the United States, Madison was the principal author of the U.S. Constitution, and the "Father of the Bill of Rights." He was Jefferson's Secretary of State from 1801 to 1809, and supervised the Louisiana Purchase, which doubled the size of the country. As president, he led the United States into the War of 1812.

I was asked to supply a scratchboard portrait for the cover of the magazine. For reference, I looked at a number of primary sources — Gilbert Stuart painted several portraits that captured a consistent likeness. These images from the period have standardized, generic "statesman" backgrounds — a bit of drapery, the base of a classical column, the arm of a chair. I wanted to include an architectural landmark so the cover would be specific to Princeton.

Marianne Nelson, art director for the magazine, suggested Nassau Hall. The only issue was that there have been several Nassau Halls over the history of the campus. The building Madison knew is long gone; I had good reference for what it looked like — but I didn't want my illustration to feel overly "archival." A man of vision, Madison must surely have imagined what the University would be like two hundred years in the future — so I tried to connect past and present with the Nassau Hall familiar to more recent alumni, shimmering like a mirage in the distance.

PENCIL SKETCH SHOWING THE MAGPIE WEARING
A MORTARBOARD.

MAGAZINES

Academic misconduct was the focus of a University of Waterloo alumni magazine cover story in 2008. The vast majority of students follow the rules, but an alarming number of cases indicates an upsurge of cheating — working in groups when you're required to work individually, copying someone else's answers on a test, even outright plagiarism.

The magpie has a reputation for stealing anything that it can carry away — especially shiny objects, and even other birds' eggs and young. Christina proposed the idea of an academic thieving magpie with a stash of prizes referring to the various UW Faculties. There are snippets of torn paper "crib sheets" with philosophy notes and mathematical equations. There are a couple of textbooks, a class ring, a silver pen, coins, a computer mouse and a data stick. In its bill, the magpie holds a University of Waterloo crest.

In my pencil sketch I placed a mortarboard on the bird's head. Earned or not, this anchored the concept in the world of post-secondary education. I even imagined that the magpie's distinctive black and white plumage might resemble the hood of an academic robe. My cap-and-gown semiotic didn't fly, however — University of Waterloo grads do not wear mortarboards at their commencement ceremonies, so that wardrobe detail was vetoed.

There was some discussion about the thieving magpie reference winging over the heads of some readers. I maintained that UW alumni would surely "get it" — just to make sure, they added a word of explanation on the title page.

ILLUSTRATION FOR CAFE BALZAC'S ESPRESSO, NAMED
"A DARK AFFAIR" AFTER ONE OF THE AUTHOR'S NOVELS.

IDENTITY

Café Balzac is Stratford's flagship coffee shop,
meeting spot, and favourite haunt of artists,
actors, and writers. With it's original tin ceiling,
zinc bar and bistro atmosphere, Café Balzac is
the antithesis of corporate-run coffee chains.
Fairtrade beans are micro-roasted daily at the
back of the shop — I prefer their espresso to
any of the Italian imports. The Café has expand-
ed its operations with two popular, high pro-
file locations in Toronto, but the success story
started in Stratford.

The Café is named for the prolific French novel-
ist and playwright Honoré de Balzac (1799-1850).
The 95 novels and stories of his magnum opus *La
Comédie humaine* form a sweeping overview of
life in French society in the early 19th-century. He
is renowned for his realistic, complex, and fully
human characters; his work influenced Marcel
Proust, Émile Zola, Charles Dickens, Gustave
Flaubert, Henry James, and many other writers.

Balzac's work habits are legendary. He often
wrote through the night, fueled by innumerable
cups of coffee. The Café staff wear black t-shirts
silkscreened with a Balzac quotation from 1830:
"Coffee is a great power in my life...it chases away
sleep, and it gives us the capacity to engage a
little longer in the exercise of our intellects."

I was commissioned to create an advertising
illustration for the Café, and imagined the great
man hard at work at four o'clock in the morning
— with his incredible focus and dedication —
dipping his pen into his coffee cup.

IDENTITY

Ever since they established their farm just north of Stratford, Antony John and Tina Vandenheuvel have been pioneers of organic farming in southwestern Ontario. They supply superb quality vegetables and salad greens to the top Stratford and Toronto restaurants — and to those of us lucky enough to be on their list for weekly home deliveries. Antony is something of a Renaissance man — he wrote and starred in *The Manic Organic*, his own television series on the Food Network. He's an ornithologist, a painter and a chef.

When Antony and Tina launched their business in 1995, we were asked to develop a logo. Jane Tribick, a friend of Ant and Tina's here in Stratford, had proposed the brilliant name SOILED REPUTATION — TEMPTATIONS FROM THE GARDEN.

It was Christina's inspiration to put this name in the context of Adam and Eve, evoking the original organic garden in *Genesis*. Instead of fig leaves, I used salad greens. Mischievously, Antony liked to boast that he and Tina posed for the illustrations themselves, but Adam actually comes from a Lucas Cranach painting, and anyone who knows Botticelli will recognize the source for Eve.

Jane Tribick, who had come up with the great name for Antony and Tina, asked us to create a logo for her own massage therapy studio. Hands came to mind — the tools of her trade — but I had seen that used too many times and wanted something less expected. When we are under stress our nerves get "frayed" and our muscles feel like "knots" — so the idea of a piece of rope seemed like an original solution — and the texture rendered beautifully in scratchboard.

Marion Kane, food writer and editor for many years at the *Toronto Star*, commissioned a logo for her freelance career. The title "Food Sleuth" perfectly describes who she is, and inspired the idea of a silver platter cover. The art was printed in metallic silver ink on her business cards.

A bouquet of cooking utensils became the logo for Kiss the Cook, a kitchen shop and bakery in London, Ontario.

kiss the cook

MARION KANE
food sleuth

writer · broadcaster · cook

GEORGE CRUIKSHANK ILLUSTRATION OF PUNCH, JUDY, AND THE BABY, FROM 1828; A 19TH-CENTURY FRENCH CUT-PAPER SILHOUETTE OF PUNCH AND JUDY, WHICH HANGS IN SCOTT'S DRAWING STUDIO IN STRATFORD.

IDENTITY

Christina and I named our design studio Punch & Judy Inc. We had both established design careers under our own names but we needed a distinctive name to represent our partnership when we formed our company. We wanted a name with a theatre connection, since that's where our careers most frequently overlap. The classic English puppet show seemed to have all the right associations with the performing arts — historical tradition, popular appeal, and a hint of anarchy.

Punch derives from Pulcinella, a character of the 16th-century Italian *commedia dell'arte*. The English diarist Samuel Pepys first spotted him in England during a Covent Garden marionette show in May 1662.

Punch has always been popular with artists and illustrators. One of my first art history book purchases was the complete *Punchinello* drawings of Domenico Tiepolo. In 1828, George Cruikshank illustrated *The Tragical Comedy or Comical Tragedy of Punch and Judy,* a script based on street performances of the period. And then there's *Punch,* the perennial British journal of humour and political comment, published from 1841 until the 1990s.

I used a scratchboard Punch and Judy for many years on our letterheads and invoices. We began to think about freshening up our image in print in 2005, and Christina — always looking for the conceptual road less travelled — sketched out the idea on the facing page. It refers in a tangential way to our individual professional activities. An arresting graphic can be said to have visual impact — or "punch." In a theatre wardrobe shop, a dressmaker's mannequin is known as a "judy." My business card features the boxing glove alone; Christina's the mannequin.

The name has worked well. Response from strangers is usually a moment of puzzlement followed by a smile of recognition.

PUNCH & JUDY INC
428 DOWNIE STREET
STRATFORD, ONTARIO
CANADA N5A 1X7

PHONE 519:271-3049
FAX 519:271-2945

first

sixth

EPHEMERA

This may sound almost Dickensian, but my earliest childhood memory of Christmas is helping to print the family holiday cards. My mother designed, cut stencils by hand and silkscreened an original card every year. I was the "runner" — my job was to pluck the wet cards from under the silkscreen frame and lay them out to dry. Mom corresponded with a huge circle of friends, so we printed a lot of cards every December. I had to overlap them to save space — depending on the design of the card, the long rows formed intricately repeated patterns across the basement floor.

This experience made a lifelong impression. I silkscreened dozens of theatre posters (and a few Christmas cards) while I was an art student at The University of Michigan. I still design and print my own Christmas cards — but now they are scratchboard drawings, printed by offset lithography instead of silkscreen (although, as line art, they would silkscreen beautifully).

I'm currently working on a "Perth County Twelve Days of Christmas" — one numeral per year. Instead of storybook settings from Medieval Europe, we wanted to feature the birds, farms and rural traditions in and around our home in Stratford, Ontario. Our Four Calling Birds were chickadees at the suet feeder in our backyard. Five Gold Rings did not involve jewelry at all — I drew the Salvation Army bellringers in front of our City Hall. And the whole idea started with Swans — Stratford's famous civic symbol — in the first place.

seventh

EX LIBRIS
MOLLY SPRATT

EX LIBRIS
JOEL SPRATT

EPHEMERA

To complement their familiar theatre posters, the Roundabout Theatre Company printed a corporate holiday card every year. Themes for these cards usually combined a theatre idea with a Manhattan setting. In 2002 — one year after 9/11 — The Roundabout requested the word "peace" as the greeting inside the card. The subject of the illustration was entirely up to me.

Christina proposed the simple, beautiful solution on the facing page. A girl feeding the pigeons in snowy Central Park is an everyday scene — but the birds have magically transformed into pure white doves. A quiet, simple moment about generosity and kindness. The girl's upraised arms convey a sense of joy — both giving and receiving.

A librarian and teacher in London, Ontario, and a personal friend, commissioned bookplates for her children in 2007. Not surprisingly, Molly and Joel are both avid readers. I had recently seen Neil Gaiman and Dave McKean's fantasy film *MirrorMask* on DVD. There's a delightful scene in which hundreds of books fly off the shelves of a library and flap around the room like a flock of birds. The 15-year-old heroine uses a butterfly net to catch the volume she's looking for. I adapted the idea for this project — the flying books seemed a great metaphor for the range of subjects, ideas, and choices facing young minds. New ideas are exhilarating and pleasurable, but they can be strange and baffling and sometimes hard to catch.

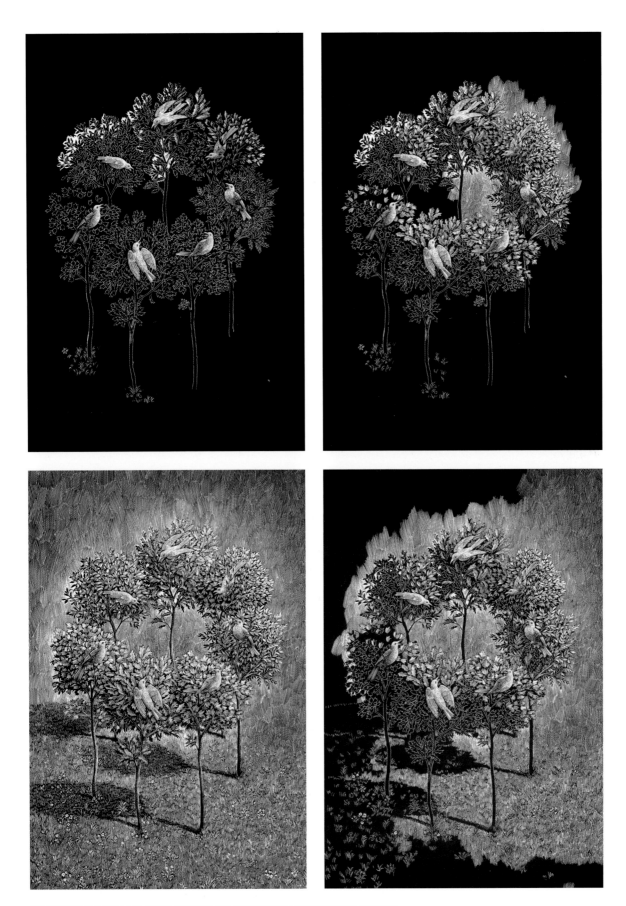

CLOCKWISE FROM TOP LEFT: STAGES SHOWING THE PROGRESS OF A SCRATCHBOARD DRAWING.
OPPOSITE: THE CROCODILE, AN INTERIOR ILLUSTRATION FOR *PETER PAN*.

WORKING IN SCRATCHBOARD

For most artists, drawing is a positive experience — in the sense that black lines (pencil, ink, charcoal, or crayon) are made on white paper. The tone of the paper establishes the value of the highlights — so all the marks made on the page automatically describe shadows. The more lines you add to a drawing with hatching to build up areas of tone, the further you render the shadow areas.

Scratchboard (or scraperboard, as the British call it) is exactly the opposite — you draw white lines onto an all-black background — so you are describing highlights. A similar experience would be drawing with a piece of chalk on a blackboard. Drawing in reverse is a little tricky. When I first tried scratchboard, I quickly realized that the free-form cross-hatch lines I used with pen-and-ink did not translate well into this new medium. I learned to use evenly-spaced parallel lines to create areas of tone. The eye registers areas of closely spaced lines as gray tone — the same way that halftone dots create the gray tones in a newspaper photograph.

The board itself is a machine-prepared surface of hard white chalk on a cardboard or Masonite base-board. A thin layer of black ink covers the chalk surface, and lines are created by scraping through the black ink into the white chalk underneath with a sharp blade. There are knives made just for scratchboard, but I usually work with Exacto knife blades — no. 11 for fine lines, and no. 2 or no. 24 for heavier lines. You can vary the line width to an extent by pressing harder on the blade (cutting deeper into the surface). This variation in line width creates the dynamics of tone — from stark contrasts to subtle shadings of light falling across a surface.

Scratchboard often looks like engraving — the lines are, literally, engraved — but this is not a printmaking medium. In traditional engraving, lines are cut into a surface (a block of wood or a metal plate), which is then inked and printed onto sheets of paper, creating an edition of prints. A finished scratchboard drawing is a single original, reproduced like any drawing or photograph by scanning or other photomechanical process. It's a black and white medium — I add colour, if required, once the line drawing is finished.

Preliminary pencil sketches are used to work out every detail of the drawing before starting on final art. Indeed, the protocol of the illustration business requires the client's approval of the sketch before proceeding to the final art. The approved pencil sketch is also used to transfer the structure of the drawing onto the surface of the board — so I have a roadmap in place when I start "scratching."

It's not the speediest medium with which to work. Precision and discipline are essential. I'm sometimes asked: "how long did it take you to *do* that?" For the record, most of the full-page illustrations in this book took two solid days of engraving; and that long again to add colour. An alternate meaning of the word discipline is punishment — but I actually enjoy the engraving process. Within the structure transferred from the pencil sketch, there's plenty of room for spontaneity, invention, and variation of line quality. There's also lots of opportunity to mess up if you're not concentrating — if a drawing goes off the rails, there's nothing to do but start over again.

My illustrations are usually commissioned for print reproduction. Once the drawing itself is finished, the process shifts gears into preparing the finished art for the printer.

The key characteristic of scratchboard is sharp, crisp, clean line quality. "Line art" is the graphic term for sharp-edged, solid black art with no gradation of tone. In the pre-digital days of offset lithography, line art was printed by placing the original under a graphic arts camera and making a film negative at the size you wanted to reproduce the art. The camera was actually a light-proof room with the lens mounted in the wall. Outside the room, a large copy stand was positioned precisely in line with the lens; banks of bright lamps were set at 45-degree angles to eliminate glare. The operator stepped through a light-lock and worked, literally, inside the camera. The film negative was used to burn a printing plate, and the resulting line art reproduction looked precisely like the line art original. That was in the good old days.

In the space of a decade, the printing industry has undergone a fundamental shift toward digital technology. The changes have been revolutionary. Files are now output electronically, directly onto the printing plate, eliminating film negatives from the process entirely. Very few printers even operate cameras any more — soon the film and chemistry required to run them won't even be manufactured.

Line art is now reproduced through a "bitmap" pattern of digital pixels, which renders curved edges as tiny "stairsteps." The sharp, crisp line quality is lost — a difficult and frustrating compromise for a scratchboard illustrator to have to make.

To counteract this bitmap effect, I scan scratchboard originals at 600 pixels-per-inch, at 400%. Then I reduce the scan to 25% (back to its original size), and boost the resolution to 2400 pixels-per-inch. This makes the pixel stairsteps finer and closer together, and less obvious to the eye, but you can never eliminate the problem entirely.

Image quality suffers even more when we move from the world of print into the rapidly expanding universe of internet communication. When my illustrations appear on websites at standard 72 pixels-per-inch monitor resolution, the engraving lines can become blurred and distorted. On a tiny iPod or iPhone screen, the image itself is often unrecognizable.

The challenges of working in scratchboard can come from old technology as well as new. For many years I have been using a product called Essdee scraperboard, manufactured by a small art supply company in Kidderminster, in the British Midlands, not far from Stratford-upon-Avon. I travel to London every year in February or March on a picture research trip for the Shaw Festival's theatre programmes. To save shipping costs, I purchase my board in England and bring it home with me on the plane. In 2008, I found that I was down to my last carton of board, and I called to order fresh supplies as usual. My heart skipped a beat when the girl on the desk said, "I'm afraid we don't make that anymore."

I spoke with the company's director, hoping there might be some last stock — somewhere — that I could get my hands on. I nervously explained that my entire career depended on his product. There was a pause, and he responded, "Well, I guess you had better think about a new career."

They had been forced by new Health and Safety regulations to stop using an animal-based glue in manufacturing the board. They had come up with a synthetic equivalent that worked well to adhere the chalk to the baseboard, but over a number of years, the new glue actually began to erode the metal parts of the machinery. The day finally came that the surface quality of the board was compromised — and the relatively small quantity of the product they sell every year would not begin to cover the costs of refurbishing the aging equipment. *C'est la vie.* My friend and scratchboard colleague Mark Summers has recommended some other options for board suppliers — I'm adjusting to "Claybord," made by Amersand in the U.S., so I am hopeful that I can continue working for a few more years. But the way of the world seems to be that any product or service that isn't a big seller goes to the top of the list for cutbacks.

ADDING COLOUR

The glory of scratchboard is the dramatic rendering of lights and darks. The key to adding colour to scratchboard, it seems to me, is to avoid competing with the linework. I find the best approach is to build up layers of flat colour on top of the black lines — as in a colouring book.

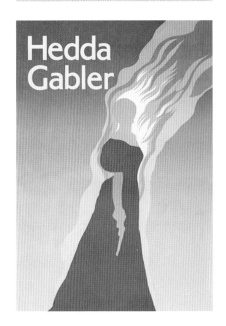

ABOVE: A 1994 ILLUSTRATION SHOWING THE TECHNIQUE OF HAND-TINTED COLOUR
APPLIED TO SCRATCHBOARD ON A PHOTOSTAT, USING MARSHALL'S PHOTO OILS.

LEFT: POSTER PRESS SHEETS SHOWING THE AREAS OF FLAT PANTONE INK COLOURS,
CREATED BY CUTTING MASKS, WHICH UNDERLIE THE SCRATCHBOARD LINES. THE LINE
DRAWING WAS PRINTED LAST, ON TOP OF THE FLAT COLOURS. THE FINISHED POSTERS
ARE REPRODUCED ELSEWHERE IN THIS BOOK.

There are two types of colour printing in offset lithography — "flat colour" and "full colour." Flat colour means that if you want a particular shade of orange, you mix that exact shade of ink (using the Pantone ink matching system). In full colour (or process colour), tiny halftone dots in the three primary colours — cyan, magenta, yellow — plus black, reproduce the full range of colours in the image. Where yellow dots overlay magenta dots, the eye perceives orange. I have used both printing methods for my posters.

Before digital printing, I frequently printed multiple colour posters using many layers of flat Pantone inks. I cut masks for each different area of colour using rubylith, a transparent red acetate material that photographs as black under the camera. The Beacon Herald, a local printing shop here in Stratford, allowed me to work closely with their pressmen. Press approvals became part of the creative process. We experimented with a "split-fountain" technique to achieve gradations of colour along a single ink roller. If a colour was slightly off, we would climb up on top of the press and alter it.

I know that other scratchboard artists add colour to the original board itself. I have never tried that — still so much to learn. In pre-digital days, I sometimes made photostats of the scratchboard drawings and tinted them by hand using Marshall's photo oils — little tubes of intense but transparent pigment intended to tint black and white photographic prints. I liked the grayed-out quality of the Marshall's colours. Then, the tinted photostat was scanned as a colour original.

Now, I mostly add colour digitally. I still make masks for the different areas of colour, but now these are drawn in Photoshop, using channels. The mask isolates all the pixels in one area of the drawing — a background, for example. I can use the mask to lighten the black lines in that background area (lightening the pixels), or flood colour over the lines (darkening the pixels). Two colours can be overlapped, creating a third colour. Working electronically, I can see these colour effects immediately on a monitor. The history palette in Photoshop provides a wonderful safety net — if I don't like a colour effect, I

can "undo" as many steps as I need to. I can just go back and try something else. I can save a copy of the file, try another effect, then compare different versions side by side. You can't really do that with a brushstroke or a pen line on a piece of paper.

Another advantage of working digitally is the ease of making proofs and sending them electronically to clients for approval. When a project is finished, I can send huge files to the designer or directly to the printer using an FTP (File Transfer Protocol) server.

DESIGN

A successful poster or book cover is a synthesis of typography and illustration working together on the page. I'm a graphic designer as well as an illustrator, and the words and the pictures have equal importance. Whenever I start a new poster project, I find myself thinking about the style and character of the type design at the same time as the illustration.

This can be really annoying for art directors who might want to hire me only as an illustrator. For me, nothing ruins an illustration assignment like an insensitive, inappropriate type layout — which I might only see for the first time when the printed samples arrive. At the risk of acquiring a reputation as a control freak, I now ask art directors to allow me to design the type, or allow me to participate in the process — and this usually works out very happily. On the other hand — I hasten to add — it's truly exhilarating to collaborate with a designer who brings a fresh perspective to the project. I love it when an art director takes a design further than I ever would have or could have — which happens frequently.

I recently heard the term "Native Digital" — used to describe someone who has grown up with digital technology and never known anything else; and "Immigrant Digital" — to describe someone like me, who had to learn the new technology as a second language. I began my graphic design career in the pre-Macintosh era, and as much as I enjoy working with the powerful digital tools in Adobe Photoshop and InDesign, I would not want to be without the hand skills I acquired back in the dark ages. (One of my pet theories is that the digital revolution has actually made hand skills more valuable.)

A great illustration, it seems to me, has to start with a great concept. The process of distilling a script or a novel into a visual idea that conveys some essence of the work is a mysterious and subjective one. Christina Poddubiuk, my wife and principal collaborator on many of the projects in this book, calls her problem-solving process "connecting the dots." She looks first at the world of the play — the historical setting, social attitudes of the time and place, contemporary literature or art history references, as well as the specifics of plot and character. Once a set of reference points is established, she looks for a solution that touches on as many of them as possible. With luck, the result is a concept that works on several levels at once. The process never ceases to be interesting.

We thrive on creative collaboration with clients, directors and other designers who challenge us to do our best work. Art and design is our vocation and avocation. We cross paths daily with painters, poets, playwrights, chefs, actors and musicians. Their disciplines inform ours — which always keeps us looking forward to the next assignment.

ILLUSTRATION COMMISSIONED
BY *THE WASHINGTON POST* AND
BOOK WORLD, SPONSORS OF THE
NATIONAL BOOK FESTIVAL IN 2004.

THE NATIONAL BOOK FESTIVAL SATURDAY OCTOBER 9 2004 ON THE MALL

ACKNOWLEDGEMENTS

Our childhood experiences have profound influences on our adult lives. My mother trained as a signpainter, so I knew that rounded letters properly extend slightly above and below the guidelines almost before I could put them together into words. My dad was a high school music teacher — I grew up as he was directing productions of *Camelot*, *Carnival*, and *Brigadoon*, which meant that I got to hang out backstage, climb around on the theatre's catwalks, and work the mysterious levers and wheels of the enormous old lighting board.

Early artistic inspiration and encouragement came as well from Ray and Phyllis Jansma in Fremont, Michigan, who demonstrated by their wonderful example that making art and music in a home studio environment is a perfectly normal career choice.

My path towards a career in design and illustration really began in Doug Hesseltine's classroom at The University of Michigan School of Art. Immensely articulate about the creative process, Doug fosters in his students a superior standard for visual and verbal communication skills. He instills a rigorous problem-solving methodology as the key to successful design solutions, with emphasis on fundamentals such as listening to the client and understanding the problem. I came away feeling well-equipped to tackle any design assignment.

I moved from Ann Arbor to Stratford, Ontario, in 1980 into a welcoming and supportive community of artists. Ken Nutt has generously shared his expansive knowledge of art and illustration (many of the public-domain text illustrations in this book came from his remakable collection). In addition, Ken has sharpened my drawing skills through countless Wednesday evening life drawing classes over two decades.

I'm grateful to Mark Summers, whose brilliant work first inspired me to attempt scratchboard, for his help getting started in the illustration business; and to my longtime illustration rep, Marlena Torzecka, and her staff in Princeton, New Jersey.

Special thanks to Christopher Newton for his generous introduction to this book, and to Lionel Koffler and Michael Worek at Firefly Books for undertaking this project.

As I've noted throughout this book, the creative collaboration with my wife, theatre designer Christina Poddubiuk, amounts to more of a shared authorship. My best posters are informed by her conceptual insights, and this book would not exist without her patience, generosity, and love.

COVER ILLUSTRATION FOR *GRIMM'S FAIRY TALES*.

PETER REUNITED WITH HIS SHADOW IN
J.M. BARRIE'S OF *PETER PAN*.

INDEX

THE CLIMACTIC DUEL BETWEEN PETER AND
CAPTAIN HOOK IN J.M. BARRIE'S OF *PETER PAN*.

ILLUSTRATION FROM
LUCY MAUDE MONTGOMERY'S
ANNE OF AVONLEA.